Baseball in ALABAMA

TALES OF HARDBALL IN THE HEART OF DIXIE

Doug Wedge

Foreword by Hal Baird, Head Baseball Coach, Auburn University, 1985–2000

THE
History
PRESS

Published by The History Press
Charleston, SC
www.historypress.com

Front cover, top left: Mark Cunningham/Detroit Tigers; *top center*: New York World Telegram; *top right*: Rickwood Classic baseball game, photo by Carol M. Highsmith, Library of Congress; *bottom left*: Wikipedia; *bottom right*: Hudson Family Foundation.
Back cover, top: Ralph Mauriello's collection; *middle*: Bowman Gum; *bottom*: author's collection.

First published 2018

Manufactured in the United States

ISBN 9781467138789

Library of Congress Control Number: 2017963929

Part of my first year in pro ball was in Birmingham, Alabama. I played in Rickwood Field, its last full-time season as home to the Barons. I remember hearing about all the history at that park, all the guys who played there like Willie Mays and Satchel Paige. Reading this book brings all that history back to me…and more. Doug Wedge does a great job of telling you about the Alabamians who made their mark in the big leagues and shares good stories about college and minor league ball in Alabama. Check it out.

Jack McDowell, winner of the 1993 American League Cy Young Award

Doug Wedge has a gift for storytelling. Reading about the impact the state of Alabama has had on the sport of baseball was a trip down memory lane for me—and it will be a nostalgic treat for all other baseball fans as well. From the Willie Mayses and Hank Aarons of decades ago to the modern-day Tim Hudsons and Bo Jacksons, the stories about every player are fascinating. Wedge's tales about the historic Barons and Black Barons of Birmingham should make every student of baseball history put the annual Rickwood Classic game on his or her bucket list.

Don Logan, owner of the Birmingham Barons

With each passing year I find myself less enamored with contemporary baseball players' stories. Doug Wedge's *Baseball in Alabama: Tales of Hardball in the Heart of Dixie* allows me to get my fix on the hardscrabble days. This book's a must-read for anyone obsessed with baseball, and/or with athletes doing the best they can with what they honed.

George Singleton, author of *Calloustown*

To Shawn, Jack, Sloan, Sophie and Sadie

CONTENTS

CONTENTS

FOREWORD

I arrived in Alabama over thirty years ago, in June 1984. My goal when I started coaching at Auburn was to attract the best players in the state to our school. At that time, the University of Alabama was doing well. They had been to the College World Series in 1983 and finished runner-up to Texas. They had a little bit of the upper hand when it came to recruiting in-state. Nonetheless, my goal—and it was central to what I wanted to do here—was a program that consisted, to the greatest degree we could make it, of Alabama-born and -raised players. And once that happened, I knew our program would take off.

Why?

Because these players had grown up *loving* Auburn. Not only did you get their athletic ability when they joined our team, but you also had their lifelong commitment to the school. We have some great baseball programs in the state at UAB (the University of Alabama at Birmingham) and South Alabama, but there is an intense rivalry between Auburn and Alabama. These kids understood that rivalry, and they knew what it means to wear that jersey and represent all that it stands for.

Add to that growing up in Alabama, which meant that these players were raised tough. They were raised right. I've seen so many players go on to the major leagues, and they change. They have attained their goals, and their personalities change. In fact, they have a term for it: they've "big leagued" you and act like they're better than others. Not if you're from Alabama. From Bo Jackson to Tim Hudson, these guys didn't let fame and fortune

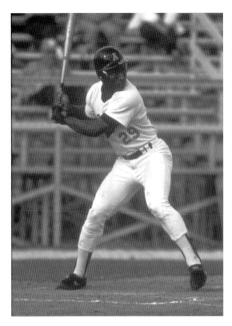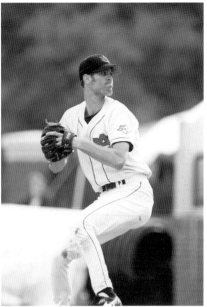

change them. They never lost their humility or their hard-nosed edge in how they played the game. I think that speaks to being reared in this state and, of course, to great parenting.

Speaking of Bo Jackson and Tim Hudson: what a joy to work with both athletes. I coached Bo for two seasons. I've still yet to see any athlete who was able to do the things he could do physically on the field—football or baseball. So intense. So intelligent. Just the greatest athlete you could see.

With Tim, he wasn't highly recruited. But he had a ton of heart. Don't get me wrong, he was talented, too. In 1997, he was named SEC Player of the Year. He was tough, and he had that gritty makeup; he was going to extract the most out of his ability. And look at what he did, going on to win 222 games in the big leagues.

When I look back on my time at Auburn, it's not so much about the moments or the individual players or the end-of-season results as it is the teams that stand out. I remember David Ross in the 1997 Regionals hitting a three-run walk-off home run to put us in a bracket that pretty much assured us a trip to the College World Series. That was a dramatic moment, for sure. I remember the 1988 squad, a great team with Gregg Olson, who was the fourth overall pick in the major league draft, and Frank Thomas, a Hall of Famer. They were 39-16, a tremendous team, and they didn't even get selected for the tournament. It was a smaller pool back then. I remember

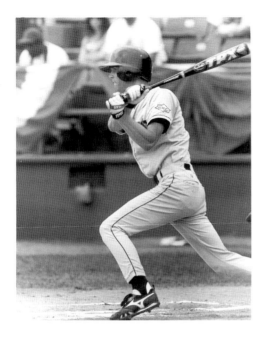

Left: Hudson getting it done at the plate. *Auburn University's collection.*

Opposite, left: Bo Jackson. *Auburn University's collection.*

Opposite, right: Tiger Tim Hudson on the mound. *Auburn University's collection.*

the 1995 team, which had the top RPI (Ratings Percentage Index) and was ranked number one in the country. There were just a bunch of great teams and a lot of great moments.

One thing I'm proud of is playing a role in designing the renovated Plainsman Park. I really wanted Auburn to use an architect based out of Jackson, Mississippi, an Auburn grad who had designed several other ballparks. And I wanted him to design a park that would stand the test of time. With the park's location at a central point on campus, I wanted it to be important and timeless. I met with him and encouraged him to incorporate elements of Wrigley Field, Fenway Park and Camden Yards. And he did exactly that. We have brick like Wrigley, a green wall like Fenway and exposed steel like Camden Yards. And more than twenty years later, it stands as a remarkable facility. A great place to play, a great place to attract athletes, a great place to host Regionals and Super Regionals. I only wish the park had been upgraded a few years earlier. If it had, I'll bet we would have a few more pieces of hardware to show off in the trophy case.

It was an honor to serve as Auburn's head baseball coach. Doing so, I traveled throughout the state, met with coaches, players and players' families. We recruited players from all over—Huntsville to Montgomery to Mobile—and even though Birmingham is solidly an Alabama town, we did well there, convincing kids from Hoover and Homewood and

Left: Thomas manning first base. *Auburn University's collection.*

Below: Frank Thomas. *Auburn University's collection.*

Plainsman Park, home of the Auburn Tigers. *Auburn University's collection.*

Vestavia Hills and Mountain Brook to join our team. Since 1984, I've seen tremendous success in Alabama baseball. When I started, some of the high school baseball coaches were terrific coaches, but there were an awful lot who were assistant football coaches, and assistant football coach was their primary responsibility. But now, I see baseball-savvy coaches who are putting solid programs together year in and year out and helping young men improve at the game. I see facilities that are wonderful places to play. I see baseball getting better and better. That is gratifying. Alabama is a college football state, deservedly so, but it has all the ingredients to produce great baseball players. You have good weather, so you can play a lot of games. And you have people who love athletics and competition.

I'm excited about the future of Alabama baseball. Now, we can look back and see what others before us have done to achieve success and learn from them—the Alex Grammases, the Billy Williamses and the Bob Veales—and continue to build on that great Alabama baseball tradition. I look forward to the next chapters we're going to write about Alabama baseball. Like Plainsman Park, that history has been and will be one that stands in a special place and stands the test of time.

HAL BAIRD

ACKNOWLEDGEMENTS

I am grateful to the athletes who agreed to interviews and shared their experiences: Britt Burns, Jim Gentile, Alex Grammas, Chris Hammond, Don Heinkel, Tim Hudson, Ron Jackson, Lance Johnson, Todd Jones, Jon Lieber, Dave Magadan, Ralph Mauriello, Mike McCormick, Lindy McDaniel, Mike Mordecai, Charlie Moore, Bobby Morgan, Charlie O'Brien, Chris O'Brien, Gary Redus, Mackey Sasser, Jay Tibbs, Alan Trammell, Bob Veale, Billy Williams and Al Worthington. I appreciate Coach Hal Baird for writing the foreword, and I thank Molly Kidd with the Chicago Cubs for coordinating the interview with Mr. Williams; Chad Crunk with the Detroit Tigers for coordinating interviews with Mr. Jones and Mr. Trammell; and Patrick Kurish with the Arizona Diamondbacks for coordinating the interview with Mr. Magadan.

Thank you, Charlie O'Brien, Stephen Russell, Justin Werner and Dave Wheeler, for reading early drafts and suggesting ways to improve the book. I appreciate Sloan Wedge's research and help in finding photographs of Alabamians, their teammates and the parks where they played. Thank you to Mark Cunningham, Charlie Nichols, Scott Scroggins and Warner Taylor for sharing your photographs. Thank you to the Birmingham–Jefferson County Library for providing research resources and to Kirsten Schofield for encouraging me to write this book. Editors Amanda Irle and Rick Delaney offered editorial suggestions that improved the book.

INTRODUCTION

*A*labama sports. These words may spark images of college football—Coach Bryant and his houndstooth hat; Bo Jackson leaping over a pile of linemen to propel Auburn to an Iron Bowl win; National Championship games ending with Nick Saban hoisting a Waterford crystal football, confetti swirling around him.

Undoubtedly, Alabama has a rich football history, with the Tide's seventeen national championships and Auburn's Heisman Trophy winners Pat Sullivan, Jackson and Cam Newton. But an equally rich history exists for another sport, the national pastime, baseball. Alabama is home to thirteen players enshrined in the National Baseball Hall of Fame. You can field an Alabama dream team with Leroy "Satchel" Paige (Mobile) as your starting pitcher, Willie McCovey (Mobile) or Frank Thomas (Auburn University) at first base, Ozzie Smith (Mobile) or Joe Sewell (Titus) manning shortstop and Billy Williams (Whistler), Hank Aaron (Mobile) and Willie Mays (Fairfield) covering the outfield. The next day, Hall of Famers Early Wynn (Hartford) or Don Sutton (Clio) can take the mound for this team. Perhaps the game would be played at Birmingham's Rickwood Field, the 10,800-seat ballpark that opened in August 1910, home to the Birmingham Barons and Birmingham Black Barons for decades and where more than one hundred hall of famers have stepped onto its grass.

Great baseball with Alabama roots continues today. The 2015 American League Most Valuable Player, Josh Donaldson, played high school baseball in Mobile and honed his skills at Auburn. Jake Peavy (Mobile) was selected

as the National League's best pitcher in 2007, winning the Cy Young Award. Dothan native Matt Cain pitched the twenty-second perfect game in baseball history, allowing no runners to reach first base on June 13, 2012. Craig Kimbrel (Huntsville) is the game's premier relief pitcher, leading the National League in saves from 2011 through 2014.

Countless games have been played in the Heart of Dixie with many pitches and hits, great catches and near misses, triumph and disappointment. This book captures some but by no means all of these moments by profiling players with Alabama roots and sharing their stories, highlights and keys to success, beginning chronologically with Birmingham's Alex Grammas making his major league debut in 1954, spending ten years as a big-league infielder and then serving as a third base coach for twenty-five seasons. We end with Tim Hudson (Salem) retiring after the 2015 season as the active leader in wins (222). The players highlighted in this book are the following: Billy Williams, 1961's National League Rookie of the Year and 1972's batting champion, elected to the National Baseball Hall of Fame in 1987; Bob Veale (Birmingham), National League leader in strikeouts in 1964; Ron Jackson (Birmingham), an American League top-ten leader in doubles (1979) and later a hitting coach who worked closely with David Ortiz to help him become a premier power hitter; Britt Burns (Birmingham), two-time top-ten finisher for the Cy Young Award; Gary Redus (Tanner), holder of the highest professional batting average for a season, hitting .462 for the Billings Mustangs in 1978; Mackey Sasser (Dothan), part of the 1988 New York Mets that won 100 games; Chris Hammond (Vestavia Hills), one of three pitchers to complete a season with an earned run average less than 1.00; and Todd Jones (Jacksonville State University), who saved 319 games, nineteenth most all time.

Profiling these players and moments of Alabamians in the big leagues charts a baseball timeline from the 1950s to today. Willie Mays (Fairfield) established himself as one of the best players to ever step on a baseball diamond. Bob Veale matched up against pitching greats like Sandy Koufax and Juan Marichal in the 1960s. Willie McCovey (Mobile) emerged as the game's best power hitter, earning Most Valuable Player honors in 1969. Hank Aaron (Mobile) ended a hall of fame career by driving in Charlie Moore (Adamsville) as his final RBI. By 1985, Jay Tibbs (Birmingham) watched teammate Pete Rose eclipse Ty Cobb's all-time hits record. Gary Redus remembers a muscled Texas Rangers team sending baseballs flying over outfield walls in the early '90s and the beginning of the steroid era. As a player representative, Todd Jones participated in negotiations during

the 1994 labor dispute that led to the players' strike and no World Series being played. Tim Hudson made multiple starts as the Oakland A's broke the American League record for consecutive wins (twenty) in 2002. Mike Mordecai (Trussville) led off the eighth inning of Game Six of the 2003 National League Championship Series when fan Steve Bartman interfered with Cubs left fielder Moises Alou trying to catch a foul ball, and the Florida Marlins clawed back from a three-run deficit to snatch a World Series appearance from Chicago. Tim Hudson describes being a part of the San Francisco Giants in 2014 as they won their third World Series in five years.

A lot of events between 1954 and 2017—milestones and memories at the ballpark. With more to come.

QUARTER CENTURY COACH

ALEX GRAMMAS

1954–56: St. Louis Cardinals
1956–58: Cincinnati Reds
1959–62: St. Louis Cardinals
1962–63: Chicago Cubs

fter retiring as a player, Alex Grammas found a new job that fit him perfectly: coaching third base. Thrilled to stay in baseball, he loved the decision-making the position required.

"You're always in the game," Grammas says. "You know what the situation of the game is: what's the score, what inning, how many outs, who's pitching, who's hitting. Those things go through your mind like that. The outfielders—where are they playing? That left fielder is in close, [so] we'll have trouble scoring on this guy. If [the runner's] got it made, I'll send him. But, you hit a ball, *boom!*, and the guy's just getting to third base, and the left fielder's got the ball in his hand, and you're going to send him? You've got to think of all of those things."

In addition to applying strategy and making the right moves, Grammas enjoyed the personal aspect of coaching. "You get a lot of joy out of helping a guy be more successful on the field." Even at eighty-eight and with a sore back and tender shoulder, Grammas demonstrates how a shortstop catching a ball across his body needs to swivel with his right foot planted so he can fire the ball to first base with accuracy and power.

Grammas was a third base coach for twenty-five years, working mostly with manager Sparky Anderson, first in Cincinnati from 1970 through 1975 and then again with the Detroit Tigers in 1980 until Grammas retired after the 1991 season. Along the way, Grammas was in four World Series, including the 1975 Series between the Reds and the Red Sox, which Grammas says is one of the best World Series ever.

"It was close, and I mean you had players on both clubs that were super. And you had to have good pitching to get through it. It was unbelievable. I know that there wasn't a better last two games than those. That one where old Carlton Fisk hit that home run and tried to make it stay fair."

BEGINNINGS

Grammas grew up in the Norwood area of Birmingham. Developed in 1910 by the Birmingham Realty Company, Norwood was touted as "The Placid Place," its location north of downtown providing distance from the steel mills' smoke and the city center's noise but only a short streetcar ride away from downtown.

His baseball career started at Phillips High School in Birmingham. "The place we played was solid clay," he says. "All clay. No grass. Now, if you hit a ball hard enough, it could get past the center fielder and almost go to Powell Grammar School across the street." He chuckles. "You hit a ball past the outfielders, there's no way to stop it."

Looking back, he says the hard surface he describes as "treacherous" may have honed his fielding skills. And without the benefit of a seasoned baseball coach to teach him the game (his coach was a football coach), Grammas learned baseball by playing it and watching others around him play.

"You'd be surprised at how much you learn on your own."

As he discovered playing techniques that worked well for him, Grammas believed in repetition so the skill became muscle memory. "If you find the right way to do something and repeat it, repetition is something that keeps you going."

Grammas enjoyed other sports at Phillips, including basketball ("I wasn't the greatest basketball player," Grammas says. "But, you know, fair."). But he favored baseball. "Of course, I loved baseball. No question about that."

After graduating from Phillips in 1944, Grammas attended Auburn University for one year. When he turned eighteen, he joined the army. He

completed basic training in California and was sent to the Philippines. Laying in a foxhole and hearing gunfire overhead, Grammas thought, "Damn. This is a hell of a place to be for an eighteen-year-old."

Grammas credits military service for shaping him into an adult. "It makes a man out of you. Living in foxholes: it's not easy."

When stationed in Japan, he was able to keep playing baseball. "We had a guy who played shortstop up at Washington for one year. Seems like his name was Sullivan," Grammas says. "And we had a guy who played second base for Memphis: Hodges. And those two guys were there. So, I went out and introduced myself to them, you know, and they gave us a uniform if you could call it that," Grammas laughs.

Although Grammas played second base in high school, he selected a different infield position in deference to the professional players who played second base and shortstop, respectively. "I got over at third, taking ground balls. To me, a ground ball is a ground ball. I didn't care where I was playing. After I was there a couple of weeks, we came up with a team."

Grammas's talent caught the attention of his teammates with professional experience. Both pulled Grammas aside and urged him to consider playing pro ball. Grammas responded, "Well, I've given it a little thought, but I haven't been real serious about it because, when I get back home, I got some more college I got to go to."

Encouraged, Grammas and his brother Pete returned to Auburn after their military service ended. Both wanted to continue playing baseball. But seeing that players stayed in a room of bunk beds and with an inch of water on the floor, Pete told Auburn officials, "We had enough of underground living in the army." Thanks, but no thanks.

Grammas was slightly worried by Pete's rebuff, but Pete had a letter of recommendation for the brothers written by a Birmingham umpire. The letter was addressed to Dudy Noble, the head baseball coach at Mississippi State University for twenty-six seasons (1920–47). The brothers traveled to Starkville and presented the letter to Noble. The coach read the letter and looked at the young men. He told them to return in January and said they could stay in the athletic dorms.

They lived there three years, winning two SEC championships.

THE NEXT LEVEL

Toward the end of his Bulldog tenure, Grammas was approached by Chicago White Sox scout Doug Minor. While State played against Tulane in New Orleans, Minor spoke to Grammas through the chicken-wire fence that defined the dugout space, with Minor explaining that Grammas needed to play for Chicago.

"We're playing a game," Grammas said. "I can't talk to you."

"Would you give me a call up in Chicago?" Minor asked.

"Absolutely. Give me your phone number."

Returning home to Starkville, Grammas called. Instead of reaching Minor, he spoke with the White Sox general manager, Frank Lane, who demanded from Grammas an immediate yes-or-no answer to joining the organization. "He was mean as hell," Grammas remembers.

Grammas said he couldn't give him an answer on the spot. In response, the general manager threatened to hang up on Grammas. As a preemptive strike, Grammas said, "Well, if you're going to hang up, then I will, too," ending his conversation with the GM.

Despite the tense conversation, Grammas signed a contract for $5,999, $1 less than what would have required the White Sox to keep him on a minor league roster for only a year. Had Grammas signed for $6,000, after his one year in the minors, the White Sox would have been forced to add him to their major league roster or place him on waivers and thus make him available to other teams.

Grammas played well in the minors and, by 1954, reached the major leagues, playing shortstop for the St. Louis Cardinals alongside future hall of famer Red Schoendienst at second base.

"[Schoendienst] had great hands. *Whoo!* He could catch balls, I don't care what position he was in. He just had great hands."

Another teammate was Stan Musial. When Grammas joined the Cardinals, Musial had already logged twelve seasons with the team and established himself as one of the game's elite players, with three Most Valuable Player awards and six batting titles. Even though he had achieved superstar status, Musial immediately made Grammas, the rookie, feel welcome. After one game, Grammas was sitting by himself in the hotel lobby. Musial stepped out of the elevator. Grammas barely knew Musial other than from a few interactions during spring training.

As Musial approached, Grammas said, "Hey, Stanley." Musial asked him what he was doing. Grammas told him he wasn't doing anything.

St. Louis Cardinals legend and hall of famer Stan Musial. *Wikimedia Commons.*

"Yeah, you are," Musial said. "Come with me." Musial treated Grammas to dinner.

As Grammas stayed with the team, he grew closer to Musial. He observed that Musial used bats with thin handles. Musial actually shaved the bats to make the handles thinner. This technique worked well for Musial, who had great hand-eye coordination and could place the ball on the bat's sweet spot time after time. But for other players with less precision, the thin handles meant sore hands if the ball touched the bat other than on the sweet spot. "If you don't hit it on the nose," Grammas explains, "it'll vibrate the heck out of your hands."

Grammas was curious about Musial's approach with thin handles. "Hey, Stanley," Grammas said. "I think I know the answer to this question, but I'm going to ask it anyway."

"What's that?"

"How can you use those thin-handled bats if you hit the ball with your fists?"

Musial looked at Grammas, puzzled. "I don't hit no balls with my fists."

Grammas laughs and says, "Stanley, he just knew he was going to hit the ball on the fat. The rest of us, we needed the length of the bat. He just needed that one spot."

Grammas attributes part of this skill to exceptional eyesight. "This pitcher could think they have great stuff, and they try to use it against those great hitters, and it's like they see it before it leaves his hand. And their eyes wide open, light up, and *bingo!* See you! But Stanley, he could hit balls. And he could run like crazy. He'd hit balls to left center: triples. Or pull one up over that roof."

Musial kept his wrists supple by playing drums in the clubhouse. He would find a couple of buckets, turn them upside down and use wire coat hangers as sticks.

After they retired from baseball, Grammas and Musial kept in touch, calling each other on their birthdays. Musial would typically get out his harmonica and play "Happy Birthday" to Grammas.

Eddie Stanky, the coach who went on to lead the University of South Alabama to nearly five hundred wins two decades later, was Grammas's

first big-league manager. Although the *Sporting News* named Stanky Major League Baseball's Manager of the Year in 1952, half of the Cardinals hated Stanky, in part because of the gruff way he treated his players. The following anecdote is an illustration: Stanky passed Grammas as Grammas entered the training room. Stanky barked, "Alex!"

"Yeah, Skip. What's up?"

Stanky said, "Which one do you like? 'I think it's nice of you to come get worked on today and get your problem solved,' or would you rather me say, 'Get your fucking ass in the goddamn training room!'"

Grammas mulled the question over and answered, "I think the former sounds more dignified." Stanky didn't say anything else. He just walked into his office. Grammas shrugged and went into the training room and asked the trainer what was going on.

The trainer said, "You don't know. The timing was absolutely perfect. He and I were talking about what you should do: screaming and yelling and cussing and all that. He gave you a choice between that and you said, 'I think the former sounds more dignified.' You were putting stars on what I had told him."

In St. Louis, Grammas's home field was Sportsman's Park. In the 1950s, major league infields weren't the smooth surfaces you see today. "Mountain Brook High School's field is better than what we played on back then," Grammas says.

One game at Sportsman's, Grammas toed the infield dirt throughout the game. His digging caught the attention of the trainer, who came out to ask if Grammas was hurt.

Reaching into the dirt and pulling out a brick, Grammas explained that he wasn't hurt; he was just wondering what was buried under the infield. He lifted the brick and showed it to the crowd.

Grammas liked visiting Ebbets Field in Brooklyn. "It's something about that ballpark I liked. I don't know what it was. But I always seemed to get base hits in that park."

One Dodger pitcher Grammas hit especially well was Johnny Podres, the Most Valuable Player of the 1955 World Series and the league leader in ERA and shutouts in 1957.

"He would get so doggone mad," Grammas says. "In fact, I think he said something to me before a game he was pitching. And the first time up, I hit a ball, lined a ball down the right-field line. Cinch double, maybe a triple. So, I'm headed to second, rounded second, going to third, and who's running beside me is Podres. Step for step with me, cussing me. Cussing me out for

Sportsman's Park in St. Louis. *Wikimedia Commons.*

Players warming up by Sportsman's grandstands, not far from where Alex Grammas discovered a brick in the infield dirt. *Gerald Massie, Missouri State Archives.*

getting another hit off of him. That was something. That was funny. Now, I ain't kidding you. He was cussing me out. Yeah. He couldn't believe a guy like me, a guy hitting two-fifty, two-sixty could get those hits off of him."

Playing baseball in the 1950s was different than today, especially with respect to travel arrangements. While coaching for Detroit in the 1980s, Grammas heard a player complain about an upcoming three-hour airplane flight. Astounded, Grammas remembered train rides from New York to St. Louis leaving in the evening and reaching the destination the next afternoon. The norm was arriving in a city early in the morning, checking into the hotel and hoping to catch a few hours of sleep before going to the ballpark for a game that evening.

"It was tough," Grammas says. "You had to get yourself accustomed to it. And fight it. If you sit there and worry about it all the time, you wouldn't be worth two cents. Because everybody's doing the same thing."

Another way the game was different: money. A major league salary in the 1950s meant that players found jobs in the off-season. To pay the bills, Grammas worked for his family's candy business in downtown Birmingham. The game had changed markedly by the 1980s, when Grammas tried to offer coaching advice to players with million-dollar contacts, players who weren't as apt to listen to the lesser-paid coach.

UTILITY MAN

In 1956, the Cardinals traded Grammas to the Cincinnati Reds. In Cincinnati, he adjusted from playing every day to being a utility player. Instead of playing shortstop consistently, he played some second base, some short and some third.

"It's always good to be playing, you know? Because you get tired of sitting around, sitting around, sitting around, and you lose your touch. You take a guy who sits there for two weeks without playing at all—it's not easy."

When the Reds struggled with a losing streak, manager Birdie Tebbetts decided to make a change and play Grammas every day. Tebbetts announced his decision to Grammas as the two rode in a hotel elevator. Tebbetts said, "Get your rest tonight. You're going to be in there tomorrow."

Grammas said, "Birdie, I've been getting a lot of rest. I'm going to get it again tonight."

Tebbetts said, "Well, you're playing a doubleheader tomorrow."

Grammas responded with seven hits in the two games. "I think I played the rest of the year that year," Grammas says.

Looking back on his playing days, Grammas assesses, "I wasn't the best, that's for sure."

If he could augment one dimension of his game, Grammas would ask for more speed. "Speed can make up for so many things. It can improve every part of your game. It can improve your hitting. You get thrown out by one step. If you can run, you're safe. If a ball's hit in the hole, [you can reach it] if you got speed. I think being fast is one of the best things that can happen to you."

A NEW DIRECTION

Grammas played his final two seasons for the Chicago Cubs. Knowing his playing days were ending, he met with the Cubs' general manager, John Holland, to discuss his future.

"I'd really like to try start something new if it's possible," Grammas told the GM. "I'd like to start managing."

Holland responded, "You'll either be managing Fort Worth in the Texas League or the Triple A club. You're going to have either one of those teams."

"That's fine with me."

The next season, Grammas managed the Double A Fort Worth Cats in the Texas League. After spending only one season in the minors, Grammas was back in the big leagues in 1965 when his friend Harry Walker became the manager of the Pittsburgh Pirates. Walker asked Grammas to become his third base coach. Grammas accepted.

Similar to his exchange with Eddie Stanky about the most effective way to communicate with players, Grammas understood how to treat players so they played relaxed and well. The 1965 Pirates were an incredibly talented team, with future hall of famers Roberto Clemente, Bill Mazeroski and Willie Stargell, along with ace pitcher and Birmingham native Bob Veale, who won seventeen games and rang up 276 strikeouts that season. A month into the season, though, the team was playing poorly, winning only nine games but losing twenty-four.

Grammas sensed that his friend Walker was part of the problem. "He'd push them, guys to do this, that. But when the season started, he was

constantly [instructing]. A guy'd be hitting, and [Walker would] be hollering about holding the bat and all that. It affected us. You know, you're trying to concentrate on the pitcher, and you got somebody screaming at you from the dugout. God dog it."

Recognizing he wasn't solving anything if he stood by silently, Grammas approached Walker privately. "I've got to talk to you," Grammas said.

"What've you got there?" Walker asked.

Grammas began, "You know, going to spring training, you took over the club, and we had a hell of a spring training the way you were stressing how things would be done." Walker nodded.

Grammas continued. "Now that the season's started, you ought to back off a little of that approach because now you're trying to teach, but you can't be teaching every day here. Every day here, you can't do that."

Walker tensed. "What am I supposed to do? Am I supposed to get all over them, or am I supposed to back off?"

Grammas said, "I'm going to tell you something. I going to tell you it as straight as I can. Because I know you better than most people do, and you know me. But between standing in the corner like a goddamn dummy or overdoing it, there are two extremes. And between those extremes is what you've got to find. You can't sit over there and overdo it this way and get mad. In between those two extremes is a happy medium, and that's what you've got to find."

Walker listened. He relaxed. The team started to play better and have more fun. "From that day forward, we played the best ball in the league. We almost won the damn pennant," Grammas says.

Grammas believes Walker listened to him because of Grammas's honesty. "He knows I'm not a bullshitter. He's the same way. He didn't bullshit you."

Honesty is a critical attribute to have if you're going to coach. "To me, honesty is the best thing that a person could have," Grammas says. "I just don't believe in trying to lie my way through things. You lie your way through it, it's going to come out sooner or later. There's just no way to hide something completely. Be honest. And you'd be surprised by how many people say, 'I'm glad you did that.' I'm not here to irritate you. My life is to be as honest as I can, and we'll be buddies and friends all our lives. That's the way I look at it."

Grammas enjoyed Pittsburgh. He even managed the club on an interim basis at the end of the 1969 season, winning four games and losing one. Going into 1970, he anticipated either being the next manager of the

team or staying as the third base coach. But a change of heart from general manager Joe Brown meant that Danny Murtaugh, not Grammas, would be the next manager. Moreover, Murtaugh was bringing his own third base coach.

Just like that, Grammas was out of a job.

Not for long. Grammas estimates that maybe an hour passed between learning his time was over in Pittsburgh and receiving a job offer to coach third base for the Cincinnati Reds, becoming a part of the Big Red Machine's success when it won three National League pennants and one World Series championship. During his first year in Cincinnati, the team reached the World Series. Reaching this pinnacle made Grammas think of his father. "When I graduated from college and told him I was going to start playing baseball, he didn't say a thing but just looked at me like I was crazy. He was from the old country [Greece]. He's not thinking about making a living playing baseball. But when I started doing it and all, he took to it, and then, when I got to the major leagues, he came up to see my first game in the major leagues. And when I'd get paid, I'd send him the check, and he'd put it in the bank for me and all that. I just wish he could've seen a little more of it, then he could've really had some fun."

The Reds team was loaded with good players. Good players usually translate to a winning team, and the Reds won a bunch. "What's good about having players that can help you win is that you have more fun. You can have laughs. You can have everything. The laughs stop when you get beat every day. No laughing any more. But we used to have a lot of laughs. Those guys would chase Sparky around in the outfield, slam him to the ground, you know. Like they were tackling him. [Pete] Rose and those guys. Oh, Jesus. He'd get up limping."

Grammas had many favorites on the Reds. He especially enjoyed catcher Johnny Bench.

> *He had a good sense of humor. He'd hate to sign balls. In the dugout before the game, sometimes, I'd take him a ball. I'd say somebody's in the hospital, and he'd say, "Oh, yeah. Right." I was lying. He knew I was lying, but he'd laugh and sign it anyway. So, I walked in there one day, and he and I were the only two in the dugout. It was about thirty minutes before game time. And, I told him, I said, "John," I said, "this is for a blind kid." He didn't say a word. I handed him a ballpoint pen and the ball, and he started punching Braille on it. Like he was making it so the blind kid could read it! When he did that, I was rolling on the floor,*

Johnny Bench signing autographs. Presumably not in Braille. *Wikimedia Commons.*

I thought it was so funny. I mean, he saw me, and he started laughing. I said, "That's the best I've ever seen in my life! Nobody could think of anything like that but you."

The Reds had multiple Alabama connections during its Big Red Machine heyday. An all-star in 1971, Parker High School (Birmingham) alumnus Lee May clubbed thirty-nine home runs for the team. Clay Carroll, a Clanton native, led the league in saves in 1972. And left fielder George Foster was born in Tuscaloosa. Despite the common ties, Grammas says the men didn't acknowledge their home state connection.

"No, I never give any thought of it," Grammas answers. "No thought much at all."

Grammas left Cincinnati when he had the opportunity to manage the Milwaukee Brewers in 1976. Grammas led the club for two seasons before he was fired. "I knew they didn't have a good team, a decent team. And, I don't know. I guess you feel like, 'Let me give it a shot.' And it didn't work out, so [I] can't growl over it."

After managing, Grammas returned to a familiar spot: the coach's box along the third base line. He spent one season as Bobby Cox's third base coach for the Atlanta Braves before reuniting with Sparky.

Grammas stayed with Anderson until retirement.

Grammas says the two worked together well because they had similar makeups. And he says Anderson was a brilliant manager. Part of why he was so good was because Anderson understood the game well. "His knowledge of the game and his way of getting along with people, the players and knowing enough about the difficulty of the game itself to be able to take it in, and, if he had something to talk to them about and straighten them out on, he knew about it because he knew the game. He just knew the game."

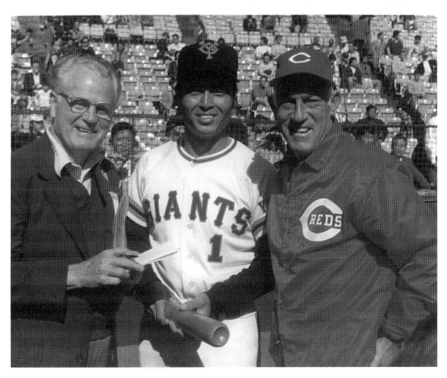

Hall-of-fame manager Sparky Anderson (*right*) with Japanese slugger Sadaharu Oh (*center*) and Fred Russell. *Public domain.*

Another key to his success was his tact in dealing with players. Anderson didn't overload his players with critiques and suggestions. "You have to transfer some of this knowledge as you get into managing. You can't say it all in one day. You've got to say it as time goes along. It's not an everyday thing, because things happen in baseball that are different from this day to the next day. You might tell a guy something today, and tomorrow he might do the same thing and you got to say, 'We just talked about that yesterday,' you know? And those things have to be revealed but in a way that you don't make everybody angry. Because when they start getting angry, their playing drops. And that's not good."

Though his baseball career took him away to Cincinnati, Detroit, Milwaukee and Pittsburgh, Grammas remained grounded in Birmingham. In the late 1960s, he and his wife, Tula, purchased a home just down the hill from Mountain Brook High School, where their children attended school. Today, he lives in Vestavia Hills. He golfs a couple of times each week. He also enjoys fishing with his grandson. Grammas and his grandson recently traveled to Detroit for a thirty-year reunion of the 1984 World Series Champion Tigers.

Looking back on nearly forty years in baseball, Grammas reflects that he found the right fit for him. "All I can say is, I'm happy that I did what I did. Because, I think part of life is doing what you like to do, and of all the things out there to do, I couldn't have enjoyed picking anything better than playing and coaching and managing baseball. I really don't. I think those are the happiest years of my life."

THE BEST

WILLIE MAYS

*A*sk one of Willie Mays's former teammates about him, and the response is universal: Mays is the best. Ever.

"Best I ever saw," says Mike McCormick, the former New York and San Francisco Giant and 1967 National League Cy Young Award winner.

"Willie was the best all-around player anybody ever saw," echoes Birmingham's Al Worthington, Mays's teammate from 1953 to 1959. "I never talked to anybody who saw him play that didn't say he was the best all-around player. He could field, run, hit and throw better than anybody. A lot of guys can do two. Some guys can do three things. He did four. And Willie was a nice guy."

Born in Westfield and growing up in Fairfield, Mays started his professional baseball journey as a Birmingham Black Baron in 1948. Signing with the New York Giants, Mays quickly became one of the league's elite players and, in 1954 as a twenty-three year-old, earned Most Valuable Player honors in the National League, leading the league in triples (thirteen) and batting average (.345).

During the first game of the 1954 World Series, Mays made the iconic over-the-shoulder catch of Vic Wertz, spun and threw, a play still shown on highlight reels and credited for setting the tone for the Giants' sweep of the Series. But Mays points to a lesser-known catch he made of a ball hit by Brooklyn Dodger Bobby Morgan two years earlier in Ebbets Field as his best. Morgan hit the ball over the shortstop, and Mays tracked the ball,

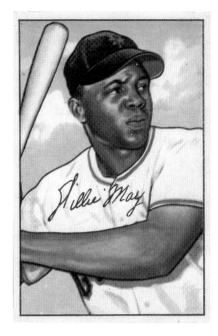

The greatest: Willie Mays. *Bowman Gum*.

diving to make the backhanded catch. Doing so, he crashed into Ebbets Field's fence and knocked himself out. But he caught and hung on to the ball.

Morgan recalls hitting the ball hard. When he rounded second base, he couldn't tell whether Mays made the catch, so he kept running, hoping to score. "I recall rounding second base and seeing him laying down in left-center field. I headed for third and went home. I looked around in the dugout, and there was guys were out there picking him up. I thought I had a home run. It was a big out," Morgan says.

In 1965 and now a seasoned veteran, Mays was again named the National League's Most Valuable Player, this time leading the league in home runs (fifty-two). One of these home runs was the five hundredth of his career. Mays became (at that time) the fifth player to hit five hundred home runs (along with Babe Ruth, Jimmie Foxx, Mel Ott and Ted Williams).

Lindy McDaniel, who pitched for twenty-one seasons in the major leagues, remembers being new to the big leagues, facing Mays and learning a valuable lesson from the power hitter. "They told me the first time I pitched against Willie Mays…pitch him up and in," McDaniel says.

McDaniel followed the instructions. And the advice was sound. Mays swung and missed. With such good success, McDaniel repeated. He threw up and in. Mays hit a foul ball.

With an 0-2 count on Mays, McDaniel continued with the strategy that led to the prior strikes. He threw one more pitch up and in. "Home run," McDaniel laughs. "This is where you learn things about hitters. Vary your pattern. Don't get them in a situation where they can guess what you're going to do. Anyway. That's what you learn."

Even today, over forty years after he retired, Mays remains one of the game's all-time top hitters, ranking third in most total bases (6,066), fifth in home runs (660) and twelfth in RBIs (1,903). And when fans, analysts and writers discuss the topic of the game's best player, they reach the same

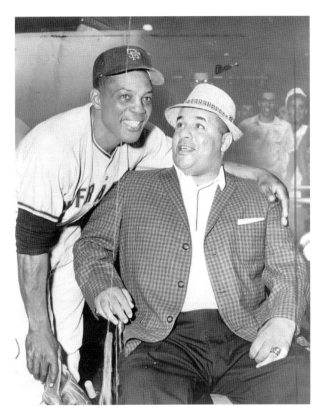

Left: Mays (*left*) with Dodgers' catcher Roy Campanella. New York World Telegram.

Below: Mays talking baseball with President Barack Obama. *Pete Souza*.

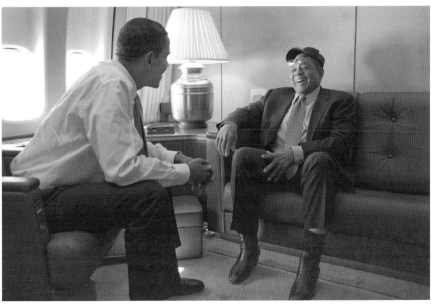

conclusions as Mays's teammates, placing Mays at the top of the list. The *Sporting News* selected an all-century team for the twentieth century, and Mays was the second person named to the team, behind Babe Ruth. In 2015, Major League Baseball asked fans to vote the game's four greatest living players. Naturally, Mays was right there, alongside Hank Aaron, Johnny Bench and Sandy Koufax.

As Al Worthington says, Mays could do it all well.

3

FROM LAST TO CHAMPS

1955 MOBILE BEARS

When the 1955 season began, Mobile welcomed its Bears, the Double A affiliate of the Brooklyn Dodgers, to town.

"The Chamber of Commerce had a big to-do at the Admiral Semmes Hotel," pitcher Ralph Mauriello remembers. "[The fans] were very enthusiastic. As we played horseshit ball, they were less enthusiastic and very much less in attendance."

In terms of mediocre play, Mauriello says some players needed more seasoning in the lower minor league levels. "Some of us were ready, and some of us weren't," he says.

Players who were ready to play included Jim Gentile, the first baseman who led the Southern League in RBIs in 1955, and Mauriello, who won eighteen regular season games.

Despite this talent, the team struggled. "When we started, we had lower-class ballplayers. They didn't hit," Gentile says.

The team reached its nadir on July 4, dropping a doubleheader in Nashville and sinking into last place. The losses sent the Bears straight to the bar. As they caroused and commiserated, third baseman Jim Baxes remained confident the team would turn things around. "We're going to come back, and we're going to kick the shit out of everybody!" Baxes said.

Buoyed by Baxes's enthusiasm, the Bears didn't quit. Gentile recalls chatting with Baxes, Mauriello, catcher Al Ronning and shortstop Chris Kitsos about the team's potential. "We knew we had a good ballclub," Gentile says. "And Chris Kitsos was real good. He had a lot to say. And he would say it in the clubhouse. 'Let's go. We've got a team. We can win.'"

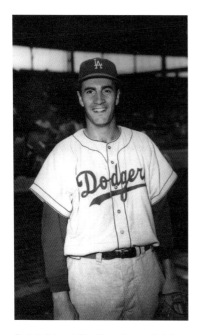

Ralph Mauriello, Bears' ace. *Ralph Mauriello's collection.*

The team kept pushing. It improved as the Dodgers sent better players to replace those whose performance wasn't cutting it. Gradually, the Bears climbed from the cellar to reach .500. As the season wound down, the team realized a playoff berth was within grasp. Going into the final weekend of the season, the Bears needed to win its last three games, and New Orleans and Nashville would have to split its series. Mauriello didn't see how New Orleans and Nashville *could* split a three-game series—one team would win at least two games, thus mathematically eliminating Mobile from the playoff spot.

Nature intervened. Heavy rains in New Orleans cancelled its final game against Nashville. The same storm poured on Mobile, but the Bears, who won two games that weekend, insisted on playing to see if it could clinch the final playoff spot. The skies cleared, and Mobile started playing at nine o'clock that night, six hours after its scheduled start time. "We were just killing time," Gentile says. "Guys were playing cards, hearts. I was sitting in my locker, twiddling my thumbs. I wanted to play. It's hard when you're ready to play and then you have to wait."

Despite the delay, the Bears won. And, improbably, they claimed fourth place and an invitation to the playoffs. The first stop: the Memphis Chicks. Mauriello pitched in games three and seven against the Chicks.

"I don't remember much about Game Three," he says. "But I'll tell you what I remember about Game Seven. I was on the mound, taking my warm-ups. Getting ready to pitch the bottom of the first because we were in Memphis. They had home-field advantage. And I think in my final warm-ups, somebody in their dugout made a few remarks about whether I had any guts or not."

Mauriello didn't appreciate having his bravery questioned. "When the first batter came up, I threw the ball right at his head as hard as I could," Mauriello says. "And he went down in the dirt like they should if they don't want to get hit. Well, I got the ball back from the catcher, and I turned around and stared at their dugout. And the message was: all right, you

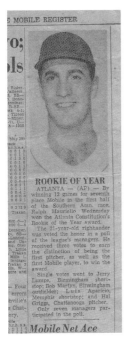

ROOKIE OF YEAR

ATLANTA — (AP) — By winning 12 games for seventh place Mobile in the first half of the Southern Assn. race, Ralph Mauriello Wednesday won the Atlanta Constitution's Rookie of the Year award.

The 21-year-old righthander was voted the honor in a poll of the league's managers. He received three votes to earn the distinction of being the first pitcher, as well as the first Mobile player, to win the award.

Single votes went to Jerry Lumpe, Birmingham shortstop; Bob Martyn, Birmingham outfielder; Luis Aparicio, Memphis shortstop; and Hal Griggs, Chattanooga pitcher. Only seven managers participated in the poll.

Mobile Net Ace

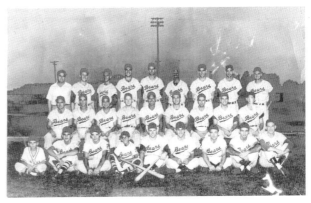

Above: The 1955 Mobile Bears, Dixie Series champs. *Jim Gentile's collection.*

Left: Bright spot in a rough first half. *Ralph Mauriello's collection.*

asshole. You're coming up next. And I don't know if it intimidated them or not, but that's how I felt."

After beating Memphis in seven games, the Bears moved on to challenge the Birmingham Barons. The Bears' hot streak continued, and they won the Southern Association championship, eliminating the Barons in six games.

In most cases, winning a championship means the season ends the best it can, but from 1920 to 1958, the Dixie Series pitted the Southern Association winner against the Texas League champions. As a result, the Bears moved on to face the Shreveport Sports.

Mauriello recalls the Sports' pitching staff stretched thin. "I pitched the opening game of the series, and we beat them like eight to nothing, ten to three, eight to four. We just scored. I think my game was the only game we didn't score double-digit runs."

The Bears swept Shreveport to win the Dixie Series, an improbable comeback from its July Fourth cellar position. "We went nuts," Mauriello says. "Squirting bottles of beer around. We didn't have champagne. But you know, we were kicking the shit out of them so bad that by the time of Game Four, it was a foregone conclusion. They knew it, and we knew it."

Winning grandly—just as Jim Baxes and Chris Kitsos said they would.

FROM WHISTLER
TO THE WINDY CITY

BILLY WILLIAMS

1959–74: Chicago Cubs
1975–76: Oakland A's

he list of hall of famers from Mobile amazes. Five of the game's all-time greats (Hank Aaron, Willie McCovey, Satchel Paige, Ozzie Smith and Billy Williams) call Mobile—a city with a population slightly under 200,000, the third largest in Alabama—their hometown. Put this in the context of thirteen *states* not having a native son enshrined in Cooperstown, and it astounds. And the city's baseball success continues today. Jake Peavy, a graduate of St. Paul's Episcopal High School, won the 2007 National League Cy Young Award. In 2015, Josh Donaldson, an alumnus of Faith Academy, was the American League's Most Valuable Player.

Billy Williams, born and reared in Whistler, six miles from Mobile, says so much baseball success flows from Mobile because its residents play a lot of baseball.

You had guys playing in the park, in the fields, just playing baseball. I think it was a hotbed for baseball players, and we just played the game. And, of course, that attracted scouts to come down because they knew we played a lot of games. I remember Buck [O'Neil] spent a lot of time in Mobile. I remember him coming over to the house and sticking his foot on the table and eating with the family. Buck was always down there. You had

Ed Scott, who was a scout for Boston. Ivy Griffin, the guy who signed me. We played a lot of games there. You could go anywhere on a weekend, and, on a Saturday, you could see a doubleheader. On a Sunday, you could see a doubleheader. That's why a lot of players come from Mobile. Because we played the game, and the people who played it before us taught us how to play the game.

Williams fit the mold of a Mobile baseball player in that he, too, spent a lot of time on the diamond. His father, Frank "Susie" Williams, played first base for the semipro Whistler Stars. Brother Franklin played professionally in the Pirates organization, and brothers Adolph and Clyde were also good athletes. They taught Billy, the youngest son and brother. "Growing up, there was always teaching you how to throw the baseball, how to hold the baseball, what [my father] had learned from the guys who had played in the Negro League," Williams says.

Teaching sessions often followed watching NBC's *Game of the Week*. All of the Williamses tuned in to the game. "After the game is over with, we'd go out and play catch. Maybe [my father would] go out and just throw the ball around or maybe throw us batting practice or something like that. He knew we wanted to play baseball. That way, he spent a lot of time with us."

From these experiences, Williams grew to love baseball. "We played baseball I guess from sunup to sundown. Matter of fact, anything that was in season, whether or not it's football or baseball or basketball, we played it. Of course, playing baseball was really an enjoyable time with me because that was my first love. Playing in the morning, just getting together with your friends. We would go out early in the morning, and then we'd play Strike Out or something like that. As a matter of fact, we'd play Tops early in the morning. Then we'd go out and play baseball."

As Billy played more, his father and brothers corrected him if he made a mistake. "All of them, anything they could teach me how to play the game of baseball, not only my brothers but also people in the area. Older baseball players that knew it was my calling, that this is what I wanted to do, play baseball. They wanted to teach me the skills of playing the game. So, every time I make a mistake, one of my brothers or somebody else who played the game of baseball would try to correct it. Because they wanted me to do it the right way."

His development attracted attention. When the Cleveland Indians and the Brooklyn Dodgers played an exhibition game in Mobile, Williams, a high school student, was invited to join the game. Walking into the locker

room, he saw Jackie Robinson, Gil Hodges and Roy Campanella, men whose faces he had seen in the sports page or on television's *Game of the Week* with this father and brothers. Now, he stood next to them, and just like him, they were dressing and preparing for the game.

"You would just ooh and aah about Major League Baseball players when you walk in the clubhouse. I don't think you can speak when you walk in there because they were major league players. That was something out of sight."

Williams's moment in the game was when the Indians' manager inserted him to pinch-hit against the Dodgers' Joe Black, the 1952 National League Rookie of the Year.

"When you look at major league players, they were ten feet tall. When you face guys like that, your knees knock 100 miles an hour. And Joe Black was on the mound, and I hadn't seen guys who threw the ball as hard as he did. I said, 'Wow!' But the one thing I did, I was satisfied just putting the bat on the baseball. I didn't strike out. I put the bat on the baseball, and of course, that gave me a great thrill."

DECISIONS

When he graduated from Whistler High School in 1956, Williams had options. Grambling University offered him a football scholarship. The Chicago Cubs also presented him the chance to play professional baseball in Class D, the lowest rung of its minor league ranks.

Williams picked baseball. "I wasn't big enough [for football]. When I finished school, I was about 165 pounds, I guess. And I played defensive end on my high school team. I was either tough or crazy being that light playing defensive end. Because you had some big running backs down there. I chose to play baseball because I thought this is my best profession."

Two days after graduating, Williams signed a contract with the Cubs. He boarded a bus and rode two and a half days to Ponca City, Oklahoma, his home for the next two summers.

His first season as a Ponca City Cub, the seventeen-year-old played sparingly. "I don't know how many pinch hits I got, but there was a lot of them. About five or six times, I got three or four pinch hits. I didn't do it that much, but they saw I could swing the bat."

The team traveled by station wagons for away games. Because he played so little, Williams didn't join the team on the road. Instead, he and his friend

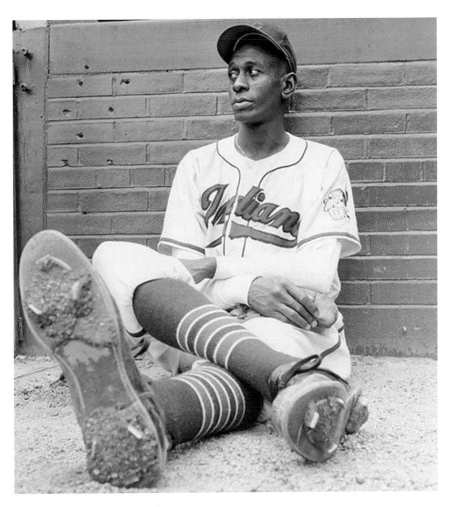

Mobile's Satchel Paige. *Wikipedia.*

Bobby Walton explored Oklahoma while the team played away games. "We'd go all over the place. Okmulgee and McAlester and Ardmore. All those Indian names down there. Those Osage Indians was down there. I saw my first rodeo in Bartlesville."

When it was time for the team to return, Williams and Walton would drive back to Ponca City.

During the off-season, Williams barnstormed with Mobile native and pitching legend Satchel Paige. Barnstorming was a way for players to earn extra money and also a way for people outside of Major League cities to see quality baseball. Paige was well known for barnstorming, facing Bob Feller

in exhibition games and continuing to gather a core of players to pile into a fleet of cars and head off into the plains from his Kansas City home after he retired from organized baseball. Williams had a similar experience.

"That was my second year in baseball when I went back to Mobile," he says. "They had a team by the name of Shippers, the Mobile Shippers. This guy by the name of Willie Davis who lived down on the bay, I think he organized it. So, we barnstormed around Florida. As we go in the city and we get ready to play the game, they would have players from that particular area playing against us. And we had about five or six guys from Mobile, and we would get about two or three guys from that city."

Davis convinced Paige to join the Shippers.

"I guess Satch had it in his contract that he would come to the ballpark about the seventh inning," Williams says. "And I remember him walking in to the ballpark, and people start cheering."

Paige would find the backup catcher in the dugout and say, "Come on, Big Catch. Let's go down to the bullpen and see could I throw a couple of balls over this chewing gum wrapper I'm about to throw down." The catcher would squat and set up behind the wrapper. And the fifty-two-year-old Paige threw so precisely that the ball zipped over the gum wrapper.

"This is a true story," Williams vouches. "It was amazing because he wasn't a spring chicken. And it was a thrill to be around him because my father used to talk about Satchel Paige."

Occasionally, Williams traveled with Paige in his Cadillac as they journeyed to the next stop on their tour.

"Satch was a great fisherman. He loved to fish. With him being who he was, he always had baseballs and bats in the back of his trunk. Along with dead fish! Because there are times he used to catch fish and leave them in the trunk."

Paige would ask Williams to retrieve equipment from the trunk. "Young Blood," Paige said. "Grab some bats and balls for us." Williams would oblige but shut the trunk as quickly as he could to avoid the stench.

RISING UP, GOING HOME

Cubs hitting instructor Rogers Hornsby took an interest in Williams. Inducted into the National Baseball Hall of Fame in 1942, Hornsby, a two-time National League Most Valuable Player and a career .358 hitter who

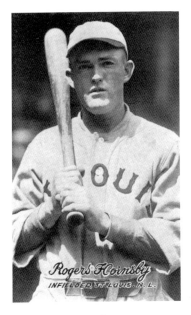

Billy Williams's early mentor, Rogers Hornsby. *Wikimedia Commons*.

averaged over .400 in three seasons, liked Williams's swing and arranged for Williams and Lou Johnson to attend major league spring training, the only two minor leaguers in the camp.

Hornsby would sit behind the two young hitters in the batting cage and watch them swing. He didn't offer mechanical advice or suggest different grips. Instead, he pointed to his eye. "Keep your eye on the ball," he said.

Not only did Hornsby emphasize following the ball, but he also preached the importance of knowing the strike zone and evaluating whether the pitch is a ball or a strike. "He said the strike zone is from your armpit to your knees over home plate, which is seventeen inches wide," Williams says. "He didn't talk about holding the bat this way, or holding the bat that way. He'd just talk about the strike zone."

After one session, as Williams stepped from the cage, Hornsby nodded in approval. "One day," Hornsby predicted, "you're going to win the batting title," a task Hornsby was accustomed to, leading the league in hitting seven times.

"Sure enough, I did," Williams says. "I won it in 1972."

Williams not only impressed the sage hall of famer, but he also produced results on the field. In Double A San Antonio, Williams was swinging the bat well and was one of the team's offensive leaders. Despite the success, he walked away from baseball temporarily. "I had talked to my brother, Franklin," Williams says. "He was home, and he talked about the swimming, the fishing, everything is great down here."

After the conversation, Williams walked to teammate J.C. Hartman's room at the Manhattan Hotel in San Antonio and knocked on the door. "Jay," Williams said, "take me to the train station. I'm going to Whistler."

"You're going to what? You can't leave," Hartman said.

"Yeah. I'm going home. I'm tired of the game. I don't want to play no more."

"I'm not taking you to the train station. You can't go home."

Williams disagreed. "Yes, I can. If you don't want to take me, I'm going to call a cab."

Reluctantly, Hartman obliged. Williams headed east to Whistler.

Williams's manager, Grady Hatton, called the Cubs' front office and reported that his outfielder, hitting .320, decided to go home. Chicago's general manager, John Holland, then enlisted scout Buck O'Neil for assistance. O'Neil had played eleven seasons in the Negro Leagues, ten with the Kansas City Monarchs. He managed the Monarchs for eight seasons (1948–55) before joining the Cubs as a scout. After speaking with Holland about Williams's departure, O'Neil hopped into his car to meet with Williams.

"I'm there for about two or three days," Williams says. "And all of a sudden, Buck always drove these Plymouth Fury automobiles. I was sitting on the porch, and I saw this Fury come in the driveway. I said, 'Oh, I'm in trouble now.'"

O'Neil stepped out of the car and greeted Williams. "Hey, kid."

"Hey, Buck."

They shot the breeze for a minute or two, and O'Neil asked, "What's going on?"

"Buck, I'm tired of baseball," Williams said. "I don't want to play no more."

O'Neil said, "Well, you were doing good. Why don't you want to play no more?" Then he said, "Later on, I'll bet you want to play again."

Williams shook his head. "No. I'm tired. I don't want to play this game no more. I thought I enjoyed it, but I don't enjoy it."

O'Neil listened. He didn't say anything for a while. Neither did Williams. Then O'Neil looked up and asked, "Where did you used to play baseball at?"

"Down at Prichard Park."

"Are they playing games down there now?" O'Neil asked.

"Yeah."

"Come on. Let's go down and check things out," O'Neil suggested.

Williams agreed. As they drove, O'Neil said little other than "Billy, the organization is real happy with how you're playing."

They arrived at the park. Some of Williams's former high school teammates were on the field. O'Neil and Williams stepped out of the car and approached them.

"Hey, Billy! Where've you been?" one asked.

"Well, I've been off to play professional baseball."

"Pro ball? Man, I bet's that great. Get to do what you like."

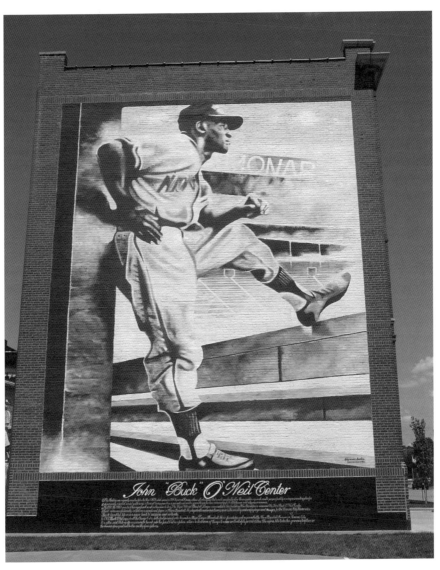

A mural of Buck O'Neil outside the Paseo YMCA in Kansas City. *Mwkruse.*

The accolades about Williams's playing professional baseball continued. O'Neil smiled and watched until they returned to his Fury for the drive home. "The guys kind of like what you're doing," O'Neil said.

"Yeah."

O'Neil dropped Williams off at home. The next day, he returned. "You ready to go back, Billy?"

Williams said yes. "I told Buck I was about ready to play. I was ready to go back. I've done some fishing. I've done some swimming. I went down and see some of the guys. So, I'm ready to go back and play professional baseball then."

In hindsight, Williams was fed up with the segregation issues he faced in 1959 Texas.

"The traveling up and down the road, it was tough," he says. "As you roll up, you couldn't go into a restaurant to eat. You had to depend on the guys to bring you food on the bus. And, you know, I grew up in Whistler. I knew what was happening there. I had certain places to go, and I had certain things I wanted to do, but driving around on the bus, you had to depend on somebody else to bring stuff from the restaurant. You couldn't stay at the hotel. They had to find you a private home. At that time, I just got tired. And I think that kind of propelled me to go home, too."

Once he returned to San Antonio, he continued his hot hitting. Within the week, he moved up to Triple A, where he hit .476. It wasn't long before the Cubs called him up to the highest level.

FIRST-PITCH FASTBALL

When Williams arrived at Wrigley Field, he played little.

"I didn't get a chance to play that much. I just went up to pinch-hit. I don't know how many hits I got. It wasn't that many. That's all I was doing. I was just sitting around, watching baseball, getting the meal money and checking things out."

From afar, his father continued to offer coaching advice, sharing cues he observed from the *Game of the Week*. "Billy," his father said, "when you face the Milwaukee Braves, if Lew Burdette is pitching, he's going to throw the first pitch right down the middle of the plate, and you swing at it."

Williams hadn't logged much time in the majors when the Cubs faced the Milwaukee Braves. Pitching for the Braves? Lew Burdette.

Williams was sent in to pinch-hit. "I'm up at the plate, and all this started running through my head. 'When you get the pitch, you swing at it because it's going to be right down the middle of the plate.' And I guess my knees were knocking so hard, I took the pitch right down the middle of the plate. But that's between minor league and major league. When you get to the major league, it's a thrill, and you're thinking about all kinds of stuff."

Williams acclimated well in Chicago, earning the National League Rookie of the Year Award in 1961. Despite the early achievements, he didn't immediately feel comfortable and settled in as a big leaguer.

"You don't think you're a major league player until two or three years after you've been playing big-league baseball. You always doubt it. I'm here in the big leagues—can I stay or what?"

Two teammates took Williams under their wings and made him feel comfortable.

"Ernie Banks was outstanding," Williams says. "So was Tony Taylor from Cuba. In spring training, Ernie and Tony Taylor, I remember them going to different places, taking me along with them. Like we go over to the Elks Club in Phoenix, Arizona. There was a place where many ballplayers used to hang out, go over there and eat and play pool and just enjoy. Talk the game of baseball. This is what they used to do, Ernie and Tony Taylor. They used to take me to a lot of places. And just talk to me about the game and tell me about how you carry yourself on the major league level."

Williams found a daily routine that worked well for him. "I'm a breakfast person. My wife would cook me a big breakfast, and I'd eat and then head to the ballpark around ten or 10:30. Get dressed and take BP and go back to the clubhouse while the other team takes BP. Then take infield and get ready for the game."

One change in today's game compared to when Williams played is how infield practice has fallen out of favor. Taking infield allows players to keep their footwork sharp, key in on their ground-ball fielding and maintain arm strength by firing tosses to first base. But few teams take infield nowadays.

"This hurts guys on the bench," Williams says. "[Infield] was showtime for them because you can see how they can make a double play. You see what kind of arm they have from the outfield. You see how the catcher can throw the ball from home plate to second base. You see the other players, and this is where the utility players got a chance to shine."

Another positive to infield: loosening your arm.

"Outfielders have to continue to throw to keep their arm loose. From the outfield. To know how to throw the ball in, and the ball has to bounce to get to the catcher or throwing the ball to second base or throwing the ball to third base. They don't get a chance to do that, and in the game, when they have to make a throw, they're really not loose. Especially in Chicago because it's cold. And, sometimes, they get out there now and take some balls off the bat, but they don't get the chance to throw and in the game they can't get an assist because their arm is not strong enough. They can't throw the ball."

After infield, Williams had many moments when he starred, working toward a Hall of Fame career and the Cubs retiring his jersey number (26). He offered consistency, playing in 1,117 consecutive games (September 22, 1963, to September 2, 1970), the fifth-longest consecutive game streak all-time. While penciling in Williams in left field and hitting third became rote for Cubs' managers, Williams produced noteworthy offensive results, especially in 1972, when he nearly won the Triple Crown, leading the National League in hitting and having the second and third most RBIs and home runs, respectively.

Billy Williams's fishing buddy Ferguson Jenkins. *Wikimedia Commons.*

Williams enjoyed playing in Chicago with its day-game schedule. Games usually started at 1:30 in the afternoon. By the time the game ended, Williams would be driving home in 5:00 p.m. traffic just like any other Chicago commuter. "You're nine to five. You go back and get your family, and you take your family out to dinner and stuff like that. You just enjoy your time playing the game of baseball. It gives you a chance to enjoy your family, too, playing in Chicago."

One way Williams escaped the grind and pressure of baseball was by fishing. "That was my time to get away. I would take my Jeep, and I would go and find a lake, and I would sit on the Jeep and just fish. Catch and release. Catch them and throw them back."

Sometimes, teammate Ferguson Jenkins joined Williams on the water. "When Fergie faced Bob Gibson and you knew we'd have a quick ball game, that was perfect for us to go fishing after that."

When seasons ended, Williams returned to Whistler. He stayed away from baseball during the off-season, although he maintained contact with fellow Mobile big leaguers like Hank and Tommie Aaron, Tommy Agee, Frank and Milt Bolling, Cleon Jones, Willie McCovey and Amos Otis.

"You had to go home and get a job. We didn't play baseball. We didn't work out. Guys go to the bowling alley and just really do things not pertaining to baseball."

Three weeks before departing for spring training, this same group would gather at Carver Stadium, near the home where the Aarons grew up. There, they would knock the rust off and prepare for another season.

We would call the guys and say we were going to have one or two rounds of hitting and some fielding, getting ready to go to spring training. We would meet at Carver Stadium, and we would take a couple of rounds of batting practice. And after batting practice, we would go sit in the stands and just talk about the game. Talk baseball. And, of course, Aaron, he was the veteran of the group, and he would have the floor. But that was the thing. We would just sit around and talk and enjoy each other. We'd do that for about two or three weeks, and at the end of the two or three weeks working out, we would just say, "See you down the road." See Aaron at the Braves. Cleon Jones with the Mets. Amos Otis with the Mets. That kind of thing.

TODAY

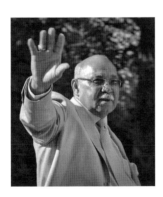

Williams today. *Wikimedia Commons.*

After retiring as a player following the 1976 season, Williams transitioned to coaching. For nineteen seasons, he worked as the Cubs' hitting coach, mentoring hitters like Ryne Sandberg and Sammy Sosa.

While coaching, he was elected into the National Baseball Hall of Fame in 1987.

Now, he's retired. He lives in Chicago, and he attends many Cubs games.

"If they're here about five or seven days, I might go out about four or five. And sit up in the box with [president of baseball operations] Theo [Epstein] and [general manager] Jed [Hoyer] and just talk baseball. But I don't go out there every day. If I wanted to be out there every day, I would still be a coach."

VULCAN ON THE MOUND

BOB VEALE

1962–72: Pittsburgh Pirates
1972–74: Boston Red Sox

*S*ince 1939, a fifty-six-foot statue of Vulcan, the Roman god of fire
and forge, has stood atop Red Mountain, visible throughout most
of Birmingham and surrounding communities, a symbol of the
city as a leader in the iron and steel industries.

At six feet, six inches, Bob Veale, a Birmingham native, towered over
hitters from the pitcher's mound like the Vulcan looks down over the city.
And much as the Roman god was known for his powers of fire, Veale, one
of the premier power pitchers of the 1960s, "had a hell of a good fastball."

Despite his dominant fastball, Veale considered giving up pitching. After
seeing minor league teammates called up to the majors while he remained
in Triple A, Veale thought about transitioning to the outfield or picking up
a first baseman's glove. But he stuck with pitching, and the persistence paid
off. He became a two-time all-star for the Pittsburgh Pirates.

Veale grew up near Rickwood Field. He learned baseball by playing
it in the streets behind Rickwood and picking up tips from his father, a
former pitcher in the Negro Leagues for the Homestead Grays and in the
Birmingham Industrial League, composed of teams from the iron and steel
mills. At Industrial League games, young Veale saw Cat Mays, Willie Mays's
father, play. Veale says Cat was "a hell of a lot better" than his legendary
son. "Called Willie 'Buck,'" Veale says. "Called him 'Buck Duck' because,

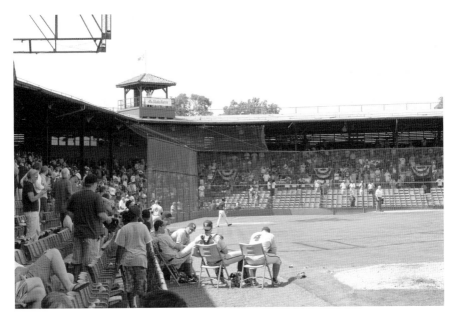

Rickwood Field, built in 1910 and the longtime home to the Birmingham Barons and the Birmingham Black Barons. *Author's collection.*

when he walks, he wobbles, you know? And he was a hell of an athlete in the Negro Leagues, [Willie] Mays was. He'll catch a line-drive barehanded. And swing with reckless abandon."

Veale's first job was at Rickwood Field. As a boy and teenager, he sold sodas. "I used to be an ace capper," he says. "Used to cap four trays at a time. And Eugene Black used to pop the popcorn. And everybody chipped in and bagged the peanuts before the vendors went out. And when they got Coke in the bottles, they stopped selling it after so long because they used to throw them out on the field. I used to collect them."

As Veale played more baseball, Barons' management took note. "When the white Barons would be playing, I used to go over there and throw batting practice sometimes," he says.

Growing up, sports were important to Veale and his friends. That's how they stayed busy and had fun. "It was all about athletics," Veale says. "There were no drugs. Not like it is now. A clean mind and a clean body make a wholesome person. Your body is a beautiful thing. Not something to deface with all these tattoos they do today."

In Alabama in the 1950s, sports were segregated. More accurately, 1950s *Alabama* was segregated. City ordinances in Birmingham, for example,

divided the races, preventing them from congregating in restaurants, movie theaters and parks and from participating together in games like cards, dice and baseball. The laws supported two separate worlds, one black and one white, and Veale experienced this separate treatment firsthand. At Rickwood, he sat in different sections depending on which team was playing. "We would sit in right field when the white Barons played, and we could sit anywhere when the Black Barons played."

Segregation wasn't limited to baseball games. Veale says he had to know how to conduct himself, know which places to avoid and "know which places said niggers keep out." Attending Holy Family Catholic Church and School, many of his friends were white. And although a law may have forbidden their playing baseball on the same field, the friends played because "it was just about being together."

But as society took a step forward, segregation seemed entrenched. As a high school senior, Veale received a scholarship to attend the University of Alabama and play basketball. Learning that Veale was black, the school withdrew its scholarship offer.

Brother Bruno at the Ave Maria Grotto in Cullman helped Veale by contacting Benedictine College, at that time an all-boys Catholic school in Atchison, Kansas. The school admitted Veale, so he headed west for college. He took science and biology courses with an eye toward going to medical school and becoming a country doctor, bartering his skills for a dozen farm-fresh eggs and the like. His experience at Benedictine was like being "a raven with a whole lot of snowbirds" with its predominantly white student body. But Veale enjoyed his experience and the close contact with the clergy.

"I was just lucky to be able to come in and meet some of the priests and the fathers that was there," Veale says. "And learn a lot about the monastery and the clergy, that they're people just like you and me. They're just dedicated for a worthy cause. It's just like baseball. Baseball is similar to clerical life. Many are called, but few are chosen."

BASEBALL CALLS

At Benedictine, Veale played basketball and baseball. "At that time," he says, "I was good at all sports. Kind of like Jim Thorpe. I played football. I could run and catch and throw the ball the length of the field. And I was mean

enough back then to retaliate if somebody hit me. I played baseball. Played basketball. Swam. I was a good swimmer. I was a good athlete."

Veale attracted the attention of baseball scouts. The St. Louis Cardinals offered him a contract, but Veale declined their offer when he learned how much more they were willing to pay another pitching prospect. "I come to find out they wanted me to sign for about twenty-five thousand dollars, and they're going to pay him ninety," Veale says. "And I told them straight up, I said, 'Well, hell, there's no difference between us other than age. He's eighteen, and I'm right at twenty-one.'"

On principle, Veale signed with the Pittsburgh Pirates in 1958 for less money.

He began his minor league career in San Jose, California. "Some places were good. And some it was indifferent. And some was just comical as hell."

Pitching for the Wilson Togs in the Carolina League in 1959, he threw a no-hitter against the Boston Red Sox affiliate in Raleigh, a team with future Red Sox star Carl Yastrzemski. The Raleigh crowd presented a challenge. Some fans waited for the team bus so they could boo players as they entered the stadium. One Raleigh fan, an old man with a chaw of tobacco in his cheek, taunted Veale and his teammates: "Here come them damn Wilson Togs. And all that black magic. You guys are going to get hell today."

Veale laughs. "I think we beat them two out of three, Raleigh."

As he grew up with divided black and white realms, that experience continued in the minor leagues. "We had to live in different quarters," he says, referring to black players. "We stayed with black families. White players were envious of us. We didn't have a curfew, so we could go wherever, pursue your hobbies, but they had a curfew."

In the minor leagues, Veale struggled with control. "I might walk two, strike out three, walk three, strike out three. Something like that. Well, the ratio wasn't in balance with what everybody expected it to be, you know? I had one good pitch. A hell of a good fastball. It would sail. It would move in but go away. And at that particular time, I couldn't corral it. And move it where it should be. And then, sometimes, I'd come in, hit a couple of guys."

While Veale "was stronger than any two men during that particular time," he didn't believe in apologizing during a game if he hit a batter.

"You can't be walking down there, saying, 'Man, I'm sorry,' all that kind of crap," he says. "That just wasn't in me, you know. I'm out there trying to win, scuffling like hell, like a dog with rabies needing a shot. And so, I just turn around and walk back up on the hill. Just like if [the batter will] say anything to me, I'm ready to come down there and close his jaw. And so, I

just go back. After the game, I might say, 'Man, I had one get away from me,' but there ain't no use in me telling you 'I'm sorry' on the field. I'll say that, to me, shows weakness."

In Triple A in 1961, Veale was leading the league in wins but saw his teammate Al McBean called up to Pittsburgh while Veale remained in the minors. The move made Veale compare himself to the pitchers on the Pirates' staff. "I know damn well ain't none of them can throw as hard as I can," he says. "But they had a little more finesse than me. And so, I got disgruntled after that. I pitched, but I pitched nothing like I normally would."

THE HIGHEST LEVEL

Veale regrouped and, in 1962, made his major league debut—a twenty-six-year-old who threw smoke. While experienced catchers could help young pitchers because of the catcher's knowledge of the hitters and their tendencies, tailor-made pitch selections weren't an option with Veale.

"Hell," Veale says. "During that time, keeping a book on them didn't do me no damn good because I've still got to throw it, you know? I know where I want it to go. But my eye, arm and the landing wasn't coordinated. You've got to have a smooth rhythm. Not one where you've got to jerk back, you've got to whip the ball up there, almost like you're popping a whip. Then, you've got to snatch it back."

While Veale may not have needed catchers to help him with pitch selection, they still made him feel comfortable. Bob Otis assisted Veale by offering a steady target. Otis said, "You throw it, biggun, and I'll catch it. Don't matter where you throw it at."

Veteran pitchers Harvey Haddix and 1960 Cy Young Award winner Vernon Law helped Veale acclimate to the big leagues. "They passed on to me what helped them when they first came up," Veale says. "You learn your battles, you learn your hitters, on base, off base. Their strengths and weaknesses. But, mainly, have an idea of where you want the ball to go. Put something on it."

By 1963, Veale was in Pittsburgh to stay. He enjoyed pitching in his home ballpark, spacious Forbes Field, "because you had a guy named Bill Virdon out in center field. And one named Roberto Clemente in right field. And I'd try to make them hit it between them. One of them would catch it. You got to hit the dog piss out of it for it to get out of there. I've seen a few of them

go out of there, though. 460 feet plus. It was so deep, they had a batting cage out there in left center, about 480 feet."

During the season, Veale's state and hometown were in turmoil. In his inauguration address, Governor George Wallace embraced segregation: "In the name of the greatest people that have ever trod this earth, I draw a line in the dust and toss the gauntlet before the feet of tyranny, and I say segregation now, segregation tomorrow and segregation forever." The Southern Christian Leadership Council and the Alabama Christian Movement for Human Rights organized demonstrations calling for an end to segregation. In early May 1963, Police Commissioner Eugene "Bull" Connor ordered the use of fire hoses and police dogs against the demonstrators, many of whom were children. Bombs exploded, including a blast at the 16th Street Baptist Church on September 15 that killed four girls. Veale knew about the chaos but did his best to block it out.

"I just had to keep my head above water and accomplish what you're trying to do." After all, he reasoned that the problems weren't isolated to Birmingham. People like Bull Connor were across the country. Veale had to stay focused and put one foot in front of the other and keep pitching.

ESTABLISHING A ROUTINE

When he first joined the Pirates, Veale pitched in relief. He pitched masterfully, posting a microscopic 1.04 earned run average in thirty-four appearances. Despite the success from the bullpen, he preferred starting because "you can go on about your business. You don't have to pick up nobody else's trouble."

On days he started, Veale's game-day routine was to prepare himself a meal at home. "I get up and cook or broil a piece of fish or a steak or something and have a salad and that was about it. It took me about eight minutes to cook. I was a pretty good cook."

To stay in shape, he ran and stretched. "I would start off with sprints, and then I would run from foul pole to foul pole. I would probably get in about four to five good miles running."

By 1964, Veale had found his stride, leading the National League in strikeouts. Following him that year were future hall of famers Bob Gibson and Don Drysdale. A year later, he set the Pirates record for most strikeouts in a season (276), a record that continues to stand. He also led the league in walks four times. With a laugh, he credits his ability to accrue strikeouts

to his lack of control. "And a good fastball. Plus endurance. I could stay out there forever. I get kind of perturbed when they come out with that pitch count and all that kind of stuff, and I've been throwing 200 pitches, 300 pitches when I was young. And then go to the outfield and play. Didn't make no sense to me. That's just a waste of a good man out there on the mound."

In terms of style and tempo, Veale liked to work fast. "Don't go out there on the mound to chew the fat. I come out there to throw and go."

Although known for his velocity, Veale also threw a good curveball. "They also told me I was giving it away, but if they're not hitting it, what the hell's the difference?"

While he won eighteen games in 1964, his compensation was austere. "[General manager] Joe Brown was stingy as a hen with teeth. He wasn't giving up nothing."

Prior to one season, Veale and Brown negotiated a new contract. "I won, I don't know, about fifteen or sixteen games down at [Triple A] Asheboro. I was making no more than about $7,500. They want to talk about doubling your contract, giving you from $7,000 to $15,000."

Veale wasn't impressed with the offer. "Shit," Veale told Brown. "My dad's making more money than this at the steel mill."

Brown responded, "Maybe that's where you should be."

Veale countered, "I'll see you. That's where I'm going."

He recalls a gathering hosted by team owners in Ohio. "He served what I call slavery-time food: some beans and chicken. And I just go around and look at it and drink a pop or a beer or something and go sit down and wait until the bus takes us back to Pittsburgh."

To save money, Veale cooked when the team traveled. "I took a hibachi on the road with me. Cook in the hotel. Or an electric skillet. And that twenty-two dollars they give you for meal money, I'd bring most of that back home. I'd get me some lettuce and tomatoes, a couple of steaks or some sandwich meat. A little mustard. Orange juice. As long as we're in the hotel, don't have to go nowhere. Have my little cooler up there, my ice up there. Or get a room with a refrigerator up there. And have my little electric skillet. That's all I need. Don't pay no nineteen ninety-five for a steak or a fish sandwich—don't make no sense."

Compensation was such that not only did Veale find ways to stretch his meal money, he also worked in the off-season. "Manual stuff. Fixed on houses or carpentry work. Masonry work. Plumbing."

He pauses. "I learned plumbing from my grandfather. He was a master plumber."

HIGHS AND LOWS

While Veale could rack up sixteen strikeouts in a game, he could also suffer close losses or not pitch as well as he wanted. Veale says he was born with an even keel, so he wouldn't get too up when things were great and not too down when things were bad. "That same write-up that people read about, you'll find it in the fish market the next day, wrapping fish," he says. "You can't dwell on it. You got to give them something else to write about: good, bad, indifferent. You give your best every time you go out. If it happens to be a win, an indecision, that's life."

Veale faced several hitters who were subsequently elected to the National Baseball Hall of Fame. One at-bat against Whistler native Billy Williams stands out. With two outs and a man in scoring position, Veale worked Williams to two strikes. "I threw him a fastball right about here." Veale holds his hand level with his chest. "He hit it right back at me. I caught it barehanded like that. It went right between these fingers right here." Veale points to his ring and pinkie fingers.

As the players walked to their respective dugouts, Veale handed Williams the ball. "Give this to your son," Veale said.

Williams looked at Veale. "Man, you're crazy."

"It might've went out of the ballpark if I hadn't of caught it," Veale says. "Because it was right about there when I caught it. Just threw my hand up. Caught it. It went right in between those fingers right there. Wedged right in there."

Not only did Veale face hall of fame hitters, he also matched up against some of the best pitchers of his day—Sandy Koufax, Don Drysdale and Bob Gibson. On Opening Day in 1965, Veale opposed San Francisco's Juan Marichal. Veale threw ten shutout innings with eight stitches in his foot. No one on the team knew about his compromised condition.

"I was running late to get to the ballpark," he says. "I hit my foot on the steel railing of the bed and had to go to the doctor. Good thing I had got up early. And the guy sewed my foot up with no Novacaine or anything. A guy from India. And he sprayed something on it. Sewed it up and put a patch on it. Told me to come back after the game. And so I didn't tell nobody."

No one noticed anything unusual until the bottom of the ninth inning. After all, he was pitching beautifully, striking out eight and giving up only three hits. "I come back in and I made the mistake, I crossed my legs like this, and blood was dripping out of my shoe," Veale says.

Manager Harry Walker noticed the blood and asked, "Biggun, what's that coming out of your shoe?"

Veale answered, "I don't know, Harry, probably sweat or something."

Walker said, "Naw, unless your sweat is red."

Veale told him about the stitches. Walker asked, "Why didn't you tell me?"

"For what? I didn't want to miss no turn. Not that you have somebody to replace me."

Veale then pitched the top of the tenth inning by striking out Mobile native Willie McCovey, coaxing Jesus Alou to ground out to first and striking out catcher Tom Haller. With the score tied at zero, Pirate teammate Bob Bailey then came up to Veale. Bailey said, "Bob, go ahead and take a shower. I'll take care of this for you. You done been out here long enough."

Bailey, the leadoff hitter for the Pirates in the bottom of the tenth, sent Marichal's pitch over Forbes Field's left-field wall, a solo shot that ended the game with a 1–0 Pirates win.

Veale spent most of his career playing for teams with good chemistry, with teams that had fun. "Baseball is a game for boys of summer as Roger Kahn would say," Veale says. "And, what does boys do? They have fun. It didn't say nothing about men. It says boys of summer. And when you become a man, it's time for you to go home. Because the responsibilities are different. Responsibility for an athlete is for the athletes around you. Normally, if you can't get along with the ones that are around you, that's a difference there, you know? So, rather than you have one over here look like representing Walmart, smiling faces, you know, and you have one over here with the smile upside down, you know, he's going to be gone within a year or so because there's something missing there."

All the while, Veale remained low-key. "I wasn't a bright light–type fellow. I'd come to the ballpark early. Leave late."

Veale supported his teammates. He picked them up from bars to ensure they arrived at the airport to catch the team plane. He tracked down a drunk teammate in downtown Pittsburgh just before a game and propped him up so he could pinch-hit. Veale's cure: hot black coffee and cold water.

To his Spanish-speaking teammate, Veale directed, "Darido. You campano un cafe. No esuga. No leche. No nada. Toma el todo, por favor."

The teammate grinned. "Bob Veale! For you…anything!"

"He drank that coffee," Veale says. "He drink it one swallow it looked like. That coffee hot as hell. Drank it all up."

Veale then guided the teammate to the showers. He sat him down with the warm water running over him. Meanwhile, Veale filled a bucket with

ice water. While his teammate hummed "Besame, besame mucho…," Veale dumped the bucket on him.

"Shit!" the teammate exclaimed.

Veale said, "You no habla English."

"Bob Veale, tu eres loco!"

After the cold-water shock, the teammate dressed for the game as he would any other day. Veale then reported to manager Danny Murtaugh that the player was ready to play. Murtaugh sent him in as a pinch-hitter.

"He went up there and hit one of the damndest line drives you ever seen. He hit a triple. He got on third base. Murtaugh called time out. 'Go get that son of a bitch off of third base,'" Veale laughs.

His closest friends in baseball were Bill Mazeroski and roommate Donn Clendenon. Mazeroski and Veale hunted and fished in the off-season, and Veale helped Clendenon as he studied at Duquesne Law School. "I went over all that crap with him. Briefs, he used to bring that home and study."

Because of his strength, Veale assumed the role of manager Danny Murtaugh's protector during scuffles. "[Murtaugh] didn't like [Cubs manager] Leo Durocher. They were just like Frick and Frack. They'd be jaw-breaking at one another, chirping at one another all game. And I'm the peacemaker. Because I was strong and I'll be the one to be his bodyguard and all that kind of shit. I said, 'Well, I just come over and do what I got to do to make this little $15,000.' And that's what happened."

Veale sees changes in baseball compared to when he played in the '60s and early '70s. Back then, pitchers threw inside to hitters more. "You throw close to somebody now, you got a lawsuit."

One at-bat, he faced Giants second baseman Ron Hunt, who crowded the plate. "I come in," Veale says. "He was going to try to turn his butt into the ball and hit him. I said, 'Uh uh. That ain't going to work no more.' And next time, I juiced him in the neck, you know. And he didn't duck it. He could've moved like this, and the damn ball would've went past him. The damn ball kept coming in on him and hit him somewhere up there. He tried to go to first base, but he made a turn and went back to the dugout."

HEADING TO BEANTOWN

In 1972, the Pirates released Veale. Manager Bill Virdon, Veale's former teammate who chased down fly balls in the outfield while Veale pitched, told him the news.

"He called me in, and I tried to make it easy to him."

Veale looked at his manager, who was reluctant to talk, and said, "What's up, Bill? My time up here?"

Virdon took a deep breath.

Veale said, "Well, come on out and tell me, man. Hell, don't make no big to-do out of it."

After his release, Veale went to the Pirates' Triple A club in Charleston, West Virginia.

"I was kind of overweight at that particular time. I weighed over 260 pounds or better," Veale says. "[A team official] said, 'Bob, you go down to Charleston and help our team out down there, you know, we'll take care of your contract.' Hell, take care of my contract? You ain't paying me that much no goddamn no way. Cut it in half would give me about $7,000, $8,000, you know? I said I would go down there for my own health. I went down there. I lost about thirty pounds."

Boston scout John Haywood approached Veale after he pitched well against the Red Sox Triple A affiliate. Haywood said, "Bob, you beat our Pawtucket team pretty good. We got some good people on there."

Veale said, "Hell, I picked up a few pounds, and they kept Bob Miller over me. He couldn't bust a grape."

After the conversation, Boston acquired Veale. He played for Pawtucket briefly before rising to Boston's bullpen.

Red Sox fans received Veale warmly. "They used to bring me a big old basket of sandwiches out in the bullpen. I just set them on the thing and let the boys eat them up. I might eat one or two. Every night, [this fan] would bring a big bag of damn sandwiches, I mean all kinds of chicken salad, every damn thing."

Veale enjoyed pitching in Fenway Park. "You had a short left field and a short right field down the line. But you had a wall up there about thirty feet high, forty feet in the outfield. I may have given up in what? Two or three years in Boston? Two or three home runs at the most."

And Veale enjoyed the atmosphere, being among knowledgeable New England fans and being on a good team. "People in Boston, you can't fool them. Great knowledge. They know their sports up there. They knew if the ball club was treating you right, too. They talked to me like I had been there for a lifetime, you know? I enjoyed it. Guys like Carl Yastrzemski, Rico Petrocelli. You had Tommy Harper riding his pony in center field. Dwight Evans in right field. They had a good nucleus of a ball club."

As his velocity dropped, Veale developed more control. He laughs. "Control. Yeah. By the time you get that, it's time to go home. When you're used to throwing in the high nineties and stuff like that and you drop down to eighty-eight and eighty-five, it looks like a changeup to most guys up there."

Pitching in relief, Veale sprinted to the mound from the bullpen "to get the adrenaline kicking. Wouldn't have to worry about blood coming up to your fingers or in your legs— it would be there when you get there. Throw two or three pitches, and I was ready to go."

LESSONS LEARNED TO THE NEXT GENERATION

After his playing career ended in 1974, Veale became a pitching coach. He made the transition because he thought it was the right thing to do. "If you can help a young person, that's what life is all about," he says. "You pass it on through teaching."

He pauses.

"Wisdom you can get from a book or you can get from experience, and you pass it along. You help the younger people, maybe make it a little easier for them and help move them down the road."

He spent several years working for the Atlanta Braves organization. As a coach, Veale believes the key to working with players is understanding them.

"It pays a lot to know his background," Veale says.

> I'm not one to get a kid coming right out of high school, never seen him pitch, only heard of his stats on paper. I would sit down and call. I would talk to his mother first. Because all boys are mother boys, you know. They can do everything as far as the mamma's concerned. You look for his lows and his highs, and you look for his stability, his tenaciousness, his love, his workmanship and all that. His mother can give you so much from a maternal point of view. Then I speak to the father. I don't want to know his high qualities. I want to know what can get him down. What stimulates him. What makes him want to be what he's anticipating being. Does he have a good work ethic? Does he have to be told what to do? Does he do everything on his own? Does he have any idea from his high school coach? Is he manageable? Things of that nature. And, above all: what would you like for him to do? What would you like to see him become? Once you get all this down mentally, you have a pretty good diagram of how to handle

Bob Veale today. *Author's collection.*

him. And then you call his high school coach. And you get right down to it,
to the nuts and bolts then, you know. You want to know his shortcomings.
And what is he capable of doing? What will he do beyond that which he
want to do? Can he play another position? Is he for the betterment of your
ball club or for the high school he's playing for? Anything extra that he puts
out that he'll do for you? If you need a substitute in the outfield if he's a
pitcher, think he'll be glad to go out there?

Veale helped his players off the field, too. Working with one young pitcher
who just signed a hefty bonus and who was wanting to get married, Veale
counseled him. "Women are going to be following you from the time you put
on that uniform to the time you take it off."

The player listened.

"Just give yourself a little time as far as marriage is concerned," Veale
continued. "You're not ready for it. You still got a bib around your neck. I
can still see oatmeal and shit dripping down in the bib. Wait 'til you learn,
wait until you've been in that uniform two or three years. Everything will
come to you smoothly. You get married now, you go away and coming back
and going away. You know, sometimes, absence makes the heart grow fonder.
Many times, it makes it go the other way. It makes it go yonder."

One parent so admired Veale's commitment to coaching his son that he sent Veale a case of Maker's Mark bourbon and named Veale an honorary Kentuckian.

Veale also coached for the Utica Blue Sox, an independent team whose owners included baseball writer Roger Kahn and actor Bill Murray. When the team was playing poorly and Kahn was upset at the mediocre performance, Veale asked him, "What did you expect? It's a club full of throwbacks. Guys that didn't make it out of spring training."

Kahn didn't have a response.

Veale said, "You write about baseball. You don't know shit about it." Then Veale told the great writer he should pen a book about his experience with the team.

"If you talk to some of your players, you can probably have another book. Named *The Rejects.*"

Kahn looked at him.

"You can be surprised when you get a bunch of rejects and they come to the top. It's just like churning milk. The cream's going to come to the top if you churn long enough. If you keep churning long enough, you're going to get some butter, and that's better than cream. Do you know anything about the country?"

"No," Kahn admitted.

Veale continued, "Well, just sit back and take your notes of each game and talk to these ballplayers, and I guarantee you'll have another book before the season's over. I ain't up here to lose. I ain't never been a loser on no team. If you don't believe that, you're checking out."

Veale proved to be correct. "The last week, we won the damn thing. Won the championship. Yep. Off of rejects."

After baseball, Veale settled in Birmingham. In 2014, he was repairing his father-in-law's home in Graysville from damage suffered during the tornado that ripped through Alabama in April 2011. Over twenty cats live on the property with Veale—Sunshine, Spats, Bear, Freida and others keep him company. When he completes the repairs, he wants to rebuild a fire pit on the patio. "Have smoked mullet. Fill that thing up there with beer. Ice. Soda pop. Water. And Beaujolais, red wine and white wine. And sit down out there and eat smoked mullet."

Active in the American Negro League Baseball Association, Veale helped found the organization and now serves as its treasurer. He explains that multiple Negro Leagues alumni associations exist and that some include players who played for steel company teams but not the actual Negro

Leagues. "The one I'm affiliated with, it's the original. You know, what they say back in the old times: it's the real thing."

At seventy-nine, Veale has faced health issues, having a hip replacement in 2006 and two perforated discs in his back, causing occasional numbness. He doesn't complain or dwell. "What the hell? The Lord don't give you no more than you can handle. I just come out here, do a little work, get hot, go inside."

Veale gazes to the front yard, a gentle slope pocked by uprooted trees he's clearing.

"You know, to me, sitting out here in the sun makes me feel good. Makes me think about summertime and playing baseball. Run 'til you're all the way wet, then you go in and take you a warm shower and get ready to enjoy a ball game or something."

6

MOST VALUABLE

WILLIE McCOVEY

obile's Willie McCovey played twenty-two major league seasons and had a hall-of-fame career spanning four decades (1959–80). But in 1969, his eleventh year, he had a season for the ages, hitting forty-five home runs and driving in 126 runs, both league leaders. He also shined during the All-Star Game, hitting home runs off Blue Moon Odom and Denny McLain and earning Most Valuable Player honors. The awards continued after the season, as he was named the National League's Most Valuable Player.

Willie McCovey today.
Wikimedia Commons.

The season had its challenges. McCovey battled injuries, including an arthritic knee and calcium deposits and bone chips in his hip. Despite the physical setbacks, he missed only thirteen games and established himself as the most feared power hitter in the league.

Among the keys to his success was Bobby Bonds breaking into the Giants' lineup. Bonds blended speed with power, stealing forty-five bases and clubbing thirty-two home runs. With Bonds hitting third ahead of McCovey in the cleanup spot, Bonds created ample opportunities for McCovey to drive in runs.

McCovey also had a new manager, Clyde King, who created a collaborative team atmosphere. McCovey says, "Clyde, well, he's always around with compliments to everyone. Ballplayers, like everyone else, like to get told they did something right."

The context proved productive for McCovey. That season, he posted season highs for home runs, RBIs, on-base percentage, slugging percentage and intentional walks—a most valuable campaign.

PAPA JACK

RON JACKSON

1975–78: California Angels
1979–81: Minnesota Twins
1981: Detroit Tigers
1982–84: California Angels
1984: Baltimore Orioles

When he graduated from Wenonah High School in 1971, Ron Jackson was torn. As one of the best running backs and linebackers in Alabama high schools, he received a scholarship offer to play football at the University of Alabama under Coach Bryant. His other option: sign a contract with the California Angels to play professional baseball.

He chose baseball.

The decision was difficult. "I was going around asking the coaches, my dad, my mom, the principal, teachers, everybody. I didn't know what to do," Jackson says.

To convince him to carry the pigskin for the Tide, Bryant, at that time coach of three National Championship teams, visited Jackson at Wenonah. The visit marked a shift from nearly a decade earlier, when Bob Veale couldn't attend the university because of his skin color, or when, in June 1963, Governor George Wallace stood in the doorway of the school's Foster Auditorium, blocking African American students Vivian Malone and James Hood from registering for classes. (Wallace didn't move until the National

Guard, on orders from President John Kennedy, commanded the governor to step aside.)

"Where is that Ronnie Jackson kid!" Bryant thundered.

Jackson hid behind some friends. "That's Coach Bryant! And he wants to talk to me!" Jackson said.

To decide, Jackson prayed. He chose baseball because he always wanted to be a Major League Baseball player.

"That's a message I give out to the kids. You've got to figure out the direction you want to go. Not because it makes your parents happy or because it's what your friends want. If you fail, you owe that fault to nobody but yourself."

BUILDING A FOUNDATION

Jackson is the fifth of Thomas and Mary Jackson's fourteen children. Thomas was a mason, and Jackson and his brothers frequently helped their father on jobs.

"I was little. I was maybe seven years old, helping him mix up the mortar," Jackson says. "I'm telling you, that's hard work. I know hard work, setting those bricks in place one by one. But I think that helped me later on. It helped me develop a good work ethic."

In the early 1960s, Jackson was assisting his father on a job for Glen West, the general manager of Rickwood Field in Birmingham. Observing the crew of children Thomas had helping him, West said, "You got yourself a baseball team there."

The elder Jackson laughed. "I've thought about teaching them some baseball."

West said, "You haven't taught them any baseball yet?"

"No, not yet."

Jackson says his parents didn't have money for balls and bats and gloves. When Thomas splurged for a few gloves one time, Mary became unglued ("You're spending money on gloves? All they're going to do is leave those gloves out in the rain!"). But the next day, West delivered a basket of baseball equipment to them.

"Take this," West said. "Teach these kids some ball."

Thomas obliged. He took the equipment to the neighborhood center. Fathers showed the children how to throw and catch and hit. Jackson was attentive to the instruction and the baseball played around him.

Rickwood Field, overseen by Glen West. *Wikimedia Commons*.

"I learned a lot from my brothers. I got better just by going out and playing catch with my brothers. I couldn't wait to get up the next morning and go get a catch with my brothers. That's what made us good. And I watched a lot of Industrial League baseball. My brother played with them and traveled throughout Birmingham. Lawrence Jackson. They called him Kenny Jackson, but his real name is Lawrence Jackson. He ended up signing with the White Sox. He and Lamar Johnson—he played with the White Sox. He and my brother signed the same day."

Jackson started playing organized baseball when he was seven years old. He played on a team based out of the community center in Powder Hills. Jackson loved it, and he continued playing baseball and football as he reached A.G. Gaston Middle School and excelled at both at Wenonah. His skills were so good he was invited to play football at the University of Alabama's All-Star Game. ("I was the first man from my high school to be selected to go down there. They had just sent me my plays. See, we got a lot of running backs. We're going to send you two sets of plays. Running back and wide receiver.") He was also invited to participate in the annual East-West All-Star baseball series at Rickwood Field, featuring Alabama's best high school baseball players. Jackson recalls playing third base in the East-West tournament.

"Guess who's on that team with me?" Jackson asks. "Charlie Moore. Butch Moore. We signed the same day. Both of us the number-two draft choice. The same day and everything. He went to Milwaukee. I went with the Angels."

GROWING IN THE MINORS

After the Angels drafted Jackson in the second round, he reported to Rookie League in Idaho Falls. There, he began learning how to play.

"My background, Wenonah High School, we didn't have a whole lot of coaching. I was really drafted on natural ability more than anything."

In the professional ranks, Jackson struggled his first season to hit .200. Despite the lack of success, he listened to his coaches and worked to improve, something his manager, Bob Clear, appreciated.

"Bob Clear was a mason in the off-season," Jackson says. "He knew about mixing concrete and hard work. He saw that work ethic in me, and he took a chance on me. He helped me in so many ways. He taught me how to hit the high fastball. Taught me how to slide. He showed me the right way of doing things and could break it down so it's easy to understand."

Clear even fine-tuned Jackson's throwing. "My throws would tail a little bit. Bob noticed that I was tilting my head when I was throwing. He told me to turn and keep my shoulder aimed at the target, keep my head straight, and it made all the difference. Made my throws more accurate."

Clear also showed him tips for playing third base and first base and how to turn a double play.

"We worked all the time, man. They worked us in the morning. Go home for about an hour and a half, two hours, and then you're right back and you play the game. But they taught us so much."

Coach Kenny Myers explained hitting to Jackson. "He had all different types of gadgets. Make and show me how to get on top of the ball. How to get your weight over the plate. I'll give you an example. They tied a harness around my shoulder. Soon as I go to swing, it would pull me over. And get me to feel going here with the bat. I started to understand what they was talking about. Get your weight back. Sit on your backside."

Seeing a globe of Earth illustrated to Jackson how the body is supposed to work when hitting a baseball. While the posts holding the globe in position remain still, the globe rotates. Applying this to hitting, Jackson realized that

his head needs to remain still while his bottom half rotates. "When I did the rotation and stayed inside the ball, then my average went way up. Instead of trying to pull everything, I ended up staying up the middle. And staying on the baseball longer. That's what helped me as a hitter, and that's when I took off as a hitter."

Jackson ran into some teammates who tried to intimidate others who played the same position. Jackson played primarily third base, but one teammate let Jackson know that third base was his position, not Jackson's.

"I just did my job," Jackson says. "My dad always told us nobody makes you mad but yourself. You control your body, mind and soul. That's the discipline I got from my dad. I know many times, going out there on the job, he didn't want to go out there. He had to put up with this, put up with that. Every day. Why? 'I got some kids at home betting on me. They need milk and food. I can't fight with a foreman or whatever.' So, you find a way to do your job, even though it's difficult."

Jackson progressed at third base until his last season in the minors, when the Angels sent word they wanted him to be versatile and able to play multiple positions.

"The technique of how to play first base: it's not easy. I found that out. You put the little fat boy at first base? No. You can get killed over there these days if you don't know what you're doing. They taught me how to touch the base, find the bag and set up so you're ready to go either way. I used to go over there looking for the base and watching the guy with the ball, and my foot's way over here. So, they taught me how to come over, hit the bag with my left foot, jump around and face your target and get a good angle."

Jackson was not surprised when he received a late season call-up to join the Angels in 1975. He met the team in Chicago after a series in Hawaii. "I didn't play in Chicago. I'm kind of glad I didn't. I was so tired from flying from Hawaii to Los Angeles, Los Angeles to Chicago."

The next stop on the road trip was Kansas City to face the Royals. On September 12, Jackson received a start at third base against Royals pitcher Al Fitzmorris.

"That field was so pretty. And the lights were so bright. It made the ball look huge."

In his first at-bat, Jackson hit a single right up the middle. "I got that out of the way quick. They stopped the game and gave me the ball. Then I stole second base and wound up scoring a run, all in my first at-bat. That was good."

THE HALOS

Jackson enjoyed playing in California. Teammate Nolan Ryan gave Jackson his nickname, Papa Jack.

"My family called me Pops because I looked like my dad. So, I was always Pops this or Pops that. But then my first son was born, Ronnie Damien Jackson Jr., and Nolan Ryan looked at me and said, 'Well, here's Papa Jack.' And it stuck."

Jackson admired the team's owner, Gene Autry. "He was the best. What a good man. We all wanted to win for him. Had never won a World Series in all those years. He had owned that team since 1963 or something like that, and the guy never griped about it. We came close in '82. We thought we had it in '82 when Milwaukee beat us. Came back and beat us three in a row! All we have to do is win one game, and we go to the World Series. That was a sad day. I'll never forget that."

One of Autry's friends was an Angels fan who spent time around the team, President Richard Nixon. "He was funny. He was always cracking jokes around the players. He was kind of funny-looking. Had a huge head and a small little body."

Fellow Birmingham native Lyman Bostock joined the Angels in 1978 after signing as a free agent. He received a hefty pay raise, rocketing from $20,000 the year before to an annual salary of $450,000. As the year started, Bostock struggled—so much so, he told Autry to keep his money and not pay him until his performance improved.

Amid the slump, Jackson and Bostock spoke in the outfield in Seattle's Kingdome before a game with the Mariners. Bostock said, "Ron, I don't know what's wrong."

Jackson said, "Man, call your dad. You're struggling."

Bostock grew up estranged from his father, a baseball player who played several seasons in the Negro Leagues. Bostock's parents separated when he was young, and he rarely saw his father. Bostock said, "No way. I don't want nothing to do with him."

Jackson said, "You should want something to do with him. He played professionally. He knows something about hitting and baseball. He can help you."

"No," Bostock said. "I'm not calling him."

"Come on. You don't know what happened between your mom and dad. You were a kid. You've only got one dad. You need to try to build that relationship with him."

"You think so?"

"Yeah. I do." Jackson looked at Bostock. "Call him tonight, please, and talk to him."

After the game, Bostock called his father. The next day, Bostock sought out Jackson. "Thank you for telling me to call my dad. That's the best thing I ever did. We talked for a long time."

Jackson is pleased Bostock made the call. "What was it? Four months later and he was dead? I'm glad before he passed he was able to make up with his dad, and his daddy got a chance to talk to him."

Bostock's shooting death during a series in Chicago shocked the team. After a game against the White Sox, Bostock met his uncle, who lived in the Chicago area. Friends and family were preparing a meal for Bostock while he was in town, and Bostock invited Jackson to join them.

"I've already been invited to go out to dinner. If I get back in time, I'll go over there with you," Jackson said.

By the time Jackson returned to the team hotel, Bostock had already left. "I said I was glad I missed him because I didn't want to be tied up. We got a day game tomorrow and all that, you know. Stuff like that. Shoot."

Jackson headed to bed and woke up during the night to teammate Don Baylor pounding on his door.

"Lyman's been shot!" Baylor said.

"Been shot?"

The team gathered in the lobby. Then they learned Bostock's injuries were fatal.

In the face of grief and loss, the team had a game to play that afternoon. Kenny Landreaux was the reserve centerfielder who would play in Bostock's place. Landreaux said he didn't want to play. Jackson approached him and said, "You've got to play. Lambo would want you to play."

Even today, Jackson shakes his head. "That was one of the toughest days I ever had to go through," Jackson says.

PLAYING EVERY DAY

After the season, the Angels traded Jackson to the Minnesota Twins. Jackson was pleased. "I was going somewhere where I could play every day. And the Twins really wanted me. Young ball club. And we could hit."

Jackson responded well to the opportunity. In 159 games in 1979, he smacked forty doubles, sixth most in the American League, and hit .271. "I was a good line-drive hitter. Hit gap to gap. Had talent. Worked hard."

He faced elite pitchers like Tommy John and Cy Young Award winners Mike Flanagan, Ron Guidry and Pete Vuckovich. "I loved hitting off lefties. Because I didn't try to pull lefties. I tried to stay up the middle off them. Guidry. Geoff Zahn. All those lefties the Chicago White Sox had at the time: Kevin Hickey, Steve Trout and Britt Burns. Britt Burns is from Birmingham. One time I went three for three off him. He says, 'You're killing me!' But the next time I faced him, he shut me down."

In Minnesota, he enjoyed playing for manager Gene Mauch. Mauch had Jackson play some first base. His advice to Jackson about playing the position? "He told me, 'You've got to be loosey-goosey over there.' He was real good to his players. I was hurt—he wouldn't play me until I came to him and told him I was ready to play. Then he'd put me in the lineup just like that."

Good managers have people skills like Mauch's. "You need somebody who will talk to his players. Who will get to know them. Find out about them. Find out what they like and what they don't like. Because not everybody is the same. If you can get to know your players and figure them out, that's critical to being a good manager. Because you've got the coaches to run things. The hitting coach to handle batting practice. The pitching coach to work with the pitchers. The bench coach to help you with game strategies. The manager handles the off-the-field stuff and keeps everybody happy."

Jackson worked with another great manager when he was traded to the Detroit Tigers, future hall of famer Sparky Anderson. "I loved Sparky. I tried to spend as much time as I could around him. He was great because he was encouraging. He just let you play. He always called me 'Ronald.'"

In Detroit, Jackson played with a talented core that won the World Series a few seasons later in 1984. "We had the best middle infield duo in Lou Whitaker and Alan Trammell. I don't know why those guys aren't in the hall of fame. We had good pitching with Jack Morris and Dan Petry. Morris, man, he was tough. I never got a hit off Jack Morris. Tough. And we had Kirk Gibson. He played college football at Michigan or Michigan State. I can't remember. But he was fast. And he was a big man. Man, he was fast."

One of his Detroit coaches was hitting coach Willie Horton. When Jackson joined the Tigers, Horton was in the hospital. Although away from the field, Horton still provided Jackson advice via phone calls. "Young man," Horton boomed. "You're going to be a good hitter. I just want you to see the

ball a little longer. You getting out front too much. Wait just a little more for the ball to come to you."

Applying the instruction, Jackson went five for five.

After 1981, Jackson became a free agent. He returned to the Angels even though the team was up-front with him about having a utility role. He joined essentially an all-star team with future hall of famers Reggie Jackson and Rod Carew, former Rookie of the Year Fred Lynn, four-time Gold Glove winner Bobby Grich, former MVP Don Baylor and four-time all-star Bob Boone.

"It can be tough managing those egos," Jackson says. The talent gelled, though, and the team won the American League Western Division. They faced the Milwaukee Brewers in the American League Championship Series and jumped out to a two-game lead in the best-of-five series.

Jackson saw limited action, coming in to pinch-hit and knocking a single off Bob McClure in Game Five. He was disappointed that Milwaukee charged back to deny the Angels and Gene Autry a pennant. One image he remembers vividly: Adamsville's Charlie Moore throwing Reggie Jackson out at third base from right field, a throw so good that after he was called out, Jackson tipped his cap to Moore.

"Never will forget that," he says.

COACHING

Just shy of having ten years in the major leagues (and thus entitled to receive full benefits under the pension plan), Jackson decided to play Triple A one season (1985) to see if he would get called up and accrue more service time. He signed with the St. Louis Cardinals and played for their Louisville affiliate. He heard whispers he would be promoted.

"One time, they said they thought César Cedeño was hurt. And if he couldn't play, they would call me up. Well, I turn on the game, and who do I see playing in center field? César Cedeño. He went like five for five that night. I was like, 'Well, that's that.'"

Although Jackson ended his playing career, he wanted to pass on the lessons he had learned from coaches like Bob Clear and Kenny Myers and from talking shop with teammates like Don Baylor to the next generation. "I was a student of the game. When I wasn't playing, I was watching the good hitters and seeing what they were doing."

Jackson became a hitting coach, working in various minor league systems and serving as hitting coach for the White Sox and Brewers. His typical day: getting to the park early and coordinating batting practice. "You figure out the groups. You get the rookies to the batting cage, and you get the reserves to hit first in BP. And you figure out what they like to hit."

Just as Jackson observed in the good managers he played for, he, too, got to know his players and spent time with them. "That's one of the biggest things that you've got to do is spend time with them just like with a family or a relationship or whatever," Jackson says. "That's what I made sure I did because the biggest thing is to get to know them. And they get to know you. They learn my philosophy, what I teach and how to break it down. And everybody's different. What's good for David may not be good for Manny. What's good for Manny may not be good for Jason Veritek."

He also watched his players. "I never missed an at-bat. I did that so when they do something wrong, I know, and I can explain it to them."

Jackson knows the mechanics of hitting. "When I look at a hitter, I start with the foundation. Because, when you build a house, you build from the bottom up. I'm real big on that. Everything starts from the feet, and then I work my way up to the knees, hips, shoulders, head and grip. Because, when you're teaching, they can go everywhere if you don't watch it. Talk about your head, then you talk about your feet and then you get a player confused, so I always start from the bottom up."

Jackson prefers a foundation of an even stance, in which hitters keep their weight back and load up to release that energy. He likes to see the knees pinched slightly, placing weight on the balls of the hitter's feet. The hitter keeps his left shoulder pointed to second base, elbows level, and his right hand in a position like he's getting ready to throw a punch. As he makes contact with the ball, he keeps his head down. That said, Jackson eschews a one-size-fits-all approach to hitting.

"A lot of coaches have to fix everybody, have everybody doing the same thing," Jackson says. "But everybody's different. Your hands are bigger than mine or littler than mine. Your body's bigger than mine. Whatever. You have to coach into that."

While he knows how the body physically works to produce a fluid swing and solidly hit ball, he balances this with knowing the mental aspects of the game. "I tell hitters to think about the pitcher. What are his strengths? How is he going to try to get you out? Focus on his approach."

He also mixes in video. "We'll put up the last game, and we'll make sure that you're hitting solid. We're not going for a single or a home run. We're

looking to make sure you hit solidly. If you do that, the rest of the things take care of themselves."

To deliver this information to his players, Jackson uses plain language, simple words. One word he avoids is "change."

"Change is negative to me. But if I tell you let's make a little adjustment today, it sounds better. Let's change this, let's change that, everything is change—geez! No. We're going to make a little adjustment here."

This teaching style caught the attention of the Red Sox. In 2002, Jackson was working in the Dodgers minor league system when Boston manager Grady Little called him. "Papa Jack, would you want to coach for the Red Sox in the big leagues?" Little asked.

"Grady, don't play with me, man," Jackson said. Changing the subject, Jackson asked how Little's brother, Bryan, was doing. Bryan and Jackson were former teammates.

"I'm serious," Little said. "Theo Epstein wants to know if you want to join us. He wants to get on the phone, and he wants to talk to you."

Little explained that word about Jackson's approach reached new Red Sox general manager Theo Epstein, who liked what he was hearing.

"Let's talk, then," Jackson said.

So, Jackson called Epstein, whom Jackson describes as "laid-back and intelligent. He knows baseball. He studied the game. Plus, he surrounded himself with good baseball people, too."

"We'd like to know if you want to join us in Boston," Epstein said.

"Really?"

"Yeah," Epstein said. "Really."

Jackson asked, "When do I come for an interview?"

"No interview," Epstein said. "We want you. We know what you can do."

"Sounds good," Jackson said. And with that conversation, he was back in the big leagues as a hitting coach. He started packing his things and headed to Boston and Fenway Park.

HITTING FENWAY

In 2003, his first season as Boston's hitting coach, Jackson made an immediate impact. For example, number nine hitter Bill Mueller transformed from a .262 batting average the prior season to hit .326 and lead the American League with the highest batting average after one season working with Jackson.

Another player new to the Red Sox in 2003 was David Ortiz. He signed as a free agent after being released by the Minnesota Twins. With all players, Jackson let them know he was available to help. Some established players did not seek his assistance. Ortiz was the opposite. He wanted Jackson's advice. Jackson was glad to assist and spent hours throwing soft toss to Ortiz.

Jackson shared a couple of tips to help Ortiz. First, he noticed that Ortiz leaned his bat back so it was nearly parallel to the ground. Jackson suggested bringing it upright.

He also told Ortiz to sit on his back side and turn his hip the other way.

Working with Jackson, Ortiz had a spectacular year in 2003, finishing fifth in the Most Valuable Player Award voting. He has gone on to a hall-of-fame career, launching 541 home runs.

Although he found success, Ortiz still had stretches when he needed fine-tuning. In 2006, on the cusp of breaking Jimmie Foxx's team record for most home runs in a season, Ortiz slumped. In response, Jackson viewed video of Ortiz when he was hot and hitting the ball with power. Comparing the hot with the cold, Jackson observed a difference in how Ortiz held his bat.

Jackson instructed a clubhouse boy to bring Ortiz to the video room. Ortiz walked in. Jackson showed him video of Ortiz crushing the ball against his former team, the Twins. Then he showed him a video of Ortiz

Ortiz's batting stance. *Parker Harrington.*

One of Ron Jackson's students, David Ortiz. *Keith Allison.*

struggling. "When you get in trouble," Jackson pointed out, "there you go with the bat like that," referring to Ortiz's bat angle nearly parallel to the ground.

"Oh, my God!" Ortiz said. "You're right!"

Immediately, the two headed for a batting cage to practice the adjustment. Applying it, Ortiz noticed a difference in the power he generated. "Papa Jack!" he smiled. "That's why you're the best."

Ortiz's first at-bat after the coaching session: a home run that tied Foxx's record.

Jackson's reaction? "It can't be that easy! It didn't come that easy to me."

The next day, Ortiz broke Foxx's record. After he rounded the bases, Ortiz sought out Jackson. He gave him his bat and simply said, "Thank you."

Jackson admires Ortiz, whom he says is the best clutch hitter ever.

"He relaxes in the clutch. Some guys get excited when they go up to home plate, and then some guys relax. Like Stephen Curry with Golden State. He's got that makeup, too. He never gets too high, never gets too low. Something about guys like that, before these guys get to home plate, they already know they're going to get a hit. And, the other ones, they don't know."

A HISTORIC COMEBACK

In 2004, it had been eighty-six years since the Boston Red Sox won a World Series. Down three games to none in the American League Championship Series against the New York Yankees, it looked like it would be at least eighty-seven years until a championship. Indeed, in Game Three, the Yankees routed the Red Sox, 19–8. The win was so convincing, some Yankees were already celebrating, believing they had the American League pennant in hand. After all, at that point, no team had ever come back from a three-game deficit to win a pennant.

Nonetheless, Red Sox first baseman Kevin Millar chirped to everyone and anyone before Game Four, "They better not let us win one!" to fire up his teammates. He strolled in the outfield and pulled players together and repeated, "They better not let us win one!"

Jackson agreed. If the Red Sox won Game Four, the Yankees would face dominant pitching in the form of Pedro Martinez, Curt Schilling and Derek Lowe. "If we just hit a little bit," Jackson says, "we're going to be all right."

The Red Sox won Game Four, 6–4. "We're going to make history!" Millar said.

Pleased with the win, Jackson realized he needed more from the first and second hitters in the lineup, Johnny Damon and Mark Bellhorn. "If these guys don't get

The spark of the 2004 Boston Red Sox, Kevin Millar. *Wikimedia Commons.*

on in front of Big Papi, David Ortiz and Manny Ramirez, we're not going to win this thing," Jackson says.

When he arrived at Yankee Stadium before Game Six, Jackson saw players huddled around a card game. He shook his head, wanting them in the batting cage, not at the card table. So, Jackson enlisted the help of Ellis Burks, an eighteen-year veteran who was likely facing his last chance to win a World Series.

"Get Bellhorn and Damon in the cage," Jackson said.

Burks nodded. "They'll be there. I need a ring."

Sure enough, the players showed up. They listened to Jackson. With Damon, Jackson tweaked his route to the ball, creating a cleaner setup in which he kept his hands up. To Bellhorn, an Auburn alumnus, Jackson said he wasn't transferring his weight, and he was dropping his hands, causing his front shoulder to come open. So, they worked on a tweak.

Both players responded. In Game Six, Bellhorn broke open the game with a three-run home run. In Game Seven, Damon hit two home runs, including a grand slam in the third inning, and Bellhorn padded Boston's lead with a dinger in the top of the eighth inning.

Ron Jackson with his 2004 World Series ring. *Author's collection.*

"I could tell what they were doing wrong," Jackson says. "I'm just glad Ellis got them in the cage to work on a few things."

In addition, clutch Ortiz had twelve hits in the Championship Series, three for home runs.

As the Red Sox rallied, Jackson watched the Yankees' fire cool. "Our confidence kept building every day, every at-bat," Jackson says. "We got off to a good start in each and every one of those games. You could see the Yankees didn't think all this was happening. When they took the field that last game, I remember looking over at Jeter, and Jeter was just like any other time. He's moving around, doing everything. Most of the other guys over there looked like they were in shock. I said to myself, 'We've got these guys.' Because they were in awe that we had come back this far, and now we're getting ready the last game here to win the whole thing."

From there, the Red Sox charged to one of the most improbable comebacks in baseball history, winning four straight and climbing out of a three-game deficit to win the pennant. The peak performance continued as they won four straight games to sweep the St. Louis Cardinals and win the World Series.

Next year became this year.

In terms of what made the 2004 Red Sox so special, Jackson points to the team's diversity. "It was a mixture of everything. We had crazy guys. You had Manny Ramirez throwing the ball to the cutoff man, and he's not the cutoff man. Johnny Damon's throwing to the cutoff man, and Manny Ramirez cuts it off. We had some different type of people. It takes that. You can't have everybody being like a choir boy. You can't have everybody being crazy. It was a good mixture of everybody, and then guys go out to dinner and hung out together and end up being like a family."

BACK HOME

Jackson is sharing his considerable baseball knowledge with Birmingham's youth. After he left professional baseball, he hosted clinics at Rickwood Field. He also developed a practice mat called Gap to Gap, which players can use to work on hitting the ball to different areas of the field. He teaches hitting lessons, but his primary emphasis is establishing an academy for Major League Baseball in the Powder Hills area of Birmingham, near the field he grew up playing on.

"It's already built. They have seven fields up there. It's a great facility," he says.

Although the fields are top-notch, Jackson is working to add an indoor facility where players can train during the rainy spring months.

The seeds are planted. And players are responding. After attending one of his clinics, players rave, "I've learned more in this camp than I have my whole life."

Thinking back to his childhood, Jackson notes a difference in today's kids in that they watch less baseball. But baseball has more competition for kids' interests—computers, iPhones and digital entertainment. Jackson is committed to capturing this interest and helping youth develop skills they need on and off the field to be successful.

"We need more African Americans interested in baseball. It's all football and basketball. What I'm saying is give those kids an opportunity so they've got a chance to go to the big leagues or they've got a chance to go to college and play baseball. Only a few of those kids are going to make it to the big leagues. I'm not trying to get them to the big leagues. It's really just to keep them off the street."

He spends time showing them techniques for how to hit a baseball, and he balances the nuts-and-bolts instruction with an emphasis on accountability ("Accept responsibility for your own actions. No excuses. You have no right to do less than your very best.") and giving back to the community ("Pay for your space. Put something back into your community, your church, your family, your friends.").

"You know," Jackson smiles, "baseball is the only game that you can fail seven out of ten times and still be successful. Life is like that. You're going to have some good days, and you're going to have some bad days. You've got to be able to pick yourself up and move on."

"You can learn a lot from baseball."

AN EAST-WEST EXPERIENCE

*S*ince 1943, the Lions Club has sponsored and organized the annual East-West All-Star tournament, featuring the best high school baseball talent in Alabama. Many future major leaguers have played in the series, including Ron Jackson and Charlie Moore, as noted previously, and Al Worthington, a Birmingham native who made his big-league debut in 1953 with the New York Giants by pitching consecutive shutouts. Worthington pitched fourteen seasons at the highest level before becoming a coach, first for the Minnesota Twins and then for Liberty University.

Worthington attended Phillips High School, where he was a talented athlete, playing four sports. His football skills were good enough for him to earn a scholarship to the University of Alabama. But he sparkled in baseball, too, receiving an invitation to play in the East-West series his junior year.

"My best pitch was my fastball," Worthington says, describing himself as a right-handed pitcher. "It slid and sunk. I didn't do anything to do that. God did that. I just picked up a ball and threw it, and it would slide and sink. Not every time. If it did every time, I'd pitch a shutout every time."

Armed with his fastball, Worthington entered an East-West game during the middle innings. He promptly walked the first three batters he faced. Then he gave up a double. The coach had seen enough. He pulled Worthington from the game.

"When I was on the mound, I looked behind home plate, and there were so many people, it scared me," Worthington says. "Didn't have that in high

Al Worthington looking back on encouragement. *Author's collection.*

school. Nobody sitting behind home plate. Didn't have any fans anywhere. That just scared me, and I wasn't a good pitcher anyway."

Disappointed in his performance in front of his parents and his older brothers, Worthington didn't want to go home that night. "I stayed out 'til two o'clock," Worthington says. "Never stayed out that late. The door was never locked, so I went in, in the dark. I got in my bed. I woke up the next morning about nine, and nobody's there but my mother."

Worthington's mother patted him. She said, "Son, I thought you did so good last night. Only one man hit that ball."

"Thank you, Mama," Worthington said.

As an eighty-five-year-old man looking back on that moment of support, Worthington smiles. "My mama didn't know the first thing about baseball. But she knew how to love you and encourage you."

He laughs. "That was funny."

9

THE LAST RBI

HANK AARON

*M*obile native Hank Aaron is a legend. A first-ballot hall of famer, he won two-thirds of the Triple Crown in 1957, leading the league in home runs (forty-four) and runs batted in (132) and earning Most Valuable Player award honors. Twice (1956 and 1959) he posted the league's highest batting average. He displayed excellence in the field as well, earning Gold Glove honors for his work in right field from 1958 through 1960. When he retired following the 1976 season, he was the home run king, a mark he held for thirty-three years, and he continues to be the career leader in RBIs (2,297).

Charlie Moore, a catcher from Adamsville who spent fourteen of his fifteen big-league seasons as a Milwaukee Brewer, was Aaron's teammate during the last two years of Hammerin' Hank's career. Moore remembers Aaron with reverence and fondness. "Growing up in Alabama, him being from Alabama, and my dad used to take me to Atlanta to watch the Braves play," Moore says.

Sharing the field with a childhood idol left Moore in awe. And the legend was a gentleman to his younger teammates. "He was so down-to-earth," Moore says about Aaron. "A really nice guy. He treated you with respect, and [I] just watched his work ethic and stuff like that. Of course, that was his last year. He was forty, forty-one years old....He mostly DH'd when he came over there [to Milwaukee]. You know, he didn't play but maybe a handful of games out in the outfield."

Longtime home run king Hank Aaron. *Arturo Pardavila III.*

Adamsville's Charlie Moore. *Author's collection.*

Moore pauses, thinking of Aaron's statistics and his being the all-time leader in RBIs and adds, "He drove me in for his last RBI. That was pretty neat."

The game was on October 3, 1976, with the Detroit Tigers visiting the Brewers in Milwaukee County Stadium. In the bottom of the sixth with two outs, Moore hit a single off Tigers' pitcher Dave Roberts. George Scott followed with a double to left field, advancing Moore to third. Next up: Aaron, who laced a single beyond the shortstop's grasp. The base hit drove in Moore.

"I've got a picture of it when he got the base hit," Moore says. "He had advanced to second base, and Jim Gantner, which was a guy called up at the end of the year, I think, and he ended up being our second baseman for years. He pinch-ran for him. When Hank came off the field, I've got a picture of shaking his hand when, that was his last at-bat."

RBI number 2,297, the most ever in major league history.

AS GOOD AS ANYBODY

MONTGOMERY BEGINNINGS

*A*sk Alex Grammas about Alan Trammell and Lou Whitaker, and the longtime third-base coach offers effusive praise about the double-play combination he worked with for over a decade in Detroit.

"That's two steady baseball players," Grammas says. "Guys that give you everything they got, and, not only that, are able to do it to the point where they are as good as or better than anybody playing that position. Turning double plays and making it look easy. And two good hitters. Both of them could run. They had good arms. They had everything."

From 1978 to 1995, Trammell and Whitaker were *the* double-play combination for the Tigers. They won a World Series (1984), played in more games together (1,918) than any other double-play combo and collectively made eleven all-star appearances and earned seven Gold Gloves. But before reaching Tiger Stadium, they learned the ins and outs of professional baseball in the Double A Southern League for the Montgomery Rebels (1977). Trammell was nineteen, a year removed from high school. Whitaker was a year older, turning twenty in May.

Guiding the young infielders was manager Ed Brinkman, who spent fifteen years in the big leagues as a shortstop. "I don't think it was a coincidence that he was there to kind of overlook and to guide Lou and I through this, and, being a guy that had just been in the major leagues a few years prior, Brink was perfect," Trammell says.

To tutor the duo, Brinkman took ground balls with them, sharing tips. But what stands out to Trammell are the off-the-field moments when Brinkman told the players about what to expect at the highest level. "As much as he instructed us, his stories: Lou and I were fascinated. We were hoping we could make it to the major leagues one day, and he would tell us about what it was like and things that happened to him. We were like sponges. We were all eyes and ears."

It's an adjustment from a high school baseball schedule to a professional season that lasts the summer. Brinkman, though, created a smooth transition for the young players. "Coming from high school, I had no idea how professional baseball worked," Trammell says. "I knew a major league schedule had 162 games, but Brink started to instill in us about the importance of preparation, about what it takes on a day-to-day basis to be a major leaguer. And we were smart enough to listen."

Brinkman also offered encouragement. "It certainly helps to give you some little guidance along the way to help you through the tough times because, in baseball, you're going to have to go through some struggles," Trammell says. "We all are, regardless of how good you are, so to have him to help us through those times was invaluable. When he knew there were nights we were struggling, we were down, he would come in there with that personality, upbeat. 'Hey, we're going to do it again today. Try it again. That's what you do. This is what you signed up for.' But he would do it in such a fashion that was so positive that it would pick you up. And that pick-me-up was huge."

Not only did Brinkman help with defensive skills and mental preparation, but he also provided hitting instruction. To Trammell, Brinkman suggested using a heavier bat. "He used a really big bat," Trammell says. "A thirty-six, thirty-five: thirty-six inches in length and thirty-five ounces. I was 165 pounds coming out of high school, not very big at all. But Brink suggested I try this bat. So I used it. I choked up on it four or five inches. But it was a bat with some meat and substance. It made me swing a little late, and I'd hit these line drives just a foot or so over the first baseman's head, and they'd kick into the right-field corner. I was fast, and that resulted in some triples."

Indeed, it resulted in *many* triples, as Trammell broke Reggie Jackson's Southern League record for most triples in a season. Trammell still holds this record (nineteen).

Trammell and Whitaker enjoyed several successes in Montgomery. Whitaker was named Southern League Player of the Month in July. Trammell was named the season's Most Valuable Player. And the teammates

were part of the Rebels' third consecutive Southern League championship, beating the Jacksonville Suns in a two-game sweep.

"Winning never gets old, and that's the truth," Trammell says.

After clinching the championship, most of the team boarded a bus to return to Montgomery. Trammell and Whitaker stepped on an airplane for Boston. On September 9, they made their major league debuts, facing the Red Sox in Fenway Park. The duo was in The Show for good.

Though his days in Montgomery were forty years ago, Trammell remembers them with fondness. A picture of Whitaker and him turning a double play as Rebels hangs in his home. "I look back on being a part of the Montgomery Rebels, and that was a great time in my career as far as I'm concerned," he says.

FATHERS AND SONS

BRITT BURNS

1978–85: Chicago White Sox

*B*aseball goes hand-in-hand with dad and lad (and dot) time. Evenings in the front yard, tossing the ball back and forth until dusk, dad offering encouragement, son or daughter trying to apply the suggestions so the father's glove snaps when it catches the ball. As the child reaches adulthood, the two can follow the same team, check in with each other about how the season is progressing, the young players called up from the minors and making a splash, the clunky third baseman with the iron glove they wish the team would trade. Going to a game, they have a dog and a beer. Among the wooden bleachers, green grass and white lines framing the playing field, they catch up on life and its challenges and triumphs—the son or daughter now rearing the next generation, the highs and lows at work, the latest current event, topics shifting or punctuated by mutual admiration for an athletic play in the field, the bat walloping the ball, the leather of the catcher's glove snapping just like the eager kid wanted dad's to when they were playing catch on the lawn thirty years earlier.

Fultondale native Britt Burns enjoyed baseball with his father. In fact, Burns credits his dad, Charles, for molding him into a control pitcher. As an eight-year-old, he would go to the front yard with his father and play catch. "If I threw one away, which I did often enough, he'd go in the house and say, 'If you want to throw the ball right, we'll come back out and play catch.'"

In 1981, while pitching for the Chicago White Sox, Burns used baseball as a way to deliver good news to Charles, who was lying in a coma, battling to recover from injuries after being hit by a car. As his dad struggled in the hospital, Burns threw thirty-one consecutive scoreless innings. "It was a different kind of motivation. I wasn't thinking so much about the outcome of the game," Burns says. "I just wanted to come home and give him some good news. That I pitched well. It was one of the most focused times of my career."

After his father passed away, Burns faced a reality: he had been playing baseball in part to please his dad. He had to learn to play the game for himself. "I had to do it for me because it made me happy because it was my life. I actually got a little bit better."

HUFFMAN HIGH SCHOOL—THE BEAST FROM THE EAST

From working with his father, Burns developed into a hard-throwing left-handed control pitcher. He was pitching well, and as a high school student at Fultondale, he was encouraged to move to the Huffman High School district to play under coach Phil English.

"That came about from a man named Lonnie Haley, who was the head baseball coach at Fultondale," Burns says. "Who I guess had been a former left-handed pitcher and who had signed somewhere along the way, maybe played a little bit of pro ball. Basically said with my dad, if it were his son, he would go over to Huffman to get with Phil English. Bigger program, bigger school, bigger exposure, I suppose," Burns says.

Charles Burns heeded Haley's advice. He sold the family's home and moved to the Huffman district for his son's junior year. With the move, baseball success continued.

"Played there the summer league in the community that summer before, and that first year there [1977], we won the state championship," Burns says. Burns enjoyed playing for Coach English, who was inducted into the Alabama High School Athletics Association Hall of Fame in 1994. English had a knack for working with talented pitchers. Former players Bill Latham and Jay Tibbs, like Burns, progressed to a big-league mound. And English had a knack for relating to his players and getting the most out of their talent.

"There was a way of…handling and communicating with and working with young kids," Burns says, describing English's style. "There was a

certain disciplinarian to him, but there was also an element of sarcastic humor, having fun. He knew where to pick his battles. It was just one of those things: he knew how to get along with and relate to us. It just made for a great situation. When we got out of line, he let us know matter-of-factly. And it was right back to having fun and playing baseball. He was really good. For most people, it's not what you know. It's how you react and your relationship and how you deal with people, and he was very, very good at it."

Burns flourished at Huffman. As the team marched toward the state championship in 1977, Burns set the Alabama high school record for the lowest earned run average: 0.00. His starts attracted major league scouts, including representatives from the Atlanta Braves, Baltimore Orioles and New York Yankees. These teams were drawn to him during the pre–radar gun days.

"Unlike this generation of players and dads and coaches that have the radar gun or five or ten in the stands, we didn't have that going on. We didn't really know," Burns says. "I grew up, getting back to my dad, thinking that walking people was a cardinal sin. You didn't walk people. And that became a part of the belief system: you just didn't do that. It all goes back to playing catch in the front yard with my dad: this idea of knowing where it's going, commanding it and staying focused and throwing strikes. All that was instilled unbeknownst to me at the time at an early age."

The combination of power and control worked well for Burns. "Even today at the major league level, that's a pretty good recipe for success. If you got good stuff and you throw it over, you've got a chance."

Burns signed a letter of intent to play college baseball at Auburn University, but in 1978, the Chicago White Sox drafted him in the third round. He was surprised because he hadn't heard they were one of the teams scouting his games.

After the draft, Burns met with the White Sox representative. "He talked for two hours, and then he got to the bottom line. My dad went through the roof. In a bad way. We had heard $75,000, $100,000 [for a signing bonus], and I think the first offer was $17,500. We were thinking it would be a lot more. My dad was like, 'It costs more than that to go to college!'"

The White Sox explained that they were including the costs of school in their offer. "We had this idea in our mind of something more, and it took a while to let that sink in. I remember telling my mom I really would rather do this, and if it didn't work out, I would go back to school."

Unexpectedly, mere weeks after signing with the White Sox, Burns made his major league debut. "I was somewhere in the Midwest and the phone

rings and the manager calls me down to the lobby and says, 'You're getting called up.'"

Knowing the White Sox Double A affiliate was in Knoxville and much closer to home in Birmingham, Burns was excited. "All right! I'm going to Knoxville!" Burns said.

"No," the manager corrected. "You're going to Chicago."

In hindsight, Burns believes the rapid acceleration to the big leagues was White Sox owner Bill Veeck's attempt to garner interest in a struggling club. "He had a big smile and was very friendly. He was definitely a promoter just trying to find ways to make the team and the business work."

The move also resulted from the White Sox's mediocre record. In 1978, the team was 71-90, finishing in fifth place, twenty and a half games behind the division-winning Kansas City Royals. "[I] was in the right place at the right time with a club that was struggling, unlike if I had been drafted by the Yankees," Burns says. "There was nobody holding me back in front of me. So I got an opportunity where I otherwise wouldn't. It's pretty cool."

Burns was excited about the call-up. He admits he had little perspective on the decision. "I was too young and naïve to even think about being afraid. Part of that was to my advantage. I didn't know any better. I just continued to do what I do. Like I said, the only thing I knew was you're not supposed to walk people, so I went up there and did that."

Sharing the news with his parents, Burns enjoyed their reaction. "My parents were beside themselves. Dad was thrilled. My mom was scared to death. 'He's only nineteen years old. What's he doing going to the big leagues?'"

At the time, Burns was exclusively a fastball pitcher. He faced the Detroit Tigers in Tiger Stadium, and he threw five innings before the Tigers adjusted and hit him. Ten days later, he faced the Tigers again, and he lasted only three innings. "It started sinking in that, obviously, if I'm going to pitch in the big leagues, I've got to learn some things. To me, it was come up with a second pitch to go with the fastball."

Burns found that second pitch in the slider. "Ken Silvestri was our roving pitching guy, and he mentioned to me the slider. Didn't tell me much more about it other than that, except I knew what it was supposed to do. One day, playing catch, that feels like how I can make the ball do that, and that's how I came up with the slider."

Before discovering the new pitch, Burns took his lumps. After his two starts against the Tigers, he returned to the minor leagues and found himself with three wins, nine losses and an earned run average approaching 6.00.

"I didn't think I was going to make it," he says. "I called my mom and said this isn't going to work out. I think I made a mistake. I should've went to Auburn. Should've went that route. She talked me out of it, out of quitting. That was a couple of days I went through that. After that, I was fine. Came up with a second pitch. Started having success. Finished up '79 pitching well and, in 1980, made the big-league club out of spring training. So that one pitch turned it around."

In terms of refining the slider, Burns says he didn't. "It came to me very easily. In fact, later in my career, the more I messed with it, the worse it got."

Keeping it simple is a lesson Burns had to master. Starting pitchers have a lot of time on their hands—four days to think about a great outing and how they can't wait to get out there and pitch again. Conversely, it may also give them four days to dwell on a subpar outing and how they can't wait to redeem themselves.

"When I started thinking about how I was having success or maybe I needed to do something different, I started struggling. I came back, I just went back to what I did when I first got there, and I had success again."

Burns compares the dwelling to trying to unscramble a scrambled egg. "I over-analyzed, and I had to learn not to do this. Worrying does you no good. It fixes nothing. You take the ball, you go back out there the next day and you go at it again."

Later in his career, Burns took a cue from teammate and future hall of famer Tom Seaver.

"He just went out and did his thing," Burns says.

Didn't seem to have a whole lot of stress about it. I noticed that, this guy, nothing bothers him. I'm like, "Oh, I've got to win today," and finally realized: I don't know if we're going to win. I'm going to go out and compete and see how it goes. That's not an easy place to get to because you think, when you're a young pitcher, the weight of the whole day is on your shoulders. And it is to a degree. Starting pitching sets the tone. But to settle in to I'm going to do what I do. I'm going to do that consistently. I'm going to try to do that well. I don't know if I'm going to get hit hard or get hit soft or these guys are going to make plays or we're going to score. There are so many things beyond the pitcher's control. Takes a while to figure that out. I struggled with that.

Burns says the outlook helped. First innings could pose difficulty for him, so he tried a range of approaches on days he started. For a while, he ran

on days he pitched. Other stretches, he did nothing. Then he had intense workouts, which settled him down and helped produce good results through four innings, but he tired quickly after that. After working with Seaver, though, Burns started doing things that kept his mind off his next start.

"I would show up and hang out at batting practice. I'd hit fungoes. Before I'd get to the park, I'd go to the mall. Play video games. Anything to stay distracted."

EMERGING AS ONE OF THE BEST

In 1979, when Burns rejoined the team in September, the White Sox had a new manager, Tony LaRussa, and a new pitching coach, Dave Duncan.

Burns liked both. "Tony was kind of quiet," Burns says. "He always had a presence about him. In retrospect, I see the leadership qualities. He didn't flaunt it, and he wasn't overbearing. He was low-key, but he kept things real. If he was concerned about something, he let me know about it. But if I was doing something he liked, he was good about giving praise. He was real good that way. He was also very protective of his players. Didn't want to see anybody get hurt. Was really more concerned with our careers than the wins and losses. Even though winning was important, he didn't want to get anybody hurt trying to do that, so I enjoyed playing for him."

Duncan, a former catcher for the A's, Indians and Orioles, used a simple approach. "He didn't really get into a lot of mechanical stuff," Burns says. "More the mental side of things, competing, first-pitch strikes. Stuff that I already had a belief in, even though I didn't put it into those words. He was good about telling us this works, this is why it works, to reinforce our confidence in things we were doing if we were doing it well, and kept things pretty simple."

Burns was also drawn to pitcher Ken Kravec, a fellow lefty who had won fifteen games in 1979. "He was very good to me as a young guy coming up," Burns says. "Just, you know, 'Hey, kid. We like you.' When you're that age, you feel like you don't fit in at all. It's no different than any other peer situation. That's what really matters most right there. 'Just keep your mouth shut. Go take care of your business. You'll be okay.' Coming from a teammate, that means more than coming from anyone else."

As 1980 began, Burns flourished in the starting rotation. He won fifteen games and posted a 2.84 earned run average. He also completed eleven

games and pitched 238 innings, accomplishments that won't be seen in today's young pitchers.

"We're so protective of guys, building up their innings little by little," he says. "We obviously didn't do that back then. Some of the old-school guys talk about that. These kids have it in their mind that, they get to 100 innings, they're going to break down. We never talked about that. Break down? What's that mean? You don't break down. It's just a different mindset. I know the guys that are ten years my senior who have been pitching coaches are more in tune with the game changing that way that we're almost enabling pitchers to fail. We're putting it in their minds with pitch counts and limiting innings or whatever, yet people tell us that the Tommy John surgeries and rotator cuff surgeries are on the rise, not on the decline."

He attributes his durability to running and good mechanics. "I had a good arm and a body that worked."

He also added a third pitch: the split-finger fastball. Like the slider, learning the new pitch came easy to Burns. "A teammate of mine, Richard Dotson, was being shown the pitch," Burns says. "I just happened to be standing there, watching. He didn't pick up on it. I started tinkering with it and using it. It ended up functioning as a kind of changeup for me, a third pitch with a little bit different look to it, a different speed."

The following season, another factor helped his pitching: new teammate and future hall-of-fame catcher Carlton Fisk. "Pudge was just a very intense, dedicated, hard worker. I mean, he would come in after a nine-inning ballgame, and he's in the weight room lifting. Of course, he was a veteran guy by the time I got to know him. He was in his thirties and a solid, established future hall of famer, and he earned all of that. No doubt."

Burns admired Fisk's approach to pitch selection. "He put it down, and I threw it. The goal is to get into a rhythm, kind of get on the same page where your catcher is putting down what you want to throw. Those are really good days. Don't know that there's any way to plan that out ahead of time. It usually falls into place."

The key to reaching this point, Burns says, is the catcher knowing his pitcher's strengths. "Some catchers just focus on the hitter, on what he's thinking or not thinking. That's really not the way to go. You've got to work with the pitcher first. And this changes. What may be a strength in the fifth inning may be different in the seventh inning."

Fisk didn't make many trips to the mound to discuss strategy with Burns. But when he did, he captured his pitcher's attention. "I was going through a

game and getting behind a little bit. I was 2-0, unaware that, at a 2-0 count, I'm kind of guiding the ball, just trying to throw a strike," Burns says.

Knowing these pitches usually get hammered, Fisk called time and walked to the mound. He pulled his mask up and rested it on the top of his head. Then he poked a finger into his pitcher's chest. "Burnsey," Fisk said. "Instead of throwing me a 2-0 fastball for a strike, throw me a 2-0 fastball for his ass!"

Burns nodded. Fisk returned to the plate. Applying the instructions, the pitcher started cutting it loose.

CHI-TOWN

Home for Burns's major league career was the original Comiskey Park. Built in 1910, Comiskey was the oldest park in use during its last season in 1990. Burns enjoyed pitching there.

"It was home," he says. "Looking back, it had character, a smell and a feel to it that's difficult if not impossible to recapture in the newer, modern stadiums. I know it was a rocking place when it was packed out. I want to say that, early on, they used to serve liquor at the ballpark. It seems like, if we had more than 30,000 or 35,000 people on a weekend, there's a fight."

The pugilistic crowd provided highlights for the players, including hijinks fueled by alcohol. "The foul pole connected the lower deck and the upper

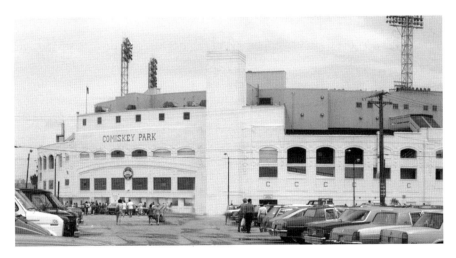

Old Comiskey Park. *Wikimedia Commons.*

deck. We look down there, and there's a guy climbing the foul pole from the lower deck trying to get to the upper deck. Obviously, he had too much to drink. Somewhere, about halfway, he had a sobering moment and just froze. Wouldn't climb up and wasn't going down. Stuck. Had to call the fire department. Stop the game. The fire department got him down. It can be a crazy place."

In Comiskey, Burns teamed with pitchers LaMarr Hoyt, Richard Dotson and Floyd Bannister to form a formidable starting rotation. "LaMarr was one of the better strike throwers in the game," Burns says. "He was like the [Greg] Maddux then of his time. Wherever he wanted to throw his fastball, he was able to do it. And he could throw everything else he had for a strike. His stuff was average. It wasn't eye-popping stuff, but he threw strikes. Won twenty-four games, a Cy Young Award winner. Two hundred fifty-nine innings, and [only] twenty-nine walks. He almost won more games than he had walks."

"Dot had really good stuff," he continues. "Good fastball and probably one of the better changeups in the American League at the time. Especially versus left-handed hitters."

During his career, Burns threw thirty-nine complete games, including eleven shutouts. Against California, he threw a one-hitter in 1983. He also threw two two-hitters and two three-hitters. But the games he remembers are the marquee matchups when he went toe-to-toe with Dave Righetti, Tommy John or one of the better pitchers in the American League and won a close one-run game. One of these matchups was early in his career, when Burns's father traveled to Dallas at the last minute to watch his son pitch against future hall of famer Ferguson Jenkins, starting for the Texas Rangers.

"That was the first time Dad saw me pitch in the big leagues. I threw a complete game. It was funny. The catcher was Ricky Seilheimer. I think he was around nineteen or twenty. Our combined age was younger than Fergie at the time."

In those marquee matchups, Burns was locked in. "The zone: it's a real place. It's tough to get there, but it's a real place. Not only is it tough to get there, it's tough to stay there and not be distracted by something that gets you out of your game. To be able to sustain it for an entire ballgame, it's not easy. At least, it wasn't easy for me. But when you do it more than once, you're, 'Okay, this is a real place. I need to figure out how to get here more often.' And it comes with time and experience."

Again, Burns thinks of Seaver. "He described pitching like you're building something. You don't really have time to enjoy it while you're doing it. You

don't stop and look at it. You don't examine it. You don't analyze it until you're done. Then you can go back and look at it and see what you've built that day. If you start thinking about it while you're out there, you're not in the moment. You're not focused on what you need to be doing."

Burns faced many great hitters over his career. "Reggie Jackson hit his four-hundredth home run off me. I also froze Reggie on a fastball down and away. Called strike three. Reggie handed his bat to the umpire and said, 'Here. I can't hit that with this.' And then got thrown out of the game. That was hilarious."

One of the first hitters he faced was Carl Yastrzemski. "I struck him out. I couldn't believe it. This was one of the guys I watched on TV."

George Brett of the Kansas City Royals "owned" Burns. "He hit like .580 off me. Including one night: home run around the right field foul pole, a home run around the left field foul pole in Kansas City," Burns says. "After our playing days, he's in Florida in Baseball City with the Royals coaching the up and up. Right after he got elected to the hall of fame. And George is good people. I walked up to him with a couple of baseballs and said, 'Well, since I helped you get into the hall of fame, would you mind signing a couple of balls?'"

One time when facing Rod Carew, Burns's life flashed before his eyes. Carew ripped a hanging splitter centered for Burns's forehead. Burns ducked out of the way. Once he regrouped, he looked at Carew on first base. "You've got to pull that ball!" Burns shouted.

Carew laughed. So did Burns. "That's when it's fun. If you can cut up with guys like that in that moment, you've arrived. You're there."

During his one-hitter against the Angels, Burns thought that once he got past Carew in California's lineup in the seventh inning, he had a good shot at the no-hitter.

"Base hit the next guy. A little dumper to right field."

Despite the success, Burns said it took him about five years in the major leagues to settle in. "It doesn't matter how long you've played in the minor leagues. You've still got to learn at the big-league level. It's a different world. It's still baseball, but it's a totally different environment than minor league ball. It's faster. There's more media. And it takes some getting used to."

Things coalesced for Burns during the 1983 playoffs. The White Sox won ninety-nine games and the American League Western Division. In Game Four of the American League Championship Series against the Baltimore Orioles, Burns pitched nine innings of shutout ball.

"Go into the tenth of a do-or-die game with zeroes: that was beyond my wildest dreams," he says. "I ended up with the loss, but in my psyche, I had an opportunity to find out I could do that. That was special. Because you don't know how you're going to react until you're put in that situation. I went out and just the best came out, and I competed my tail off and left it all on the field, so to speak. As far as performance goes, wow. It was a good one. The way this game goes, I could go out five days later and throw the ball the exact same way and do the exact same thing and give up five runs. That's the ugly and the beauty side of the game. But for that day, it was pretty good."

Although the White Sox came up short against the Baltimore Orioles and did not advance to the World Series, Burns says the 1983 season was special. "We had good chemistry and a good group. We had veteran leadership in Fisk and [Greg] Lusinski. Hoyt stepped up to lead the staff. Winning is fun. You know, everybody at that level is good. Over a 162-game schedule, you'll have your highs and your lows. Maybe one week you beat the Yankees two out of three, but if you faced them the next week, you only beat them one out of three. It all just came together for us. Everybody checked their egos at the door. It was a good group of guys, and guys liked each other."

Burns suspects part of this camaraderie comes from many of these players coming up together in the White Sox minor league system. "That gives you a sense of doing it together."

PEAKING, INJURIES

Burns had his best year in 1985. He won eighteen games and finished seventh in the Cy Young Award voting. It was also his final season in the big leagues.

He was twenty-six years old.

"My hips started bothering me in '85. Early in the year, I received some injections. That took care of the pain."

Burns's hips had troubled him at age twelve when the joints outgrew their sockets. Doctors inserted pins to hold the joints in place. But by the end of 1985 after the injection had worn off, Burns was in serious pain. He missed his last two starts because he was hurting so badly. The cartilage was gone, and his hips were grinding bone on bone.

The White Sox traded Burns to the Yankees after the season. Describing his disappointment in not being able to play for New York, Burns says, "It's

like let a kid go in the candy store and then tell him, no, you can't have anything."

Burns had surgery to reposition the hips and hopefully slow the degenerative process, but he didn't pitch again. "So many guys have gotten hurt. I was fortunate and blessed to get seven years in the big leagues. Who gets to do that? It's perspective. Sometimes, it takes you a while to arrive at the right one."

He admits he struggled losing what he loved, but he says, "It's in God's hands. There's a reason. Move on to the next thing and have peace about it."

Although tranquil, he says he still has dreams that he has to get ready for a game, that he needs to get his uniform on and pitch. "That's one of the things I try to tell guys now as a coach. The game ends for everybody. So, get all out of this you can get out of it. Don't take anything for granted. Don't waste it. Enjoy it. Don't let it slip away. It's going to end. It's going to end soon enough if you do everything right. Don't do anything to speed that up."

PASSING THE TORCH

Away from baseball for a few seasons, Burns bought a ranch out west and hiked. He felt better and, in 1990, tried making a comeback with the Yankees.

"My arm still worked, but my mechanics weren't the same," he says. "I couldn't get enough strength in my landing leg to finish my delivery and get out over my pitches like I used to. I started feeling it catch up in my arm."

After his comeback bid ended, Burns transitioned to coaching, working as a pitching coach for the Florida Marlins rookie ball team in 1993. Since then, he has worked in the Detroit, Houston and, now, White Sox organizations. Recently, he's served as the pitching coach for his hometown Birmingham Barons.

Among the organizations, he sees some differences in their player development philosophy. "Some organizations are more dedicated to player development. We're not going to get caught up in wins and losses. You're here to instruct and teach and maintain the structure and integrity of a program that leads to eventually preparing guys to get to the big-league level. Other organizations are all about we're here to win."

As examples, Burns points to using a bullpen. Although a starter may be having a great game and could continue pitching, the manager will pull

him and bring in relief pitchers in order for these pitchers to get some work because he wants to ensure that his relievers receive training and experience, not just the starter. Another example: assume a top prospect has gone hitless in a few games. Critical situation in a tied ball game, winning run on board, and the top prospect comes to the plate. Do you pinch-hit for him with somebody with a hotter bat? If you're going for the win, yes. But if you're looking long term, you want that prospect to get that game-on-the-line experience and build on it. Even if that means failing.

"You let them work through some things. You have to let them fail. You can't rescue them every time they get in trouble. They don't have a chance to learn from it, overcome it and get better at it. It can be frustrating sometimes. Frustrating for them. Frustrating watching it as a coach."

Put another way, players need experience. "There's some things you can't be taught but that can be learned. And a lot of what we learn in baseball is learned by trial and error and experience. You can give guys information. More often than not, until they go through it and experience it, they're not going to know what you're talking about," Burns says.

He enjoys working with the next generation of baseball players. "I like sharing information. They're good kids, fun to be around, funny and intelligent. They'll be successful at whatever they do because they have a good work ethic."

As he has coached, Burns has thought often about his former coach Phil English and his style at Huffman High School.

"Bill Latham and I both talk about [how] Coach English influenced our lives....I look at him, and it wasn't about him. It was about us. It wasn't so much about the wins and losses. It was about us playing the game the right way. And, obviously, we were talented, and we took it all the way to a state championship. But...the guy didn't try to intimidate us. It's not like he tried to act like he knew everything. It was just a great experience. So, yeah, it's carried over into my career as a pitching [coach], no doubt, just relating to players and keeping it real but down to earth. There's a saying, 'People don't care what you know until they know that you care.' Coaching is very good at that."

One thing that he sees pitchers needing to do: overcoming the fear of getting hit, of someone making contact with the ball. Burns reminds them that contact is fine—that's why there's seven players behind the pitcher to catch the ball and make defensive plays and keep the opposing team off the bases. "Lots of guys try to avoid [getting hit], and it's not a recipe for success."

The most challenging thing about coaching: patience. "Sometimes you can see a talented kid, and you're wanting to speed him up. It's hard to do that. Everybody has their own timetable. But you can see it: when the kid matures, he'll be good. And you know that, while he's on your watch, it probably ain't going to happen. It's probably going to happen two years from now. You know he's got talent. You also know this maturity thing is going to show up."

Perhaps a similar thought went through Charles Burns's mind as he played catch with his son in the front yard—realizing the talent was there, and nurturing and watching its growth.

DEFENSIVE WINS ABOVE REPLACEMENT

OZZIE SMITH

Statistics have evolved beyond a comparison of which pitcher has the most wins or which hitter has the highest batting average. Now, new sets of acronyms populate baseball analyses, including WAR (wins above replacement). WAR attempts to capture a player's total value to his team, combining multiple offensive, defensive and baserunning factors into one number that answers the following question: If the player in question had to be replaced by a Triple A call-up or a bench player, how much value or wins would the team lose? Moreover, players have an offensive WAR value as well as a defensive WAR. Ozzie Smith, who was born and spent the first nine years of his life in Mobile, has the highest career defensive WAR, 43.4.

During his nineteen-year career and prior to the ubiquity of WAR, Smith was acknowledged as one of the game's best defensive players. From 1980 to 1992, he won thirteen consecutive Gold Gloves for his work in the National League at shortstop—the most won by a shortstop for his career. Former Cardinals coach Red Schoendienst, a hall of famer for his work as a second baseman in the 1940s and 1950s, says Smith is one of the best infielders to play the game. "He's got great hands. He's quick. His hands and feet are quick. That's what makes an infielder and a shortstop. His arm is good. He can dive for a ball and bounce up quicker than anybody I've ever seen. I've seen a lot of great shortstops, outstanding shortstops, and he's right with them."

Simply put, Smith used quickness, range and athleticism to prevent other teams from scoring runs.

"There's no statistic kept for saving runs," Smith says. "Good defense puts your offense in a position to win."

Good defense means having the ability to make dazzling as well as routine plays consistently. "I prided myself on making not just the great play," Smith says, "but on concentrating on the routine plays, too."

In 2002, acknowledging his sustained excellence, the Baseball Writers Association of America elected Smith to the National Baseball Hall of Fame in his first year of eligibility.

BASE HITS, STOLEN BASES AND CLUBHOUSE LEADERSHIP

GARY REDUS

1982–85: Cincinnati Reds
1986: Philadelphia Phillies
1987–88: Chicago White Sox
1988–92: Pittsburgh Pirates
1993–94: Texas Rangers

*R*ecently, the Billings (Montana) Mustangs honored one of their alumni, Gary Redus, who posted the highest batting average (.462) for a professional season during his 1978 campaign in Billings. Commemorating Redus and his feat, they hosted Gary Redus Bobblehead Night, giving away bobblehead dolls bearing Redus's likeness to fans attending the game.

The only detail they overlooked was notifying the honoree.

After his bobblehead night, Redus learned about it. He couldn't believe a bobblehead depicted him. He nosed around the Internet and confirmed its existence. Puzzled and amused, he called the Mustangs. "Did y'all have a Gary Redus Bobblehead Night?" he asked.

"Yes, we did."

"Do you have any left?"

"I think we do. We may have one or two."

"If you wouldn't mind sending them to me, I'd appreciate it," Redus said.

"Sure. What's your name and address?"

"Gary Redus."

"What?"

"This is Gary Redus. You mean to tell me you had a Gary Redus Bobblehead Night and didn't even invite me?" Redus laughed.

The team sent Redus a few bobbleheads. He gave them to his children and grandchildren, and one sits on the mantel in his den.

"One of my grandkids got one, and he tore the head off," he says.

WEIGHING OPTIONS

An excellent athlete in high school, Redus played football, ran track, starred on the basketball court and played baseball. His football ability attracted the interest of colleges, namely Troy State University, which wanted him to play cornerback.

"We went down for a visit. You go to Montgomery, and you take 231 and drive the lonely highway—you run into Troy. And it used to be, that's all you would run into. It wasn't nothing else. Just Troy."

Redus watched a Troy State football game, mindful that the team wanted him to play cornerback. "I'm standing on the sideline and watching the cornerback, and I'm watching these big linemen pull around, and they just wiped out the cornerback. I'm like, 'I don't think I'm playing cornerback. I don't think I'm playing football.'"

Back home in Tanner, the baseball coach at Calhoun Community College, Fred Frickie, contacted Redus. Frickie said, "I hear you may not be playing football."

"No," Redus said. "I don't want to play football."

"Do you want to come to Calhoun and play baseball?"

Without hesitation, Redus said yes.

At Calhoun, Redus played baseball and basketball his freshman year. During his sophomore year, he concentrated solely on baseball and earned conference MVP honors.

After two years at Calhoun, Redus wanted to transfer to the University of Alabama and play baseball for the Crimson Tide. But because he hadn't graduated with his associate's degree, he couldn't transfer. So he drove ten miles up the road and continued his education and his baseball career at Athens State University in Athens, Alabama. There he continued to play well. In the 1977 amateur draft, the Boston Red Sox selected Redus in the seventeenth round.

As a signing bonus, the Red Sox offered Redus $5,000. He wanted $10,000. They couldn't reach an agreement, so Redus headed to Massachusetts to spend his summer playing in the Cape Cod League against top amateur talent. At the end of the summer, as Redus prepared to return to Alabama, the Red Sox scout approached Redus. He asked, "What would it take for you to sign?"

Redus repeated, "Give me $10,000."

"Okay. I'll draw up the contract."

Later that night, Redus met the scout to sign. But when he read the contract, he saw the signing bonus remained $5,000. "Just sign it," the scout said. "I have to send it to your parents to sign, too, because you're underage."

Redus signed and headed for home. And for Athens State. He didn't want to play for Boston.

His senior year, Redus hit .400, was named Conference Player of the Year and earned national All-American honors. Scouts flocked to his games, and he worked out for many of them. "At most workouts, you're a number. But I worked out for the Dodgers, and they knew my name," Redus says.

With the improved statistics and increased attention, he expected to be picked in an early round and to get $10,000.

Day one of the 1978 draft concluded, and no team selected Redus. "Now, I'm pissed," he recalls.

Day two had nearly ended when the Cincinnati Reds selected Redus in the fifteenth round. The Reds' scout contacted Redus. He said, "Well, young man. Let me see about getting some money in your pocket."

Redus read the contract the scout presented and was amazed. The offer was for $2,000. Better statistics, a higher draft selection and less money. It didn't make sense.

Redus put the contract down and looked at the scout. "I don't want to play," Redus said.

"You don't want to play?"

"No. I don't want to play."

The scout said he would make some calls and see what he could do to increase the bonus. He returned with an offer of $3,000.

"Forget it. I don't want to play," Redus said. "You can leave. I ain't signing."

Before the scout left, Redus's mother pulled her son aside.

"You've always wanted to play baseball," she said. Redus listened.

"You can't find a job here where you'll make $3,000 this summer." He continued to listen. "You might as well go ahead and do it."

Redus followed her advice. Then, consistent with the Cincinnati Reds' way of doing business, the scout and he drove to a sporting goods store, where the Reds bought him a pair of shoes and a glove. While he appreciated the gesture, Redus thought the selections were a little unusual. "They bought me a Joe Morgan model glove for second basemen. It was about the size of your hand. Pretty small."

The cleats were small, too. By design. "They said if your feet hurt, you'll run faster." Redus shakes his head. "That makes absolutely no sense."

And so, Redus became a Red.

PLAYER DEVELOPMENT

Redus's first stop in professional baseball was in Billings. Disenchanted with his draft selection and modest bonus, Redus arrived with a chip on his shoulder. He wanted to prove he was one of the best players. "Plus, I was already having a good year at Athens. Things just kept rolling for me."

He joined a talented team. Teammates like Skeeter Barnes, Tom Lawless and Nick Esasky all ultimately joined Redus in the major league ranks. The core played well and created a fun atmosphere for fans. "We were scoring runs," Redus says. "The team had this deal where you hit a home run, it was thirty minutes of free beer. Because, they just didn't [hit home runs]. Well, we started hitting home runs. It was like a stampede running to the concession stands. They had to change that to like five minutes because we were hitting so many home runs."

The team hit so well that teammates had a friendly competition to maintain the offensive surge. "Before a game, I had a goal. I know me and Skeeter did this: to get two hits a game. And then, we'd say anything over two is just gravy. And most of the time, we did it. We pushed each other."

Overseeing the talent was manager Jim Hoff. "He taught us everything," Redus says. "He taught us how to wear the uniform. Believe it or not, he taught us how to sign the baseball. He taught us how to act on the field. Everything you can think of in baseball, he taught us."

As part of the Reds' minor league system, Redus progressed methodically, from rookie ball to A ball to Double A and so forth. With one exception. After a brief promotion to Double A, the Reds asked him to spend another season in A ball because he couldn't hit a curveball.

"Who can?" Redus responded.

Redus is convinced that after his spectacular season in Billings, some organizations would have fast-tracked him to the big leagues. He wishes the Reds had done so, but he understands their philosophy. "It works for some players. But I was ready. I could have been brought along faster."

The slow and steady progression placed a financial strain on Redus and his family. "The first couple of years, I played winter ball because, I mean, even to my second year in the big leagues, we spent time trying to catch up financially. I mean, you're behind the eight ball all through the minor leagues."

One resource for Redus as he worked his way up through the minors was Reds roving hitting instructor Ted Kluzewski, a four-time all-star and one of the game's best power hitters during the 1950s. Redus admires how simple and accessible Kluzewski's lessons were. After placing a ball on a tee, he would look at Redus and ask, "Gary-E, what's going on?" (Redus says Kluzewski wouldn't call him "Gary," only "Gary-E.")

Redus would explain the problem. Klu listened. Then he said, "Okay. Get yourself set. Get going…come through. That's all hitting is. Get yourself going, come through."

Immediately in the minor leagues, Redus had to learn a new position, second base. He was accustomed to playing shortstop or outfield. Using the small infield glove the Reds bought him, Redus made multiple errors during games. "[With the glove], all I could do was just knock it down and throw it to first. I'm serious, I would make three, four errors a game sometimes, but I'd get three or four hits to make up for it."

Then, in Double A, he moved to first base. "That was horrible," Redus says. "That was a bad experiment. Then they put me in left field, and that's pretty much where I stayed."

Indeed, when called up to the big leagues at the end of 1982, Redus received a month of starts in left field.

His first hit was off the San Diego Padres' Eric Show. First baseman Steve Garvey gave Redus the ball. "Congratulations," Garvey said. "I'm sure there's going to be many more of these."

As a rookie, Redus said little and paid attention to what was going on around him. One example of paying attention was a game against Houston in the Astrodome. Nolan Ryan was pitching for the Astros, and Redus stole home. "It was a double steal. The guy at first was running. Once he took off, then I took off from third."

That game, Reds manager Russ Nixon used a young and fast lineup and told his speedsters to steal.

Ryan didn't cotton to all of the running. Fed up, he plunked Reds batter Dave Van Gorder as Redus stood on third base, poised to break for home again. "I mean, you can hear it. It looked like it went down his whole body," Redus says.

After he hit Van Gorder, Ryan caught the baseball for the next pitch. He rubbed the ball and looked at Redus standing on third base. "I guess we can stop all that running," Ryan said.

"I'm like, 'Is he looking at me?' And I kind of turned, and I'm like, 'Yeah. He's looking at me.' So we stopped running after that," Redus says.

Redus was good at stealing bases. In 1987, he had the third most stolen bases in the American League, and when he retired, he had stolen 322, 138th most all time. He says part of the stolen bases are attributable to his speed. But he also analyzed pickoff moves and pitchers' and catchers' tendencies to know when to steal.

"We had Eric Davis and Eddie Milner, Paul Householder and different guys that, we were always trying to figure out an edge to help us. We would figure out what kind of lead we should get here. What we should watch and this and that. And we were so fast, basically, all we did was, we got over there. The pitcher picked up his leg, and we took off running."

Not only did Redus talk shop with other base stealers, but he also worked with teammates like catchers Johnny Bench and Carlton Fisk to learn the catcher's perspective and factor this in as he evaluated situations for stealing. "They kind of told us what they did when runners were on base. What signs they would use. When pitchers shake off, what would happen then. And we would pick the pitchers' brains, too. How to figure out what they were thinking, too."

One catcher he watched was Tony Pena. A four-time Gold Glove winner, Pena gave most base runners fits because he threw to a base frequently. "He thought he was the smartest thing in the world. He'd throw behind you. And he had such a good arm that nobody would ever steal on him and stuff like that. And then we finally got him where we could figure him out. He always threw from his knees. So, we'd get out there. He'd never look at you. He'd catch it. Get on his knee. Throw it right to first. So we got to where he'd catch it. As soon as he would drop to his knees, we'd take off."

ARRIVING AND ADJUSTING

Opening Day 1983 was memorable for Redus. Growing up, he always tuned in to New York Yankees announcer (and native Alabamian, born in Johns in 1913) Mel Allen's program, *This Week in Baseball*. Making it to the big leagues, Redus beamed when the show included one of his plays.

"Cincinnati was always Opening Day. We played the Braves. And somebody hit a ball to the gap, and I'm running, I'm running. I make the catch and smack into the fence. It made *This Week in Baseball*, and that was pretty neat because everybody saw that game. Because it was the only game. It's not like now where there's three or four opening games. This was the only game played, so everybody saw that. I made that catch. Hit a home run. So it was a pretty good day."

Redus had many grand moments during his tenure with the Reds: a home run off Tom Seaver; throwing out former Red Joe Morgan, now playing for the Phillies, at home from left field; and hitting a double off future hall of famer Bruce Sutter in the eleventh inning to drive in the winning run. During his rookie season (1983), he played well against the Cubs, knocking a single and then a home run. The Cubs noted the success and tried to dial it back a notch. For his next at-bat, the pitcher drilled him.

Riverfront Stadium, the site of Gary Redus's debut on *This Week in Baseball*. *Blake Bolinger*.

"I go to first base, and I'm mad," Redus says. "And I've got tears. And I wipe the tears away—okay. Let's go. Let's go. And I stole second. I said, 'Okay. This is what baseball is all about. I've got to get used to it.'"

Redus also learned the importance of making adjustments. "When I first came up, if you threw a fastball, I usually hit it. So then they started throwing changeups, and I started swinging at them, and it was like swatting flies up at the plate because I was swinging at everything. Then I had to adjust. Then when I adjust from that and started taking that, and then they made an adjustment. The game is always about making adjustments. It's who can make the adjustment quicker. Because, it was weird: if you were swinging at a lot of changeups and missing, and you played this one team. Then you move on to the next team. That information beat you to the next city. So they knew, and they did the same thing. So you had to make an adjustment."

BASEBALL IS A POLITICAL BUSINESS

Toward the end of 1984, all-time hits leader Pete Rose returned to Cincinnati via a trade with the Montreal Expos and became the Reds' player-manager.

Rose cut Redus's playing time, opting to play the veteran César Cedeño instead of Redus in left field. "Pete said something like he wasn't going to penalize Cedeño because he's older. Redus is young, so he can sit on the bench," Redus says.

Redus then became Rose's personal runner. Rose would get a hit and then tell Redus, "Go run for me. And steal second." Redus went along with the arrangement. The outfield was crowded, with rookie Eric Davis recently called up from the minors, veteran slugger Dave Parker, Eddie Milner, Cedeño, Redus and Nick Esasky, displaced from first base since Rose joined the team. Redus was playing sparingly when a reporter asked him, "Don't you think a lineup with Eddie Milner, Eric Davis and Dave Parker in the outfield and Nick Esasky at first is a good lineup?"

Redus said, "Yeah. That's a pretty good lineup."

The result: a headline story in the *Cincinnati Enquirer*, "Redus Says Rose Should Bench Himself."

"[Pete] never said a word to me after that," Redus says. "It wasn't even, 'Hi. How you doing?' Nothing like that. So, with the Reds, there was a rule: no facial hair. So we were on the last two weeks of the season. I said, forget

this. I started growing all this," pointing to his goateed chin. "What can they do? I'm not playing, so they can't not play me. They can't keep me off the plane. They got to get me on the plane."

In Rose's doghouse, Redus became the subject of trade rumors. But Redus believes Rose tried to end his career early by stating, "I don't think anybody wants Redus." Thankfully, the Philadelphia Phillies, Rose's former team, wanted Redus, trading for him in 1985. "I was like, yea. You hated to leave your friends and the organization that you started with, grew up with the guys and stuff. But for me, it was a fresh start, and it was a way for me to prove myself again. I had a ball in Philly."

In Philadelphia, Redus enjoyed teammates like Steve Carlton and Mike Schmidt. Redus observed Schmidt's outstanding season in 1986, when he won the National League Most Valuable Player Award. "We had Michael Jack [Schmidt] at third. Clutch. And he is so, I guess 'cool' is a good word. Because you think a superstar would be, 'Okay, I'm a superstar, and I'm over here, and the rest of you guys are over there.' But any time we rode the bus, we'd be sitting in the back. He'd come back and say, 'All right, guys. How are we going to win this game today?' He always wanted to talk baseball, and I loved being around him."

Although the '86 Phillies finished a distant second place behind the eventual World Series–winning New York Mets, the Phillies took pride in the fact that during a four-game series against the Mets late in the season, the Phillies swept the series. The sweep delayed the Mets from clinching the division. Facing Mets pitcher Bob Ojeda during the series stands out to Redus.

"Bob Ojeda walked me three times in one game. It was a close game. And the fourth time come up. It seemed like he never threw a strike. He finally threw me a strike, and I hit a home run off of him."

Redus settled into Philadelphia and enjoyed being a part of his new team. He thought it had a core of good players and looked forward to being a part of the team for a long time.

Then, in spring training in 1987, he was shocked to learn that the Phillies traded him to the Chicago White Sox. Unlike his joy to get a fresh start outside of Cincinnati, he wasn't excited about a new chapter on the south side of Chicago. "I didn't want to leave because Philly was nice. They are a first-class organization from top to bottom. I loved it. I loved the guys."

As a White Sox, Redus played in original Comiskey Park, one of the older stadiums in use at the time. "It wasn't a nice place to play in," he says. "It seems like the infield was always wet. The uniforms, I used to say, we looked

like Bingo Long and the Traveling All-Stars in those things," referring to the 1976 comedy about former Negro League players who, fed up with the poor treatment by team owners, formed their own team to barnstorm small midwestern towns and wore garish uniforms similar to a rainbow.

Redus began his White Sox tenure hitting well, including two dingers in his first game. Despite the success, hitting coach Deron Johnson pulled Redus aside to adjust his batting stroke. "I didn't need to be tweaked," Redus says. "Everything just went downhill. I mean, I stopped hitting. It was one of those things where, hey, leave him alone until he struggles. Then work with him. But it was like, 'Okay, he's doing good. Let's mess with him now.' So, it was kind of weird."

Highlights included Redus's speed. In 1987, he was leading the American League in stolen bases when manager Jim Fregosi stopped playing Redus the final month of the season. As Redus sat on the bench, Seattle Mariner Harold Reynolds passed Redus with eight more steals.

"Jim was funny," Redus says. "You'd ask him why he wasn't playing somebody, and he'd just say he didn't feel like playing them. I don't know why he didn't play me much."

Redus began to hear rumors that he was going to be traded in 1988. He asked Fregosi if they were true. "As long as I'm here, you're not getting traded," Fregosi said.

The next morning, Redus called his agent. He relayed Fregosi's statement to him and added, "There's rumors I'm going to get traded to Pittsburgh. Can you call Pittsburgh to see if that's true?"

A minute later, the phone rang. It was Jim Fregosi. "You've been traded," Fregosi said.

"Where?"

"Pittsburgh."

FIVE GREAT YEARS WITH THE BUCS

With the trade to Pittsburgh in 1988, Redus went from a second-division team to one in the thick of a pennant race. The Pirates were loaded with talent—great pitching with 1990 NL Cy Young Award winner Doug Drabek, two-time all-star John Smiley and Zane Smith ("Zane was unbelievable! It would be a two-hour game sometimes. Strikes, strikes, strikes."), and a great defense with an outfield of eventual seven-time Most Valuable Player Barry Bonds, five-time Gold Glove winner Andy Van Slyke and Bobby Bonilla.

The team scored runs by focusing on advancing base runners.

"If somebody got on first, we'd bunt him over. We'd try and score a run. A lot of people didn't like that and would say, 'Why did you do that?' [Manager Jim Leyland] would say, 'We do that one time per inning, and we score one run per inning—that's a pretty good game."

Redus holds Leyland in high regard. "The good thing about Leyland is that he treated everybody the same. If Barry Bonds is the best player, number one, and I'm down here, the twenty-fifth guy on the roster, he treats you the same. If he gives Barry a day off, whoever plays in his spot hits in his spot in the batting order: third."

Model manager Jim Leyland. *Keith Allison.*

Redus enjoyed the cohesive atmosphere in the Pirates clubhouse. "We were the most together team, the most fun five years I ever had. I mean, it was outstanding."

Players set up a basketball goal in the locker room for a weeklong basketball tournament. They kicked a hackey-sack around and played Flip, a game in which players hit or "flip" a ball to other players without using their hands and without letting the ball touch the ground. "It's twenty guys before batting practice and stuff. We're lined up and playing [Flip]. We're having an absolute ball. On the road, we'd go out to eat, a lot of us together. When we're inside, we're cutting up. Everybody got along great. It was just fun."

At this point in his career, Redus acted as the clubhouse leader. "If it was cold, I mean freezing cold, me and Lloyd McClendon, we'd get dressed and go, 'Let's go, let's go! It ain't that bad out there! It's warm there! Come on! Let's go get 'em!' And we'd go out there, and the game would start, and we would come back to the clubhouse."

Redus also pushed Barry Bonds, "the best player I ever played with, period. And then if you want to put after that period, maybe the biggest butthole I ever played with."

In terms of ego, Redus says Bonds was arrogant. "I heard he got that from Reggie [Jackson]. You had to play with sort of an attitude to be great.

It's hard to explain. He was good. He could flat out hit. And he could play outfield. He could run. He could do it all."

Redus tapped into Bonds's self-pride. "We fed his ego a little bit. We would say, 'Okay, two dollar bet on whoever gets the most hits today.' We couldn't out-hit Barry, but we'd have a little small pot and say, 'Whoever gets the most hits gets it today.' And just a way to pick him up and stuff, and we had fun doing that."

Redus played well in Pittsburgh. He hit for the cycle as a Pirate against the Reds on August 25, 1989. "I always liked hitting at the Reds' stadium. I remember I hit a single or a double or something. Then I hit a home run. And I think the last time up I needed a triple. I was kind of aware of it. I was telling the guys, 'Man, if I hit this thing, I ain't stopping at all.' And I remember hitting it down the [left field] line. I'm coming around second. I ain't stopping. I kept going."

Redus was also a part of baseball retaliation that season in a game against the Dodgers. Dodger pitcher Tim Crews hit Redus just below his eye. The context: with the Pirates leading 6–2, former Dodger but now Pirate R.J. Reynolds stole second base. Wanting to do well against his old team, he stole third.

The Dodgers didn't admire Reynolds's ambition. The very next pitch after Reynolds swiped third, the ball headed directly for Redus. After the ball struck him, blood poured from his eye. As he writhed in pain, Redus heard someone say, "That'll teach you to run with the score like that."

As he recovered from the injury, Redus shared the comment with Jim Leyland. Redus said, "Now, I doubt if the umpire said it. I didn't say it. That leaves one person." Dodger catcher Mike Scioscia.

For their next trip to Los Angeles, the Pirates let Scioscia know there would be retaliation. And when Redus reached the plate to lead off the game, Scioscia said, "That's pretty sorry, you telling everybody I said that."

Redus backed out of the batter's box. He looked at the catcher. "Mike," Redus said. "When I was down, somebody said, 'That'll teach you to run with the score like that.' The umpire didn't say it. I didn't say it. Who's left?"

"You can't say nothing like that. That's wrong."

Redus disagreed. "Mike. You said it. You had to say it. Nobody else was there."

"No, no, no, that's wrong. If y'all get me, we're going...."

Redus stopped him. "Mike, I'm telling you. That's the way it happened."

The umpire intervened to get the players to focus on the game at hand. "Hey, hey. Let's go. Let's play ball."

Redus backed out of the batter's box as Scioscia continued to chirp. "We're going to get you."

As mad as he ever was on a baseball field, Redus said, "I tell you what, Mike. If this ball hits me, me and you are going to fight right now."

The first pitch was outside. Scioscia kept talking. So Redus said, "I tell you what, Mike. If this pitch even comes close to me, we're fighting."

The next pitch was outside. Now, with his toes nearly touching the plate, Redus said, "If it even comes close me, Mike, we're fighting."

Again, the ball was outside. The story concludes with Scioscia getting smoked in his first at-bat that game.

"And it's over with. It's done."

Redus is surprised his eye injury wasn't more severe. "The baseball hit me so hard, it imprinted the stitches around my eye. But I'm very blessed I didn't fracture anything."

Redus admits he was nervous stepping into the batter's box after being hit. "Leyland was smart. The first game I played when I got back was off a right-hander. Because he wanted me to get back in there and feel it. Wasn't any problem."

LEARNING A NEW POSITION

Seeing he was in a crowded Pirate outfield with little playing time, Redus volunteered to play first base when the regular first baseman went down with an injury. Although his previous experience at first base in the minor leagues had been a misstep, he saw a chance to play and help his team. As a result, he was willing to learn a new position.

Redus taught himself the position by taking lots of infield practice. He caught baseballs from all of his teammates so he could learn when to stretch and how to gauge whether balls would make it to him in the air or if he needed to play the bounce. "I would draw an imaginary line. If the ball's at that line, I can get it. But if it's short of it, don't stretch. Wait for the bounce. And I learned to do that. It made it so much easier."

He also adjusted his throwing technique. Throwing as he did from left field, his arm tired. So he developed kind of an underhand flip that was accurate, with good pace and that strained his shoulder and arm less.

The Pirates played excellent baseball, winning the National League Eastern Division in 1990, 1991 and 1992. Redus thrived in the postseason, hitting .438 in the National League Championship Series in 1992. Despite

the consecutive playoff appearances and playing well in them, Redus says little stands out about the playoffs.

"We lost. We got beat by the Braves. We had them on the ropes both years and just could not put them away. They just had great pitching. Good pitching beats good hitting. They beat us two straight in Pittsburgh. In the final game, we're up two to nothing in the bottom of the ninth and lose with two outs. That always sticks with me."

DYSFUNCTION IN TEXAS

After 1992, Redus became a free agent. Happy in Pittsburgh, he approached Jim Leyland and said, "Jim, I want to play one more year, and I'm done."

Leyland thought about it and said, "You know what? You keep yourself in good shape. Are you asking for a lot of money?"

"I'll take the same contract I had. I ain't asking for nothing."

Leyland said, "You know what? Let's get it done."

Leyland approached general manager Ted Simmons about keeping Redus one more year. Simmons was noncommittal and put Redus off, explaining he needed to concentrate on re-signing Doug Drabek.

"Ted kept dragging his feet. It turned out he wanted to sign Lonnie Smith instead of me. That's fine. But Texas approached me. They offered two years, so I figured why not?"

Joining the Rangers, Redus became a part of a team that, talent-wise, reminded him of Pittsburgh. In terms of team chemistry, it was the polar opposite. "It was dysfunctional. So many superstars. So many different egos. The team didn't stretch together. During batting practice, everybody didn't come out. There'd be some guys come out. Hit. Then they'd go right back in. They didn't do any defensive work or anything like that. And it was just real dysfunctional."

Chris James, Billy Ripken and Redus shook things up by convincing the bench coach to reverse the batting practice schedule and have the bench players hit first and the starters hit last. The bench coach agreed. "So [the starters] never came out to stretch, so they didn't know what was going on. So we go out, and we stretch, and we start the groups. So when they come out, their group is done. So they can't hit. They're pissed. And I mean, they're yelling. They're mad. And of course, they're looking at me and Billy Ripken and stuff. And I mean they are absolutely pissed. We used to get onto

[Jose] Canseco because he would hit and he wouldn't come out and shag or do anything. He would go and lift weights and sit around. It was the big thing for those guys to sit around with their shirts off to show their muscles off and stuff. So it was a big blowup that day."

The blowup led to a team meeting. During the conversation, Canseco said, "Everybody should mind their own business. If I want to hit and come in and lift weights, that ain't nobody's business but my own. If I don't want to stretch, that ain't nobody's business but my own."

Redus responded, "No. If we're a team, we have to do things as a team if we want to win. We can't be separated."

The two sides went back and forth until Nolan Ryan stood up. "If we're going to be a team," Ryan said, "we're going to stretch as a team. We're going to hit as a team. Case closed."

From then on, the team hit and stretched together.

Redus played a minimal amount in Texas. "There were times in the American League, if you're an extra guy on the bench, you don't do nothing. You just sit there and watch the game. You might as well have a ticket. I remember there was thirty games straight where I didn't do anything. Because there's nobody to pinch-hit for. You have an all-star lineup. [First baseman Rafael] Palmeiro never took a day off. The only time he took a day off was against Randy Johnson. And then I had to play. Thanks. Of all people."

One opening for Redus was in right field on Sunday day games. For some reason, regular right fielder Jose Canseco could not play Sunday day games. "So I ended up playing," Redus says. "Start playing a pretty good outfield. The pitchers wanted me out there. I start playing out there every day. And it was weird. Canseco couldn't play Sunday day games at all for some reason. He just couldn't see, catch or whatever."

By the time he retired in 1994, Redus was ready to leave the game. "It was an easy transition. I knew I was ready to stop playing. If I had to go to spring training to try to make a club, then it was time to quit. It's pressure enough in baseball, but when you're one of the last guys and you're trying to make a club, it's really, really hard."

Redus observed some changes from his first year in the big leagues to the time of his retirement twelve years later. "The ballparks were better," he says. "When you get the new stadiums, you're in luxury compared to the old stadiums. Some of the ballparks you'd go to—Detroit, Chicago—there was barely enough room for all the players to get in. Detroit—half the players had to get dressed. Then they'd come out, then another group would go in

and get dressed. There just wasn't enough room. Same way on the bench. Everybody couldn't sit on the bench. There wasn't enough room."

Players also became bigger and stronger. The steroid era was beginning. During the 1990s, seven players hit fifty or more home runs in a season, yet from 1961 to 1990, only four players (Roger Maris, Mickey Mantle, Willie Mays and Tuscaloosa's George Foster) reached this mark. In hindsight, a number of players are suspected of using steroids or other performance-enhancing drugs, but at the time, Redus says he and other players were naïve. They would see longer home runs, more home runs, and just look at each other in amazement and appreciation.

"Steroids never crossed anybody's mind," he says. "You'd just say, 'Gah, these guys are big and strong.' And you left it at that."

After he retired from playing, Redus returned to his roots and became the head baseball coach at his alma mater, Calhoun Community College in Decatur. He also worked as a roving instructor for the Pirates, then later the Astros. But Calhoun discontinued all athletic programs, so for the past four years, Redus has been retired. It coincided with his son, Gary II, playing college basketball at Centenary College in Shreveport, Louisiana, and then the University of South Alabama. The extra time gave the elder Redus a chance to travel to watch his son play.

Today, he's found a new passion in golf. "I never played golf as a player, but now, I love it," he says. Jim Bibby worked with Redus as a roving instructor, and before one of their assignments, Bibby said, "Bring your clubs."

Redus brought an old set of clubs, played a round and now he's hooked. "I used to collect classic cars and go to car shows. Now all I've got laying around is a bunch of golf equipment."

Gary Redus today.
Author's collection.

In November 2015, Redus turned fifty-nine. By all accounts, he's enjoying life. He's appeared at some fantasy camps with the Reds and the Pirates. He hasn't tried to get back into coaching—he's happy at home in Decatur, hitting the links, spending time with his wife of thirty-seven years, Minnie, and his children and his grandchildren.

His hometown of Tanner even named a street after him, Gary Redus Road. "You kind of resemble whatever people think you are. You can't look at me and that road and say, 'Okay, I see this,' because that road's got a lot of bumps and holes in it, so it's not like who you are. But it's something I'm proud of."

BARONS RETURN!

*D*ating back to 1885, the Birmingham Barons have been a part of the minor league Southern Association, later the Southern League, from its beginning. But the team also had stretches outside of Birmingham. After the 1961 season, the Barons moved. They returned in 1964 and stayed for another eleven seasons, but following the 1975 season, the Barons again left town.

In 1981, owner and general manager Art Clarkson brought the Barons back to Birmingham, this time as a Detroit Tiger Double A affiliate. In 1983, expectations for the team were minimal. "We were picked to finish third or fourth in our division," says Don Heinkel, a starting pitcher for the Barons in 1982, 1983 and 1985 and an inductee in the Barons Hall of Fame (2016).

To everyone's surprise, the Barons won the Southern League in 1983. In fact, with a 91-54 record, the team ran away with the league title. "It was kind of a magical season," Heinkel says. "We had a bunch of young guys. We played well together. We did the little things well. We were really tough up the middle with [shortstop] Doug Baker and [second baseman] Scotty Earl and [outfielder] Raul Tovar, and Bobby Melvin and Dwight Lowry were our catchers. And starting pitching turned out to be a lot better than expected."

Indeed, starting pitching was outstanding. In thirty starts, Heinkel won nineteen games, including two shutouts. Keith Comstock went 12-3, and Colin Ward went 10-3.

Heinkel attributes the success to selfless chemistry. "I think both the manager, the owner, the leaders of the team and the players need to have that team-first attitude," he says. "And you don't always find that, especially in the minor leagues where guys are thinking about making it to the next level, making it to the big leagues, maybe to get themselves promoted instead of what can they do to help our team win. And that was kind of the thing for me: if you were a good team player, and you could help your team win, it could help everybody look better. And it helped everybody get a shot. Unfortunately, I don't think people always saw it that way."

Like other prior incarnations of the Barons, the 1983 championship team called Rickwood Field, the concrete-and-steel ballpark near the fairgrounds that opened in August 1910, home.

When asked about Rickwood, Heinkel smiles. "Old Rickety-wood," he chuckles. "Well, boy, let me tell you: in the Birmingham summer heat, it was a sauna in those dugouts because they were dark green. And they were small. Boxed in underground. But I really enjoyed the tradition. The atmosphere there was good. We had a lot of people come to the games, and they enjoyed baseball. Art Clarkson, our owner, made it fun to come to the ballpark."

The Barons were back in Birmingham. Winning. And to stay.

HIT KING MANAGES ALABAMIAN TO SUCCESS

*N*ew to the major leagues in 1984, Huffman High School alumnus Jay Tibbs accepted a dinner invitation from his Cincinnati Reds player-manager Pete Rose. The dinner party consisted of Rose, Tibbs and Reds pitching coach Stan Williams, who had pitched fourteen seasons in the big leagues and later coached for Boston, Seattle, the White Sox and the Yankees in addition to the Reds.

During the meal, Rose looked at Williams. "You know, Stan," Rose said. "Between me and you, we have fifty years' experience in the big leagues."

Williams nodded. "Yeah, Pete. That sounds about right."

Rose took a bite, then pointed to Tibbs with his fork. "Add Tibbs to that, and you've got fifty-one."

Tibbs laughs. "That's Pete. That's how he was. All he thought about was baseball on and off the field. As a person, you probably wouldn't like him if you meet him for the first time. You would call him arrogant or cocky, but he had the tenure and the statistics to back it up. He was one of the best, and he wasn't ashamed to tell people about it."

Tibbs's journey to reach the major leagues was a lengthy one. Drafted out of high school by the New York Mets in 1980, Tibbs immediately became a project for the team. Coaches adjusted his mechanics with hopes of creating more movement on his fastball. The constant tweaks to his natural delivery resulted in Tibbs losing his curveball and spending three seasons in rookie ball or Single A. Seeing roster assignments at the end of spring training in 1983 and realizing he was slated to start another

season at Class A ball while other pitchers were being promoted ahead of him, Tibbs informed the Mets he was quitting baseball, returning home to Alabama and going back to school.

The Mets asked him to reconsider. Tibbs said he would, on one condition: "I pitch my way. No more adjustments. I pitch how I want to pitch."

The team agreed. Striking a balance between what came naturally to him and the modifications suggested by the Mets, Tibbs took off. He won fourteen games and attracted the attention of the pitching-hungry Reds, who traded for him in 1984.

Working with Rose in his combined role of player-manager presented some interesting moments. "It was kind of funny, because he couldn't just call time and walk over from first base because it would count as a visit from the manager," Tibbs says. "So sometimes, he'd talk to me from distances. And sometimes, he'd talk to me more like a player than a manager. Most managers come out to the mound, and they're calm and ask you how you're feeling. Pete would get fired up. 'Hey, Tibbs! You're throwing ninety-one today—just throw the ball! We'll get everybody out.'"

Tibbs liked Rose. "He was good to me as a manager. He would tell you like it is. There's no sugar-coating anything. Which, I think players appreciated that."

As an example of Rose's direct approach, Tibbs points to his second season in the big leagues. Tibbs was the team's number-two starter and pitching well but not getting results. By the all-star break, his record was four wins and eleven losses. He was hearing murmurs that the club was going to shake things up and make a change.

"I don't know what was wrong," Tibbs says. "I felt good. I don't know if it was a question of no run support or I lost my confidence or what it was."

The low point was a demotion to the bullpen. Tibbs came into a game against the Mets and faced George Foster. With the score tied at four, Foster launched a two-run home run. As Tibbs watched the ball clear the fence, he knew the whispers about a move would become a louder, more definite voice.

After the game, Rose called Tibbs into his office. "Look," Rose said. "We've got to do something. Let's send you down to Denver. Let's let you get your confidence back, pitch two or three games and then we'll call you right back up."

Tibbs did just that. True to Rose's word, Tibbs was back in the big leagues in August. Not only was he back with the Reds, but he was also effective again, winning six games during the second half of the season. Two wins

Jay Tibbs. *Author's collection.*

were five-hit shutouts—one against the Pirates in August and one against the Astros in September.

"It made me feel good the fact that they did what they said they were going to do," Tibbs says. "And they hadn't given up on me. Of course, I was still young. I had only one year under my belt at that point. They saw a lot of potential."

Tibbs rejoined the Reds as Rose neared Ty Cobb's all-time hits record. "I pitched a game in Chicago," Tibbs says. "Pete was like two or three hits away from breaking the record. Our owner, Marge Schott, told him not to play, that he needed to make sure he broke the record in Cincinnati and not on the road. I don't know what he said to her, but he played. With Pete, his thinking was you pay me to put the best team on the field, and I'm part of that. That's why I'm playing. You pay me to win ball games. And so Marge Schott hopped on a plane to Chicago so she'd see the game if he broke the record. He got a couple of hits and was one or two away from the record. But he played that whole game. Then we headed back to Cincinnati."

Rose's chasing the hits record was fun for the Reds. "We had a lot of media coverage. People were interested in the team and how we were doing

and when Pete was going to break the record. I always kid that there's a segment they'll show on ESPN. Right when Pete gets his hit and he gets to first base, you can see in the background all of us players coming from the dugout. Well, my mug is one of the very first ones coming out."

Although Rose has been banned from baseball since 1989, Tibbs believes he should be enshrined in the National Baseball Hall of Fame. "I just think he ought to be rewarded for what he did on the field. I just see we all make mistakes. I see the other players with other things they were involved with off the field. They gave them another chance."

Tibbs sees the counterargument, too. "If you go into any locker room or clubhouse in the major leagues, you see that little poster on the board before you go in that there's no gambling in baseball, and here's the ramifications if you get caught. I think that's the chance he took. I just think he thought he would never get caught because he was Pete."

Still, based on his performance on the field, Tibbs hopes Rose will be included in the hall.

"He just won't see it," Tibbs says.

HARD ROADS

MACKEY SASSER

1987: San Francisco Giants
1987: Pittsburgh Pirates
1988–92: New York Mets
1993–94: Seattle Mariners
1995: Pittsburgh Pirates

*M*ost junior-college baseball players balance the classroom with practice and games, a challenge with considerable time demands. Mackey Sasser also juggled being a husband and father and working six hours a day to make ends meet.

"I'd work at UPS from two to eight in the morning every night five days a week. And then go to school, and it was the same old thing over and over again," Sasser says. "I was married in college. My wife would work at night, so I was taking care of my daughter, trying to get four hours sleep."

As part of this routine, Sasser starred on the baseball diamond, hitting .380 both seasons at Wallace Community College in Dothan. But the schedule taxed him. "My freshman year, I weighed 220. My sophomore year, I was 179. No sleep, just working and grinding."

Noting his strong hitting, the San Francisco Giants drafted Sasser in the fifth round of the 1984 January amateur draft. Sasser signed, but UPS made a play to keep him. "They offered me my own route. Some folks told me I was crazy to turn it down. But I asked them, 'What would you do if you were in my shoes? Would you try it?'"

One answered yes. "Well, that's what I'm doing."

Even today, Sasser encourages others to pursue their dreams. "I say go for it. You can live it. You just got to work to get it because nobody's going to give it to you."

To that end, Sasser credits balancing school, baseball, parenthood and work for giving him discipline and keeping him on track. "It was the best thing that ever happened to me. It taught me to grow up. I wasn't laying out at night and doing irresponsible things. I was doing things I needed to do to prepare myself."

BEGINNINGS

Sasser grew up in Tallahassee, Florida.

"My dad was manager of a liquor store, and my mom was a nurse. They were always hard workers. Really didn't have a whole lot of money."

With his parents concentrating on keeping a roof overhead and food on the table, Sasser had an abundance of freedom as a kid. As a result, he saw plenty. "My sister and I were right there when my five-year-old brother was run over by a car. To me, he just was never really right after that."

Roaming the streets, a teenage Sasser witnessed drug deals and found himself in situations where gunshots were fired. One time, he left a liquor store only to learn that, within five minutes of his exit, the store manager was robbed and killed.

In this context, Sasser "was just a boy," getting into fights for the hell of it, crossing busy streets and daring cars to hit him and not playing high school baseball because the coach and he disagreed about the appropriate length of Sasser's hair.

One constant, though, was sports. His grandfather Mert Wofford took an interest in Sasser's development as a baseball player. Wofford played baseball until he was fifty-six years old, and he was happy to offer advice and instruction to the next generation. "He always taught me about my hips—getting through the ball," Sasser says. "It paid off when I got to the minor leagues and the big leagues. Because I had a lot of people tell me you've got the best hips, and the way you get through the ball is just phenomenal."

Wofford's enthusiasm for the game passed through the bloodstream. His four sons and his daughter, Sasser's mother, all enjoyed and played

the game. "We played in clay pits in front of the house," Sasser says. "We used to play ball with all of our kids and their kids and everybody. It was just something we did. We all liked it."

Sasser starred on the football field, too, quarterbacking his high school team.

His parents divorced when he was in high school, and he moved with his mother to Dothan for his senior year. Ineligible to play baseball for the high school, he attracted interest from one school, Wallace Community College, based on his play during summer league ball.

SHORTSTOP TO CATCHER

Ken "Squeaky" Parker scouted for the San Francisco Giants. After signing Sasser, Parker said, "Go get a catcher's mitt. That's where you're going to play."

"A catcher?" Sasser asked, puzzled. At Wallace, he played shortstop.

"Catcher," Parker answered.

Sasser says, "I didn't have the speed to play shortstop, the range, and they thought a left-handed-hitting catcher is where I needed to be. And he was right."

Once in the minor leagues, Sasser volunteered to play *any* position so he would have a chance to get in the lineup. At rookie ball in Clinton, Iowa, he played fifty-two games at first base, thirty-four at third, two in the outfield and one behind the plate.

"I knew that I had to hit my way to get anywhere," he says. "When I got out there, Charlie Hayes, who played twelve years in the big leagues, was third baseman. Was third round draft pick in the June draft. And he had tendonitis in his arm, and he couldn't play in the spring. So I saw an open door and an opportunity. So I played third until he got there. And I led my team in hitting. And so, when Charlie got back, I played right field and first base. And what happened was, one of our catchers got hurt, and I went in and told the manager that, look, if you need somebody to back up catcher, I'll catch."

The manager looked at Sasser funny. "Oh. You can catch, too?"

"Well, hell," Sasser said. "You signed me as a catcher."

The next day, Sasser arrived at the clubhouse, and his locker now held a catcher's mitt and catcher's equipment. "Eight or ten days later, I caught a game. All the big brass was in town. I caught a one-hitter and threw somebody out. And from then, it just took off."

Sasser repeated the pattern of playing multiple positions until he reached Double A and played for the Shreveport Captains. There he worked closely with Tim Blackwell, the Giants' catching instructor, to develop into a receiver. In one session, Blackwell explained how to field bunts. Then he showed Sasser how to block balls in the dirt. Days later, he shared tips on pitch selection and how to set up hitters. In addition to sharing nuts-and-bolts tips for being a good catcher, Blackwell supported Sasser, encouraging him if Sasser struggled.

Although Sasser played well in the minor leagues, hitting .338 in 133 games in Fresno and rising to the Giants' second-best prospect behind pitcher Terry Mulholland, the minor leagues were a grind. "To me, they make the minor leagues tough to see if you can handle it," Sasser says. "You've got long bus rides. You get off the bus at eight, nine in the morning and get you a couple hours of rest and play baseball. You're sleeping in different beds. You go to sleep sometimes eleven, twelve o'clock. By one o'clock, you're waking up. You've got every kind of bug in the country on you."

In July 1987, Sasser was playing for the Triple A Phoenix Firebirds when he received the news he was being promoted to the big leagues. First, though, he had to receive a karate kick to the face. On the road in Albuquerque and playing a day game against the Dukes, Sasser pursued Dukes base runner Jose Gonzalez in a rundown between home plate and third base. As Gonzalez dove for third base, Sasser tagged him.

"He thought I tagged him too hard," Sasser says.

Sasser turned away and was walking back toward home plate when Gonzalez charged and planted a kick on Sasser's face. "Luckily, I still had my mask on."

The kick created a memorable moment. Now, whenever Sasser sees Terry Collins, the Dukes' manager at the time, Collins asks, "Do you remember that karate kick?"

"You know I do," Sasser says.

Sasser coming up in the Giants' organization. *Mackey Sasser's collection.*

Even with the catcher's mask on Sasser's face, Gonzalez landed a blow. "I had a big scar on my face from my eye all the way down to my mouth, a cleat mark all the way down my face."

After the game and back at the team's hotel, Sasser received a phone call from Dave Kingman, one of the game's best power hitters in the 1970s. Kingman was attempting a comeback with the Giants and was playing on the Firebirds. "Come on down and have a beer with Wendell and me," Kingman said.

"All right," Sasser said. He went to the hotel pool, and Kingman and manager Wendell Kim were in the hot tub. They had a bottle of champagne. Kingman poured a glass and handed it to Sasser.

"Hey, man," Kingman said. "We just want to let you know congratulations. You've been called to the big leagues."

"Aw, come on. You're telling me a joke," Sasser said.

"No. Your plane leaves at 5:30 in the morning."

It sunk in. He was being promoted to the San Francisco Giants.

"You can't imagine the feeling," Sasser says. "You've worked so hard to get to where you want to get, and it was there. That moment was finally there."

One problem. Sasser was playing behind Bob Brenly, who was the hottest hitter in the major leagues at the time. "You understand. They're in a pennant race. He's playing. He's hot."

As a result, playing time was limited during Sasser's first two weeks in the majors. His first at-bat, he pinch-hit against the Cubs and faced six-foot, five-inch closer Lee Smith. Still, he picked up his first major league hit before returning to Triple A Phoenix. He wasn't there long when manager Kim called him in to talk.

"I don't know what in the hell they're doing!" Kim said.

"What?" Sasser said.

"You just got traded to the Pirates."

At first, Sasser was heartbroken. But then he started to think about how much the Pirates wanted him, and how stacked its lineup was, with young players like Barry Bonds, Bobby Bonilla, Doug Drabek, John Smiley and Andy Van Slyke.

"You could tell they were going to win. Because they were young, and they were hungry. When I was with them, the last month or thirty games, they were like 20-5. You wanted to be a part of that."

THE BEST

In Pittsburgh, Sasser observed the most talented player in baseball, Barry Bonds, and one of its best managers, Jim Leyland.

Bonds, who later became the all-time home-run leader, had all of the tools to be a great player. "Had bat speed, talent. I mean, he had it. But, one of the biggest jerks you'll ever meet in your life. Because it was all about him."

As an example, Sasser remembers a Pirates team party he attended after becoming a New York Met. The party celebrated the Pirates clinching the National League Eastern Division. "Everybody's there, having a good time. I'm not even on the team, but I'm with them because those guys are my friends. The whole time: Barry Bonds is in a back room shooting pool by himself. I don't know why. He can be a nice guy and have a nice personality. I just don't get it."

Manager Jim Leyland was similarly decorated with awards as Bonds, winning the 1997 World Series with the Florida Marlins, two American League pennants with the Detroit Tigers and three Manager of the Year honors. "Jim Leyland is probably the best manager I ever played for. He was just a manager. He managed everything. He knew how to deal with players. He knew how to deal with the front office. He knew how to deal with anything that came about. He knew how to get into players' butts, and he knew how to pat your butt. He's probably the most respected guy I ever met in baseball."

Sasser played for a lot of good managers—all of them with great qualities. Roger Craig: "He believed in outings. Like dinners and cookouts. He always wanted the families and people together. He was older, and he believed in that stuff." Lou Piniella: "He was the funniest guy I ever played for. I mean, he would rant and rave. He would drop the GD bombs, and one game, he dropped the 'Jesus Christ!' bomb sixty-nine times. Me, Dave Magadan and Dann Howitt counted sixty-nine 'Jesus Christ! What the F?' on the bench one night. Sixty-nine. We sat there and counted. We wrote it down. But it was hilarious because that's a word that flows, just a normal word for him." Davey Johnson: "He believed in just go play. And he put good people around him. He had Mel Stottlemyre as his pitching guy, which is probably the best pitching guy I've been around as far as a coach. He'd get the best out of every one of his pitchers." But today, as a coach of eighteen-, nineteen- and twenty-year-olds, Sasser relies most on lessons learned from Leyland.

THE BIG APPLE

As he settled into the Pirates clubhouse, Sasser received a surprise during spring training in 1988. He was traded to the New York Mets for first baseman Randy Milligan. The trade happened during a hectic time for Sasser. His wife, Lynne, was pregnant and only a day or two away from delivery. As a result, Sasser explained to the Mets' traveling secretary that he would report to the Mets' camp after the baby was born. Apparently, the message didn't reach manager Davey Johnson, who greeted Sasser saying, "I thought you was supposed to be here yesterday."

With no rest after racing from the Pirates' training facilities to Dothan and down to the Mets' spring training camp, Sasser was worn out and tired. Nonetheless, Johnson placed him in that day's starting lineup. "I played four innings. I throw out Cal Ripken Jr. And then they put on the hit-and-run, and I successfully hit-and-run."

Johnson had seen enough. He pulled Sasser out of the game. "Congratulations," Johnson said. "You made my team. Now go get some rest."

Sasser did exactly that. "I went and got on the bus and went to sleep," he laughs.

The team Sasser made was one of the best of the 1980s. The 1988 club boasted a marquee starting pitching rotation of Dwight Gooden, David Cone, Ron Darling and Bob Ojeda, two of whom won the Cy Young Award. The lineup included future hall-of-fame catcher Gary Carter and eight-time all-star outfielder Darryl Strawberry.

"When it's all said and done, New York is *the* place to play. They love their athletes. You walk down the street, there's millions of people there, and they know you."

Being in the media capital of the country, celebrities were drawn to Shea Stadium and Mets games. Some even threw out the ceremonial first pitch of games. Sasser was often behind the plate to catch those pitches, thrown by everyone from President George H.W. Bush to Roger Rabbit, George Carlin, Lisa Lisa, Cult Jam and professional wrestler King Kong Bundy. Sasser says he offered to catch anyone. One of his favorites was the thirty-seventh president, Richard Nixon. "President Nixon was an avid Mets fan. I got all his books signed. Me and Dave Magadan were supposed to go to his house and eat dinner, and his wife got sick, so we didn't go."

In New York, Sasser settled into a backup role. If starter Gary Carter took a day off and the opposing pitcher was a right-hander, Sasser played, typically catching either Bob Ojeda or David Cone.

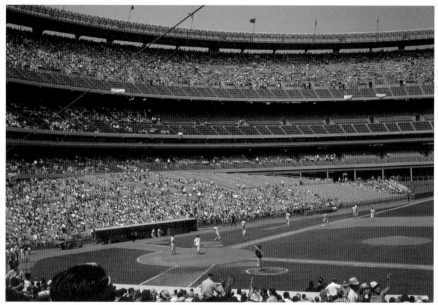

This page: Sasser's New York home, Shea Stadium. *Exterior by Metsfan84, Wikimedia Commons; interior by Dada1960, Wikimedia Commons.*

"At that level, catching is easy. [The pitchers] pretty much hit their spots. And in the big leagues, we had every chart you can have on a hitter. We knew who could beat us, who couldn't beat us, who was hot, who wasn't hot. How to pitch to guys. And if you studied those charts, it was pretty simple. You study that, and the pitchers go with you."

Most of the time, that is. After one pitch from Ron Darling, Sasser stood up and started jogging toward the mound to talk strategy. Seeing Sasser approaching, Darling held up his glove and waved it, dismissing his catcher. After the inning and in the dugout, Sasser confronted his battery-mate. "Don't show me up on damn TV like that. Just let me get out there."

As Sasser dealt with Darling's dismissive attitude, he also honed his skills at blocking balls by catching David Cone during the season when he won twenty games and lost only three. "Cone threw a lot of balls in the dirt. His theory was to make you look as absolutely sick as you could look as a hitter. That was his theory. That's why he couldn't finish a game early in his career. When he learned just to throw strikes, he threw no-hitters and lasted longer in games. But I'd say there's guys who would call in sick when they got to the park because they didn't want to face him."

Sasser behind the dish. *Mackey Sasser's collection.*

Although Sasser was known more for his bat than for his defense, he worked at his catching. "You're studying hitters all the time. I'm studying their swings. I'm studying where their feet are because they may be moving back off the plate. They may be moving up to the plate. I mean, good hitters are doing different things all the time. They're not in the same spot all the time. They're trying to figure out what you're doing to them. If their swing is too late. Or if they're getting a good swing on something. If they're getting a good swing but they're out in front on a curveball, well, I'm going to pop him right back in with a fastball on the hands."

He had some memorable moments behind the plate, catching Cone and Gooden as they threw shutouts. "I think folks were always surprised when pitchers had a good game with me behind the plate," he says.

Defensively, Sasser took pride in his strong arm. One game in St. Louis, he displayed it against Vince Coleman, one of the National League's best base stealers, who led the league in stolen bases six times. At Busch Stadium, Sasser noticed a sign reading that Coleman had stolen fifty-six consecutive bases off of Gary Carter. "Then he stole another, so make that fifty-seven."

When Sasser received a start behind the plate, he remembered the statistic as Coleman led off the game. He also knew his starting pitcher, Ron Darling, had a quick release, improving Sasser's chances of throwing out a base runner. "Hey, Vince," Sasser said.

"Hey, Sass."

"Get on base. I'm going to throw you out," Sasser said.

"Yeah? Okay."

"Yeah."

"We'll see," Coleman said.

Coleman reached first base. As Darling started his windup, Coleman took off for second. Sasser caught the ball and fired a laser and threw Coleman out.

"I'm proud about that," Sasser says.

Coleman wasn't. During his next at-bat, he told Sasser, "That was lucky."

To demonstrate it wasn't luck, Sasser threw Coleman out again.

"I really felt on top of the world then. That was in 1990, and everything was just falling into place for me then."

In addition to developing behind the plate, Sasser was hitting well. He faced Nolan Ryan in New York and went two for four with a double.

"I hit the ball hard that game. Ryan didn't have his curveball. But a couple weeks later, I faced him in Houston. The first at-bat, he threw me a fastball, and I turned on it. I was a left-handed hitter. I turned it right on our side of the dugout. He walked halfway up the line, and he's staring at me the whole time. He grabbed that ball, and I just remember how his swagger was. He got the ball from the catcher and snatched it like he

Grit getting the job done. *Mackey Sasser's collection.*

does, looking at me the whole time, and he threw it right under my chin. It seemed like it was 150 miles an hour."

Sasser struck out that at-bat as well as his final at-bat to end the game. When he did, the Astrodome's scoreboard lit up with an animated bull kicking and celebrating the strikeout. Sasser learned that Ryan just set the record for the most strikeouts by a pitcher over forty.

"Don't worry about it, son," manager Davey Johnson consoled Sasser when he returned to the dugout. "I'm in that book, too."

The 1988 season culminated with the Mets facing the Los Angeles Dodgers in the National League Championship Series. Sasser was thrilled to reach the playoffs. His lasting memory: how close the Mets were to returning to the World Series.

"We're up two games to one. We're in the ninth inning. Dwight Gooden has pitched a gem. He gets two quick outs. We got Randy Myers throwing ninety-five down in the bullpen. Twice, he lifted his cap to signal that he was ready. But Johnson didn't bring him in."

Instead, Gooden faced John Shelby and walked him. Mike Scioscia drove him in to tie the game, and the teams went on to play five more innings before the Dodgers won the game in the bottom of the fourteenth, tying the series at two games apiece and eventually beating the Mets twice more to win the pennant.

"That's just one of those gut calls you make as a manager," Sasser says. "I do it all the time out here. Second-guess yourself. That could've been a World Series for us. And then you also think, I was that left-handed hitter, that one hitter on the bench. If we could've got there, I could've been that DH. No telling what I could've done. But it didn't work out that way."

ONE PLAY

In 1990, Sasser was playing nearly every game and making an impact, including hitting a grand slam off of Jose DeLeon in NBC's *Game of the Week*. But a collision at the plate derailed the excellent season and detoured Sasser's career.

In a game against the Atlanta Braves, Sasser dropped to his knees to field a throw from shortstop Kevin Elster. As he kneeled, base runner Jim Presley barreled into Sasser. "Jim's a friend. I like him. But what happened was, instead of just knocking me straight down, he kind of buried me down and

145

then hit me. And when he hit me, he rolled my ankles." As a result, Sasser's ankle stretched and contorted beyond normal limits.

"That game was right before the all-star break. I flew down to Panama City for a few days at the beach. When I woke up, the ankle had swollen up to the size of a football. I couldn't move it."

Despite the injury, the Mets kept Sasser in the lineup. They wanted his bat. To keep it, they wrapped Sasser's ankle so thickly and tightly it felt as if he were wearing a cast when he played.

"Because my ankle was taped so tight, I couldn't move the ankle. I couldn't rock back or forward, and then [when it was time to throw] I started trying to flip the ball. I couldn't ever get out of it when I started flipping the ball. Once I got to where I could move my ankle, it was already set in. It was mentally set in and started getting worse and worse and worse."

THE YIPS

After the collision with Presley, Sasser could still fire the ball to a base to throw out a base runner, but the routine toss between pitches back to the pitcher became an ordeal. He'd pump, hesitate, pump and hitch. Sometimes, the throws bounced to the pitcher. Others sailed over his head. At first, pitchers were understanding. But after a while, they lost patience.

"I couldn't blame them," Sasser says. "I mean, shoot. I wouldn't want me out there catching with them if I was pitching."

Sasser tried various ways to solve the problem. "I'd drink beer after games to relax. I'd take half a Valium to relax before a game. I went to a priest to put me under hypnosis. I saw anybody I could see to try and fix it. None of it worked."

As Sasser tried to work through the yips, manager Buddy Harrelson moved him to different positions on the field. In his first start in the outfield, Sasser was responsible for all three outs in the first inning. The first batter for the San Diego Padres, Bip Roberts, reached second base. Then Tony Fernandez hit a line drive to right field where Sasser was playing.

"It was one of those cloudy days, and the ball, you really couldn't see it that well. It was going over my head. I didn't get a great jump on it, and I catch it over my head, and [Roberts is] already trying to score, and I turn around and make a double play on him. Throw it to second and get him out."

The next batter was Tony Gwynn, who hit a shot to right field. Sasser ran back to the outfield wall and timed his jump to snatch the ball just before it cleared the fence for a home run. "During BP, we liked to try to catch home run balls. Go up against the fence and get them."

Despite finding success in other positions, his problem throwing the ball back to the pitcher continued to frustrate Sasser when he caught. The inability to perform a simple task frazzled him. "It's on your mind all the time," he says. "It's like you go to bed with it on your mind. You wake up with it on your mind. Because that's your profession. It's a bad habit you wanted to get rid of, and you couldn't. And there really wasn't a whole lot you could do. The only time I was free of it is when I was hitting."

Sasser never resolved the problem while playing. In fact, the problem affected him while throwing batting practice as a coach to his players at Wallace Community College. Eventually, he found peace in 2005 working with psychotherapist David Grand. "What happens is, there's a part of your brain that can only take so much trauma. Once it gets overloaded, it can't take no more," Sasser says. "They break down that trauma and try to get you to unload it and get it all out of you. But it works. You'd be surprised at the trauma you don't even know you have. It could be anything. Just beaten up and the ball hitting off of you. Me falling out of trees and having one-hundred-something stitches in me at one time. Getting run over at home plate and that kind of stuff."

With Dr. Grand, Sasser released that trauma. Doing so allowed him to move beyond the throwing hesitation. "We talked on the phone for a few hours. And I flew to New York and went through their process for about four hours. And then we did some more sessions over the phone. They go through your whole history. From Day One. Through all of your trauma."

FLUSHING FIASCOS

The New York Yankees were known as the Bronx Zoo in the 1970s. Headlines shouted George Steinbrenner's many managerial changes (*six* from 1973, when he bought the team, through 1979). Tension in the clubhouse sometimes escalated into fights among teammates (Cliff Johnson and Goose Gossage scuffled early in the 1979 season, placing Gossage on the disabled list with a sprained right thumb). The craziness carried over to

the New York Mets in the 1980s. For example: Sasser being sucker punched by teammate Darryl Strawberry.

"Darryl just talks and runs his mouth all the time," Sasser says. "He don't know how to keep his mouth shut. He's a thug is basically what he is. And he wants to bring everybody around him down."

The context for Strawberry hitting Sasser was that, earlier in the day, Sasser appeared at a baseball card show and signed autographs. Returning to the ballpark, Sasser deposited his appearance fee, a stack of bills, in one of the training room's cashboxes, where players could secure their valuables.

On the bus to the hotel, Strawberry started complaining how someone stole his cash. His cash was missing. Someone stole his cash. Then Sasser heard Strawberry say his name and accuse him of stealing his money.

Sasser stood up and confronted Strawberry. "Hey, man. If you're going to say something about me, be a man and say it to my damn...." Before Sasser could finish his sentence, Strawberry sucker punched Sasser in the mouth with his World Series ring.

Sasser lunged and tried to retaliate, but teammates held him back. "That's it! I ain't putting up with your shit!" Sasser said. Sasser went to his hotel room with blood on his face and "World Series" imprinted on his mouth. He was pissed.

To diffuse the situation, manager Davey Johnson met with Sasser and Strawberry the next day in his office. Sasser voiced his displeasure of being accused of theft. "That's my money," Sasser said. "Don't accuse me of something I haven't done." He paused, then added, "He shouldn't be spending his money on drugs."

Strawberry bristled.

Johnson convinced the players to put the episode behind them. After the conversation, things were cordial enough between the teammates. "We pretty much just left each other alone," Sasser says. "We might pass each other in the clubhouse, and Darryl would say, 'What's up, Sass?' But that was it."

Even though the issue was resolved, Sasser disagrees with how it was handled. "He's your superstar guy who gets special treatment. When what they should have done is sent him to rehab. They weren't going to do that, though."

HEAD NORTHWEST, YOUNG MAN

After the 1992 season, Sasser signed as a free agent with the Seattle Mariners. He picked Seattle because he knew and liked one of its coaches, Sammy Perlozzo, and because he wanted the opportunity to be a designated hitter.

"Seattle is a beautiful city. And a good baseball town. We drew pretty well. Maybe it was because they could see Lou Piniella go crazy and start throwing bases all over the place or whatever he was going to do."

Sasser played with two Mariner teammates later enshrined in the National Baseball Hall of Fame, Randy Johnson and Ken Griffey Jr. During this early stage of Johnson's career, Sasser remembers Johnson throwing ninety-seven miles per hour but removing himself from a game because he was tired.

Later, outfielder Jay Buhner pulled Johnson aside and told him he was quitting on the team. "Buhner was our enforcer. He let Randy know that he wasn't bigger than the team."

Sasser admired Ken Griffey Jr., on and off the field. "He could call his own shots. He'd tell them he was going to hit it, and he'd hit it. I'm serious. One time, he hit eight home runs in a row. It was eight bombs for eight games. I mean, just massive bombs. Foul pole to foul pole—they were going out everywhere."

Griffey also had an effervescent attitude. "He was a hoot. Practical joker in the locker room. It didn't matter if you were a coach or a reporter or a player, he did stuff like that. That's just who he was. If he had a bad game or he had a good game, he was the same guy."

Playing in the Kingdome offered pluses and minuses for Sasser. The positive is that it was a good hitter's park. The negative: its hard Astroturf. "It was hard as a rock. That's what happened to Ken Griffey Jr. I think it shortened his career. I mean, the ball would bounce up thirty feet on a pop-up if it hit between third and second or in the outfield and behind the infield."

WINDING DOWN PLAYING DAYS

In 1994, Sasser moved to the Mexican Leagues, which had a much more laid-back atmosphere compared to the majors.

"Mexico is a little different. I never seen guys drink beer before games and go out and play like it's just a Sunday afternoon baseball game. It was no big deal to them. Every game meant something to me. When I went out there, I wanted to win, first of all, and I come to play."

The Pittsburgh Pirates contacted Sasser, and he returned to the big leagues. "I thought I was going to be with them that whole year," he says. "I was going to be an outfielder and kind of back up a lot of things, and I got thrown into catching because Don Slaught went down, and I wasn't doing as good catching. I was a little hurt. My shoulder was bothering me. And one thing led to another, and they brought up a new kid, and they were fixing to pay me some good money, and they wound up cutting me. And it kind of threw me for a loop because they told me I would be there the whole year. So I went out and got my places [to live], done everything. That was a frustrating year for me because it ended wrong, the way I felt. But it is what it is. It's got to end some time."

Sasser's next move was into coaching. An opening was at his alma mater, Wallace Community College. Sasser was attracted to coaching, both for the opportunity to work with young athletes and the stability it offered in terms of pay and benefits. "We've had some good teams. We've been runners-up three or four times here in the state. And we do some good things for the

Plotting the next move. *Warner Taylor at WarnerTaylor.com Photography.*

Mackey Sasser on his way to accept Alabama Community College Conference Coach of the Year honors. *Warner Taylor at WarnerTaylor.com Photography.*

community. The other day, we had a Hits for Heroes home run derby where we raised money for veterans."

When he started coaching in 1997, Sasser pushed his players. "I'd make them run fifteen or twenty hills or barrel rolls or crawls. Carrying a block over their head. I'd cuss the living daylights out of them."

The tough love worked both in terms of wins and players' improvement. "It's rewarding when your former players come back, and they've gone on to be doctors or teachers, and they say, 'Man, I can't believe some of the stuff you made us do, but I appreciate it.'"

After nearly twenty years of coaching, Sasser has softened his approach. "I think with kids playing travel ball, they really aren't interested in listening to you until they fail. Until they struggle. Until they get to that point, they don't trust you. If you tell them a way they could improve, their response is 'Why would I want to do that?' Because they're already, in their minds, great. When really, all I'm trying to do is help them."

In 2011, Sasser became the athletic director at Wallace. "It's good," he says. "The rules are always changing, and you have to keep up with that."

Now Sasser enjoys spending time with his seven children. He likes teaching baseball to his two youngest sons, teenagers Cree and Max. "They're both good athletes. They can both play."

Sasser today. *Author's collection.*

Perhaps as good as their dad, the man Shea Stadium cheered for, a man thankful for the breaks he caught to help him reach that point.

"Coming where I came from, the childhood I had with the negativity around my lifestyle, I never thought I'd get to where I got. It was a blessing. Just very fortunate. A lot of people behind me. My dad was disabled most of his life, and I had a lot of outside help to really push me along to get to where I got. I was like nine lives. There were a lot of situations I've been in that could have gotten me in a lot of trouble. Not that I was doing anything wrong. I was around a lot of things and easily could've got killed or anything. But the good Lord was watching over me, and He put me in a lot of good situations."

DAD OPENS, SON CLOSES

HUNTSVILLE STARS

n 1985, minor league baseball arrived in Huntsville. Batting second and catching for the Huntsville Stars in its first game: Charlie O'Brien.

Thirty years later, the Stars departed, headed for Biloxi and a new $36 million stadium. Playing against the Stars in its final game in Huntsville: Chris O'Brien, Charlie's son.

At the Stars' inception, the town embraced its new team.

"I really enjoyed the people there," Charlie says. "They were excited because I think this was the first time they had baseball there."

In its maiden season, the Stars led the Southern League in attendance with over 300,000 people at home games. Fans had an abundance of talent to watch. The team, then a Double A affiliate for Oakland, was loaded with the A's' best prospects. Jose Canseco, Stan Javier and Luis Polonia patrolled the outfield; pitchers included Tim Belcher, Eric Plunk and Greg Cadaret; and O'Brien and Terry Steinbach worked behind the dish. All of these players went on to long big-league careers.

The team arrived at its new ballpark, Joe W. Davis Stadium, as the city was completing construction. "A lot of the stuff wasn't done in the clubhouse [yet]," Charlie says. "But it was nice. For a Double A stadium, it was really nice, actually. A lot more cement, more so than the old wood-and-beam places were before that."

Although new, the park wasn't sterile. "They had kind of a fence in the left-field corner," Charlie says. "The fence went back, but they kind of shortened

the fence up in the left-field corner. It's probably ten feet of short fence, and then it went to a bigger fence, so it's kind of a little added attraction to it."

Charlie also remembers the Stars' first game, a 10–0 win over the Birmingham Barons, on April 19, 1985, complete with an inside-the-park home run by Ray Thoma and a grand slam by Jose Canseco. "[Tim] Belcher pitched very well," Charlie says. "Canseco, I know that was the start of his career where he just took off. I think he hit forty, forty-eight home runs in the minor leagues that year. He had a phenomenal year."

Just as the initial team was competitive, so was the final version of the Stars, now a Brewers affiliate. In 2014, the Stars reached the first round of the Southern League playoffs and faced Dodgers affiliate Chattanooga. Chris O'Brien was the Lookouts' catcher. "Their pitching staff was unbelievable," Chris says of the Stars. "We didn't really want to play them because, especially in the Southern League where it was a five-game series, [and] you always face the number-one [starter], and you always face the best back-end relievers twice."

Walking into the stadium, now the oldest in the Southern League, the younger O'Brien was not dazzled. "I thought it was a football stadium," Chris says. "It kind of has that Roman Empire feel, like you're down in the pits. The first time I walked into it, I thought, golly! This thing's got to be one hundred years old."

Visiting clubhouses in cities like Birmingham offered individual lockers and space, but Huntsville's accommodations were spartan. "There were probably fifteen lockers for twenty-seven guys. And they were no bigger than, hell, like a school locker. They were tiny, and you had all these grown men in there just piled in. Probably no bigger than a bedroom. You had everything stacked in there."

Where thirty years earlier the town celebrated the team and led the league in attendance, times had changed. By 2014, Huntsville was last in attendance. Fewer than 100,000 people showed up for home games. "It was pretty dead," Chris says.

Although the town's support of the team faded, the Stars were ready to play its final series in Huntsville. So were the Lookouts. "We had that little rivalry with them because their manager, Carlos Subero, the year before, he was probably 75 percent of our team's manager in High A," Chris says. "He used to be with the Dodgers, but now he was over there with Milwaukee, so he knew all of us. It became more of a personal feel. Just because you knew him. He knew you. He watched you play for 140 games. So he knew what you were about. You knew what he was about."

The Lookouts were on a hot streak, including Chris, the Southern League's Player of the Month in August. In the first game of the series hosted by the Stars, the Lookouts pounced. In the top of the second inning, Chris and O'Koyea Dickson hit back-to-back home runs. "[The pitcher Drew Gagnon] kept throwing me front-door changeups. He threw it to me once. He threw it the second pitch, and I took it, I think. And then he tried throwing it again, and that's what I hit out."

In the final game for the Stars at The Joe, Huntsville's Austin Ross pitched a one-hitter, sending the series to Chattanooga tied. The Lookouts went on to defeat the Stars and advance to the next round of the playoffs. The Stars closed a chapter of baseball history in Huntsville and started a new one in 2015 as the rechristened Biloxi Shuckers.

Thinking about being a part of a team's first game in its brand-new stadium and his son being a part of that team's final game, Charlie smiles. "It just shows you what a small world things can be. How weird things work out. I had the better time because it was more exciting, and the sad time, well, Chris gets to see that."

He pauses.

"It's neat to have your kids playing pro ball, just in general, but then having them play the last game in the place where you played the first one, definitely is an interesting scenario. A rarity, obviously."

Straightforward.

LESS THAN ONE

CHRIS HAMMOND

1990–92: Cincinnati Reds
1993–96: Florida Marlins
1997: Boston Red Sox
1998: Florida Marlins
2002: Atlanta Braves
2003: New York Yankees
2004: Oakland A's
2005: San Diego Padres
2006: Cincinnati Reds

Only three pitchers have maintained earned run averages below 1.00 for a season. Ferdie Schupp did it in 1916. Hall of famer Dennis Eckersley duplicated the feat in 1990. The third person? Vestavia Hills native Chris Hammond. In 2002, he pitched seventy-six innings and gave up a miniscule *eight* earned runs, resulting in a 0.95 ERA.

Making Hammond's accomplishment even more remarkable is the fact that, four seasons earlier, he had retired from baseball. Going into 2002, he was making a comeback and just wanted to earn a spot on the Atlanta Braves roster so he could share his baseball experiences with his children, who had been too young to enjoy his 1990s tenure. "My wife and I were thinking about different things we could do," Hammond says, recalling why he returned to baseball. "She's a great cook, so we were considering opening a restaurant. Then she looked at me and said, 'The

one thing I regret is our kids never saw you pitch in baseball. Never saw you on the field.'"

That comment sparked Hammond to knock off the rust and see what was left in the tank. After all, he was only thirty-five years old. He was left-handed, a prized commodity for a pitching staff. He had walked away from baseball, but not because of arm injuries.

As it turned out, he went on to pitch five more years in the big leagues.

THE CHANGEUP

Prior to spring training in 2002, Hammond joined Braves pitchers and catchers at Camp Leo, pitching coach Leo Mazzone's voluntary workouts at Turner Field. "Everybody's out there sitting around the bullpen, and one guy gets up, and he starts throwing. And to me, that's nervous," Hammond says.

With all eyes on him, Hammond stepped onto the mound. "Throw some fastballs. Spin a couple of curveballs. And then I throw a changeup."

Relief pitcher Mike Remlinger watched Hammond's off-speed pitch and said, "What was that?"

"Changeup," Hammond said.

Remlinger smiled. "Throw that again!"

Hammond obliged. Now, Braves pitchers like Greg Maddux, Tom Glavine and John Smoltz took note and raved, "That is awesome!"

Their excitement encouraged Hammond. Although confident in his ability to pitch and get hitters out, he felt great receiving praise during this early stage in his comeback. But this wasn't new. Throughout his career, fellow pitchers appreciated Hammond's changeup, a pitch he taught himself at eleven.

"I had one of the best changeups in the history of baseball," Hammond says. "Just because I could throw it with a ten to fifteen mile an hour differential. The slowest I threw it was around fifty-eight, and the fastest I threw it was around seventy-two."

Jamie Moyer, a twenty-five-year major league veteran who won 269 games in his career, once sought out Hammond to learn more about how he threw the pitch. Moyer said, "Man, I love watching you pitch."

Hammond thanked him for the compliment.

"Last week," Moyer continued, "I watched you pitch, and you threw a changeup. It was sixty-nine miles per hour. The next pitch, you threw another changeup. It was sixty miles an hour. How did you do that?"

Hammond explained that the difference-maker was how he stomped his foot during his delivery. "The harder I stomped my foot: that's when I released my changeup. The slower it would get."

Moyer looked at Hammond as if he were joking. Hammond said, "I'm serious."

Later that season, Moyer's and Hammond's paths crossed again. Hammond asked how Moyer was doing. "That stomp stuff don't work for me," Moyer said.

Hammond laughed. He acknowledges the technique takes time to master. "You definitely ain't going to learn it during the season. Because you're not going to have enough time to really figure it out. It's going to take two or three weeks or a month if you really stick with it to figure out the concept."

The combination of his baffling changeup that upset hitters' timing and his great control led Atlanta Braves manager Bobby Cox to call Hammond into the dugout near the end of spring training in 2002. "Hammy," Cox said. "Looks like you're going to make our club."

Hammond smiled. "Bobby, I wasn't going to Triple A. I can pitch."

"Show me," Cox said.

BEGINNINGS

In 1984, Hammond graduated from Vestavia Hills High School. Coached by Sammy Dunn, a man whose career spanned twenty-seven seasons as head baseball coach and who won nine state titles from 1991 to 2000, Hammond pitched some but primarily played left field. He played well enough to advance to collegiate baseball and the University of Alabama at Birmingham. After a year, he transferred to Gulf Coast Community College in Panama City, Florida.

"That's what I tell kids these days," Hammond says. "It's not about going to Alabama or Auburn right out of high school. Go to a junior college and build your confidence. I mean, baseball and everything that comes along with it, it's tough. It'll chew you up and spit you out if you think it's all about going to Alabama or wherever, Southern Cal, and playing baseball as a freshman. That's just what I've seen."

Hammond continued to play in the outfield and was the designated hitter at Gulf Coast, but his occasional pitching attracted the attention of the Cincinnati Reds. "I pitched a few simulated games in the fall, and I pitched one game against South Alabama," Hammond says.

After one game, a Reds scout approached Hammond and said, "We're thinking about drafting you."

To himself, Hammond said, "Yes!," thinking the scout liked his hitting.

The scout continued. "I think we're going to draft you as a pitcher."

"Pitcher?" Hammond asked.

Sure enough, the Reds selected him in the sixth round in 1986. As a pitcher. He signed for a $500 bonus.

In the minor leagues, some of the higher draft picks who received hefty bonuses motivated Hammond. When they brazenly announced the Reds would be calling them up soon, Hammond thought, "Not if I can help it." He wanted to prove he was as good as they were. Pushing himself, his confidence soared during his third year of professional baseball. As a Double A Chattanooga Lookout, he won sixteen games, lost five and maintained a 1.72 ERA. "I knew I could pitch," he says.

Despite the success, Hammond did not target the big leagues as a priority or even a goal. "Don't have your goal to pitch in the major leagues because, if you have a goal like that, very few kids will reach that goal," he says. "And to me, that's what hinders them from moving on. If you have a bad game, who cares? You're getting paid to play baseball. If your goal is to make it to the major leagues, you hit three or four bad games in a row. You're probably going to have three or four bad games in a row after that. Because you're going to start getting down on yourself."

Hammond progressed methodically through the Reds minor league system much as Tanner native Gary Redus had done a decade earlier. Thinking of his superb season in Double A, Hammond observes a difference in today's game compared to when he played. "How many pitchers in today's time would have an 18-5 [record] with a 1.60 [ERA] and not get called up from Double A? Nobody even mentioned that I should get called up. That's baseball back then. You didn't go to Triple A yet," he laughs.

THE HIGHEST LEVEL

Hammond made his major league debut on July 16, 1990, against the Montreal Expos. New to the big leagues, Hammond endured some rites of passage like carrying a veteran's luggage. And wearing a fan's pungent clothes.

"We were in Pittsburgh, and this guy, this old drunk, he runs down to the bullpen. You could smell him," Hammond says. "And he throws his

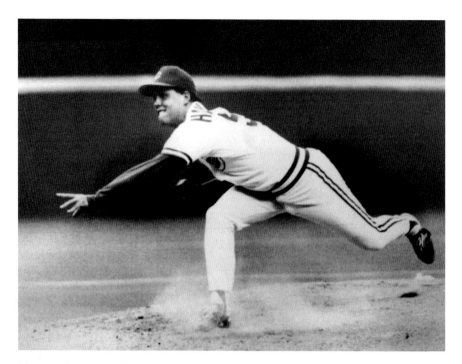

Hammond as a young Red. *Chris Hammond's collection.*

sports coat into the bullpen. It was a getaway day, and I had to wear it. But compared to everybody else and what they had to do, I was happy to wear that thing."

From 1990 to 1992, Hammond started forty-seven games for the Reds, winning fourteen and losing nineteen. His career shifted when Major League Baseball added two expansion teams in 1993, the Colorado Rockies and the Florida Marlins. Prior to the Marlins' inaugural season, the Reds traded Hammond to the Fish.

"The first time you're traded," Hammond explains, "you feel let down. Like your team has given up on you."

Hammond didn't get bogged down in feeling rejected. "With the Marlins, we were just a bunch of young kids going out there and having a ball," he says. "I lost my first three games, and if I was with anybody else, I'd probably be in the bullpen or down in the minor leagues. But they come up to me after the game, 'Come on, man! We know you can pitch!'"

Pitching coach Marcel Lacheman delivered the same upbeat message. "He believed in me," Hammond says. "He built my confidence. He

would tell me, 'You can pitch. Don't let the results from this game affect your next game.'"

Lacheman believed in Hammond even after a dismal spring training when hitters rocked him and his earned run average spiked to 12.00. Some coaches urged Lacheman to move Hammond to the bullpen.

Lacheman refused. "This is spring training," Lacheman said. "You use spring training to get ready for the season. We can't go by stats in spring training when you have a veteran pitcher."

With the vote of confidence, Hammond responded by starting the season against the Los Angeles Dodgers and Ramon Martinez. Hammond's line: seven and two-thirds innings, four hits, no runs and six strikeouts. "I got the win: one to nothing," he says. "I owe a lot to Marcel Lacheman. He believed in what I could do."

He also found an ally in his catcher, Charles Johnson. "He presented such a big target. He was great."

Hammond appreciated Johnson's acumen in pitch selection. "I wanted a catcher that could care less about if he's a good hitter. Good hitters: they strike out, bad call, whatever. They bring it to the next inning, and I'm shaking off, shaking off. That's why I enjoyed throwing to backup catchers. His goal is to call a good game."

Between innings, Johnson sat next to Hammond and discussed strategy. Hammond liked this one-on-one communication, something he fears may be disappearing from today's game.

Hammond also enjoyed spacious Joe Robbie Stadium as his home field. "I loved it. Big stadium. You can get away with throwing fastballs."

These factors coalesced into success. In June 1993, he won all six of his starts and earned National League Pitcher of the Month honors. The next season, he pitched twenty-five and two-thirds consecutive scoreless innings.

The positive results built his confidence, an essential trait for a major league pitcher. "I remember this game in St. Louis. I pitched two and a third innings. Twelve hits. I got taken out of the game. I gave up eleven singles, five or six infield hits against guys like Willie McGee and Ozzie Smith and Vince Coleman. And I'm sitting in the clubhouse, just gave up five or six runs, thinking, 'What else could I have done?' I mean, they chop the ball and run. They're fast. You bring in another pitcher, they're going to do the same thing to him."

With these outings, Hammond learned to wipe the slate clean and start fresh, reminding himself that he's a good pitcher and the box score doesn't tell the entire story.

But injuries started to set Hammond back. After 1996, the Marlins wanted Hammond to transition to a bullpen role. He wasn't interested, especially after the Boston Red Sox offered to sign him as a starter. His contract with Boston was laden with starter incentives, bonuses based on innings pitched and wins. Despite the incentives and the intent, Hammond wound up in Boston's bullpen. The switch left Hammond disenchanted. And he liked the idea of spending more time with his young family at his ranch in Wedowee better than he liked the idea of playing baseball. With his wife, Lynne, experiencing a difficult pregnancy, Hammond retired, happy to care for his family and perform the various tasks needed to maintain his spread, a deer and hunting reserve with a twenty-acre bass lake.

THE COMEBACK

Three years removed from the game, Hammond was thirty-five years old. After his wife mentioned her regret that their kids hadn't seen him pitch, Hammond started getting his arm in shape. He let teams know he was interested in pitching again. The Cleveland Indians reciprocated interest, signed him to a minor league contract and assigned him to their Triple A team in Buffalo, New York.

Hammond pitched well, giving up so few runs that his ERA was below 2.00. He threw so effectively that teammates and he wondered if the Indians would call him up to the big leagues. Then he heard a rumor that the Indians wouldn't promote any pitcher who didn't throw at least ninety miles per hour.

Hammond asked his agent about the rumor. Hammond said, "If it's true, tell them I want my release." Three days later, the Indians released Hammond. "I guess the rumor was true," he laughs.

A few days passed, and the Atlanta Braves called. Their message: we don't care how hard you throw so long as you get hitters out. After that, Hammond began pitching for their Triple A team in Richmond, Virginia.

Hammond says he wasn't pitching any differently compared to his prior seasons in the big leagues. "I've always been able to throw the ball where I want to. Throw my off-speed where I want to. Command the strike zone."

He pitched well enough in the Braves farm system to merit an invitation to spring training in 2002. After being away from the big leagues for four

years, Hammond took the mound at Atlanta's Turner Field on April 4, 2002. In the top of the seventh inning with one out, he faced Dave Rollins of the Philadelphia Phillies.

As Hammond toed the rubber, he wasn't thinking about the long road back to the big leagues, the stops in Buffalo and Richmond, the odds against a thirty-six-year-old returning to pitch at the highest level after a lengthy layoff. "All of that was overshadowed by the fact that my family's watching," he says.

Hammond struck Rollins out.

The next batter reached base on an error. Then Hammond walked Doug Glanville. He ended the inning by striking out Bobby Abreu. "I had a lot of focus," Hammond says about both that game and his comeback season. "I pitched every game like it was my last."

Although his control and changeup remained the same during his comeback compared to earlier in his career, Hammond's focus intensified during the second half of his playing days. "Just because two years off, and I'm coming back. Older guy. They weren't going to give me too many chances. And now, it's like you better focus or you're gone. And with the Marlins, you have a bad game, it's like, 'Come on! We know you can pitch! I know you lost three in a row—come on!' And they'll walk with you because you're young and left-handed."

Hammond enjoyed many aspects of his time with the Braves, including its leadership, manager Bobby Cox and pitching coach Leo Mazzone. "I liked a manager that if me, Greg Maddux, Chipper Jones and John Smoltz all walked into his office together, we're all on the same page. He doesn't show any favoritism."

Cox was thrown out of a record 158 games. Hammond says this demonstrates Cox's support for his players. "He has your back. Whether you're right or wrong, you're right."

Pitching coach Mazzone likewise looked out for players. Before each game, Mazzone made the rounds, checking in with each pitcher to see how he felt. "If you didn't say right off the bat, 'I'm good,' Leo would be like, 'Hammy?' If I said I was a little tired, he'd go, 'You'll be the last pitcher we use. We're going to get you a day off.'"

Not all teams gauged their pitchers' readiness like the Braves. In fact, Hammond says, "I've never, ever been on a team like that." The Braves' approach contrasts that of the Yankees, Hammond's subsequent team. When Hammond told pitching coach Mel Stottlemyre he was tired after pitching six out of the previous seven days, his candor landed him an

extended stay on the bench. "You don't tell Yankees when you can pitch and when you can't," Hammond says.

With the Braves, Hammond pitched middle relief. In hindsight, he wishes he had transitioned to that role earlier in his career. "If I had to do it over again, for a guy who threw in the mid- to upper eighties, and I had mastered the off-speed. I had a great changeup. Really good slider. And a good curveball. For somebody to come in in the sixth, seventh or eighth inning and pitch one or two innings, hitters don't want to face somebody who has mastered the changeup. They want the fastball. And I can get in and get out, and they don't have time to adjust over two or three at-bats."

As he settled into the bullpen, Hammond enjoyed its camaraderie. "We had a ball. We'd watch the game and tell stories. Darren Holmes and I, we'd tell stories about hunting and fishing."

In 2002, future hall of famer John Smoltz began his role as the Braves' closer. Not only did he make an immediate impact by saving fifty-five games, but he also became an advocate for the relief pitchers. Seeing the bullpen room, Smoltz said, "This room is too small. We need to be able to relax in here."

When the relievers returned from their next road trip, they walked into an expanded bullpen room, four times larger than it had been before. "They've got a big-screen TV in there and two lounge chairs. And then, every road trip we'd go on: another lounge chair."

Hammond describes the rest of his pen mates as a "bunch of no-fit guys that all fit together," discarded arms the Braves pieced together to form one of the league's best relief staffs. Thirty-six-year-old left-hander Mike Remlinger made seventy-three appearances and posted an ERA below 2.00. Darren Holmes also received a considerable amount of work; he, too, carried an ERA below 2.00.

Hammond believes one reason for the corps' success was wanting to do well for Atlanta's front-line starters. "For me, it all had to do with who got the start. When you're coming into a ballgame for Greg Maddux, Tom Glavine, those guys—it puts a lot of pressure on you."

AN UNSPOKEN GOAL

From the end of June 2002 to the remainder of the season, Hammond gave up no earned runs and had a thirty-five and two-thirds scoreless inning streak.

"For the last half of the season, I mowed them down."

As his ERA dropped, he began pushing to end the year with it below 1.00. "It was a personal thing. Nobody talked about it. It was kind of like a no-hitter where you don't say anything about it when you're trying to get it."

Speaking of baseball codes, Hammond honored the game's eye-for-an-eye tradition while targeting his goal. On September 7 against the Montreal Expos, Braves outfielder Andruw Jones hit two consecutive home runs. For Jones's next at-bat, the Expos' pitcher greeted him with a pitch to the helmet.

Braves pitchers were upset. Hammond says, "We're all thinking, 'One of their guys needs to get hit.'"

Relief pitcher Tim Spooneybarger entered the game for the Braves and pitched a one-two-three sixth inning. Then Bobby Cox looked to Hammond to pitch the seventh. At this point in the season, Hammond's ERA was on the verge of dipping below 1.00. But if he gave up a run, just one run, he had no chance of ending the season with it under 1.00. Bullpen mates told Hammond, "Get two outs. Then hit the next guy."

He mulled it over. Then he said, "Somebody better get loose. I'm hitting the first guy."

True to his word, on the first pitch, Hammond plunked batter Brad Wilkinson. "Back then, I threw pus. He probably had to get out of the way of the ball anyway." In response, home plate umpire Wally Bell ejected Hammond. On top of that, Hammond served a brief suspension.

Around that time, Hammond cut his finger. Reaching into his shaving kit, he scrapped his left pointer finger against his razor. As a result, he spent time on the disabled list. Once the finger healed, he threw a bullpen session to practice for his return to the field. He was surprised when Greg Maddux approached him and asked, "Do you mind if I stand in there?"

Hammond thought, "What for?"

Maddux said, "I want to see your changeup."

Hammond says, "Having Greg Maddux stand there while I'm throwing a bullpen is the most nervous I have ever been in my life."

As the season wound down, Hammond's goal of finishing with an ERA below 1.00 was within reach. But one game against the Florida Marlins made him wonder whether he came close only to be disappointed.

He started the seventh inning by issuing a walk. Kevin Millar then ripped a line-drive double to the right-center gap. Facing no outs and runners on third and second, he thought, "All this for nothing." Then he reminded himself: focus. Focus on the hitter. Pitch to him like this is the last hitter you'll ever face.

Mike Lowell hit a ground ball to the shortstop, Rafael Furcal, who made an easy throw to first base. One out.

Hammond intentionally walked Derrick Lee. Bases loaded.

On an 0-1 pitch, the next hitter popped out to second base. Two outs.

Hammond breathed deeply. "Focus!" He watched the signs from his catcher, Henry Blanco, and delivered the pitches. The Marlins' Mike Redmond lined out to first base.

Out of the jam and knowing his sub-1.00 ERA was secure, Hammond displayed emotion for the first and last time that season. He pumped his fists, tossed his head back and howled for joy. "I was excited. I felt fifteen feet tall."

THE YANKEES CALL

After his incredible 2002 season, Hammond became a free agent.

"I told my agent I didn't want to play in New York or on the West Coast. I wanted to stay closer to home."

While Hammond was hunting on his reserve, his agent, Bo McKinnis, called. "What are you doing?" McKinnis asked.

"Deer hunting," Hammond whispered.

"Well, I'll be quick. The New York Yankees called."

"I told you," Hammond said. "We ain't playing in New York."

"Well, they offered two years. This amount: $5.6 million."

"Whoa!" Hammond screamed, shattering the silence surrounding the deer stand and sending any nearby bucks fleeing. "We're playing in New York!"

Pitching for the Yankees offered some highlights, like pitching in Roger Clemens's three hundredth win ("The fans booed me when I came in. They wanted Roger to keep pitching."). But it also presented some peculiarities.

"As soon as you walked into the clubhouse, you'd see twenty reporters," Hammond says. "You can get there at twelve o'clock, right after lunch. There's twenty reporters there, waiting for something to happen. And it keeps a team from being a team. Because I never saw [Roger] Clemens. I never saw [Derek] Jeter. Bernie Williams and [Jason] Giambi. It was just me, a few of the relievers and a few of the bench guys. They didn't want to ask us anything."

Not that Hammond felt isolated. Andy Pettitte had kids around the same ages as Hammond's, so the two pitchers brought their children to the ballpark early to throw batting practice to them.

Yankee fans were very demanding. As he prepared for his first home series, he heard comments from teammates about The Gauntlet.

"What's The Gauntlet?" Hammond asked.

"You'll see."

Pitcher Jeff Nelson finally explained to Hammond that a barricade separates players as they walk from the stadium to their cars. "Every game, there's hundreds of fans there. And if you do good, they cheer you on. If you did bad—because they could care less what you did last night. It's what you did tonight. If you did bad, they will let you know about it."

One night, after following a player who had had a bad game through The Gauntlet, Hammond resolved not to have a bad game. "You can look up my stats at Yankee Stadium that year. I think I gave up one run that whole year. I told myself, 'Me and my family ain't walking through no Gauntlet.'"

Hammond spent three more seasons pitching for the Oakland A's, San Diego Padres and, coming full circle to where his career began, the Cincinnati Reds.

Hammond knew it was time to retire when his kids quit wanting to join him at the ballpark. "They'd rather stay with their neighborhood friends and play kickball. And I remember driving home one night after my last game, and I just felt that was it. I ain't going back. So I get home, and my wife has the TV on. Lights are out. And I went around on that bed. Sat down right next to her, and I go, 'I just played my last game.'"

Hammond's wife was relieved.

Hammond said, "I'm going to pray that the Cincinnati Reds somehow release me before I get to the field." He said this because, if the Reds released him, he would get paid through the remainder of the season.

The next day, Hammond received a call from his agent.

The Reds released him.

HELPING ALABAMIANS

After his playing career ended, Hammond started the Chris Hammond Youth Foundation. Its goal is to help bring organized sports to underprivileged children.

"When God put us in Wedowee, Alabama, and me growing up in Vestavia where we had everything, and once my kids started experiencing what kids in rural areas experience—not much—I'm like, this is a tragedy." The

Left: Chris Hammond sharing a positive message with young players. *Chris Hammond's collection*.

Below: Hammond today. *Author's collection*.

foundation helps build ballparks, install lighting, provide equipment—whatever is needed for kids to play sports. "If you play on an organized team, no matter what it is, to me it helps build the characteristics and everything that helps prepare you for life. What having a job is all about." The foundation raises money by accepting donations ("I'm happy when somebody gives us five dollars.") and by hosting an annual auction paired with a golf tournament. Hammond wants tournament participants to have fun.

"I want there to be something on every hole, so folks are like, 'Oh, look! Full Moon Barbecue's coming up on the next hole! Can't wait for some Full Moon!' I want lots of giveaways for the players, and I want everybody to have a good time."

Hammond doesn't place goals on the foundation to raise X amount of money and build Y amount of baseball fields annually. Instead, his approach is to reach people with his message. As more learn about the foundation, support will grow and the building will continue.

Hammond maintains his ties with the Atlanta Braves, and he enjoys participating in the team's alumni activities. "It's fun for my kids. We'll go back to Atlanta and see Chipper Jones. He'll be like, 'What's going on, Hambone?' My kids get a kick out of that. I like it, too, getting that respect from your teammates."

Work with the foundation keeps Hammond busy, but he has fun by "being the hands, feet and voice of Jesus Christ in a lost world." A religious man, Hammond questions the strength of religion in the United States, with some churches transforming worship service into an hour of entertainment. And he notes that, with America's resources, in which most have a roof over their heads and three meals a day, people lose sight of right from wrong and become more focused on material pursuits. The people who hit bottom—they are the ones most open to hearing God's message.

Hammond meets these people by working in a prison ministry. "These guys, the ones who know they need to turn their lives around, they're looking for the right path. Some of them haven't made it yet, but the ones who are looking for a better way, I'm happy to help them."

COLLEGE HARDBALL

ultiple players (including Gary Redus, Mackey Sasser, Chris Hammond, Todd Jones and Tim Hudson) enhanced their skills by playing college baseball in Alabama. Undoubtedly, college baseball offers players an incredible opportunity—a chance to further their education, learn from experienced coaches and hone their talent against good competition.

Over sixteen seasons as head coach at Auburn (1985–2000), Hal Baird concentrated on helping his players, particularly his pitchers, improve. "I didn't think about it at the time, but when it was all said and done, looking back on it, almost every one of [the pitchers] who became a pro later on or whatever, it was one of two things, and a lot of times, it was adding a third pitch," Baird says. "The third pitch, be it a split-finger fastball or a straight changeup, that seemed to be the thing that I had to do most to give guys a chance to have an equal opportunity to get both left-handed and right-handed hitters out."

Baird applied this philosophy by helping pitchers find a pitch they could throw for a strike on both sides of the plate. "That was sort of the thing that drove us," he says.

The drive produced results, as Baird won 634 games during his Auburn tenure, the most in school history, including Southeastern Conference championships in 1989 and 1998 and two trips to the College World Series. One team that stands out to Baird, though, is a club that didn't reach the College World Series.

"I think the best team, or certainly one of the best teams, was the 1995 team that had the number one RPI and was ranked number one in the country," Baird says. "Didn't get to Omaha [and the College World Series]. We had to go on the road for the NCAA tournament, which was a shame. No number-one ranked team had ever had to do that. We went to Oklahoma, which was the defending National Champion, and got beat in the finals. That team finished 50-12, which is an unbelievable record. We were the fastest SEC team ever to win forty games. I think 40-5."

Coach Hal Baird. *Auburn University's collection.*

In west Alabama, the Crimson Tide also enjoyed victorious moments on the diamond, winning fourteen regular season SEC championships and finishing runner-up in the College World Series in 1983 and 1997. One player from its 1983 team, Dave Magadan, was named *Baseball America*'s Player of the Year after hitting .525 and setting still-standing team records for most doubles (thirty-one) and RBIs (ninety-five) in a season.

Thinking back on 1983, Magadan recalls a team that caught fire toward the end of the season. Igniting the fire? A meeting led by Coach Barry Schollenberger after the Tide lost to Delta State, a small school. "Coach Schollenberger and the rest of the coaching staff had a meeting that we were going to have to play a lot better than that, that we got beat by a school we shouldn't have gotten beat by," Magadan says.

After that, the momentum built as the Tide won twenty-two of its final twenty-seven regular-season games. It carried into the SEC tournament, as the team won three straight games to clinch the tournament. Alabama then marched into its NCAA Regional, knocked off powerhouses Miami and Florida State and earned an invitation to the College World Series, where it continued to win, beating Arizona State, then Michigan.

"We surprised a lot of teams," Magadan says. "I think we didn't really get a whole lot of respect when we got to Omaha [for the College World Series]. I think everybody thought of Alabama as a football school, and rightly so.

Won a lot of national championships [in football] and really hadn't done a whole lot in baseball, and we showed up in Omaha, and I think a lot of people were surprised. Alabama's got a baseball team? We kind of snuck up on people a little bit, and the offense really shined the first couple of games. Then, once we won those first two games, I think everybody was aware of how good we were."

The hot streak may have been partly a blessing from the baseball gods, but it also stemmed from hard work. "I had a lot of experience, and we had some guys on our team that were new to the program, so I felt like I really needed to set the tone and show a lot of focus," Magadan says.

To do that, Magadan displayed dedication on multiple fronts, from working with the football team's weight trainer and adding some muscle to his six-foot, three-inch frame to doing extra rounds of hitting with third baseman and leadoff hitter Bret Elbin after every workout. "We would throw to each other," Magadan remembers. "We would try to get each other out. That ability to have that kind of focus day in and day out is a big reason why I had the success I did."

College baseball success isn't limited to the SEC stalwarts. Down south in Mobile, Eddie Stanky, the three-time all-star and former manager of the St. Louis Cardinals (1952–55) and Chicago White Sox (1966–68), took over a fledging baseball program at the University of South Alabama in 1969 and transformed it into a baseball proving ground. During his fourteen-year coaching tenure, Stanky won 490 games and led the team to five postseason appearances. He taught a hard-nosed approach to baseball, playing fundamentally sound and doing whatever you can, large or small, to obtain an advantage.

Trussville's Mike Mordecai, who went on to play twelve seasons in the big leagues, was drawn to the blue-collar style. Although Stanky had retired by the time Mordecai joined South Alabama in 1987, the former coach still stopped by and shared tips with the team.

"With Coach Stanky, it was all about helping your team," Mordecai says. "If it means getting hit by a pitch, busting up a double play. Coach [Ronnie] Powell told a story about how one time when he was playing for Coach Stanky, Coach [Stanky] called him into the game to pitch but said, 'Do not throw one pitch. I want you to pick the base runner off at first base.' Because Powell had a great pickoff move. So Powell threw his warmup pitches, nice and easy. The game starts again, and he throws over to first base. He gave him a lousy move, just kind of a toss over. Comes set. *Pow!* Picked him off. Inning over. That was Coach Stanky

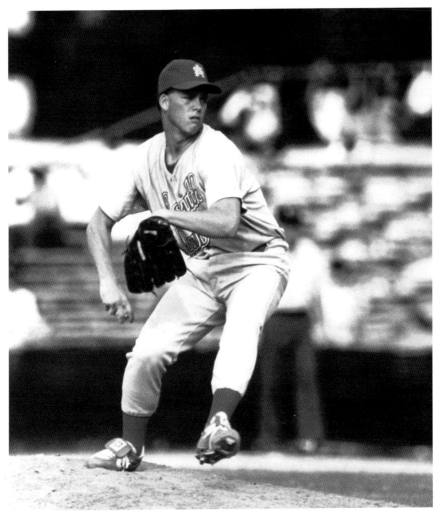

Jon Lieber mastering pitching. *University of South Alabama's collection.*

and the University of South Alabama: doing the little things to find a way to win."

Jon Lieber echoes the South Alabama scrappy ethos. Later a twenty-game winner in 2001 with the Chicago Cubs, Lieber was playing community college baseball in Nebraska after high school. He was pitching well, but South Alabama saw how they could make him better. "When [pitching coach Ronnie Powell] scouted me and saw me throw, he knew that I had a great arm angle [a three-quarters delivery] for a good slider," Lieber says.

Once Lieber was in Mobile, Powell taught his young player the pitch by presenting instructions in concrete terms. "The way I threw mine was, at the bottom of the horseshoe, fingers on the inside," Lieber says. "Basically, stay on top. Throw it like your fastball. And when you come through, it's like turning a doorknob."

Powell's transformation of Lieber is consistent with University of South Alabama baseball. "South Alabama was an old-fashioned, blue-collar type baseball team," Lieber says. "They weren't a Florida State or a Cal-State Fullerton, where you recruit five-star prospects, five-tool players, or whatever. That didn't happen. You took the talent that you see, and you know what they can become, and you work with them."

Powell not only worked with Lieber to teach him a new pitch, but he also helped him develop mental toughness to battle hitters. "When I got here, I didn't have the fire or the determination to really go out there and compete," Lieber says. "I just enjoyed playing the game. I would get rattled. Get scared. [Powell] just challenged me."

Challenges occurred during fall practices, when Powell called Lieber out in front of his teammates. They escalated to a boiling point during a game early in the season against Mississippi State. Although Lieber had good stuff, he was falling behind in counts and pitching tentatively.

When Lieber reached the dugout between innings, Powell grabbed Lieber's cheeks as hard as he could. "What do you feel like doing?" Powell screamed.

"I feel like kicking your ass!" Lieber screamed back.

In hindsight, Lieber says, "I didn't care if they were going to send me home. I got tired of it. Just constantly on me."

Powell looked at Lieber. "Good," Powell said. "That's what I want to hear. Next time, take it out there." Powell turned and walked away.

Tears welled in Lieber's eyes. Looking back, he says the exchange was a turning point in his career. "I never lost the fire after that."

Lance Johnson arrived at South Alabama in 1984 after playing two years of junior-college ball at Triton College in River Grove, Illinois. Johnson, nicknamed One Dog as he played fourteen seasons as a major league centerfielder, loved Mobile's warm climate. "Being from up north gave me an advantage when I came down here," Johnson says. "These guys down here, they played all year-round, and I was only playing half a year because of the weather. So when I got a chance to play year-round, I was already better when I came down here. Having that extra six months to practice catapulted me unbelievably. I just took off."

One difference he observed: more speed, running a sixty-yard dash in 6.5 seconds instead of 6.8 in cooler Illinois. Perhaps that extra speed helped Johnson steal eighty-nine bases in 1984, at that time an NCAA record and still the South Alabama record for most stolen bases in a season. Johnson played so well he was selected an All-American, and he captured the attention of the St. Louis Cardinals, who chose him in the sixth round of the amateur draft. Before heading to short-season A ball in the New York–Pennsylvania League, Johnson met with Coach Stanky. Stanky handed him an index card.

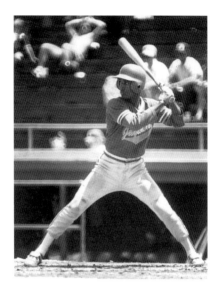

Setting records: Lance Johnson. *University of South Alabama's collection.*

"This is what you need to do to make it to the big leagues," Stanky said.

Johnson read the card. Hit .250. Steal thirty bases. Walk one hundred times. "I carried that card everywhere I went," Johnson says. "I still have it."

He pauses. "Coach Stanky took care of me. Not only did he stick up for Jackie Robinson, he hooked me up in my career, too," referring to Stanky's actions in 1947, Robinson's season to integrate the major leagues. Stanky defended his teammate Robinson against the taunts of the Philadelphia Phillies, who aimed their bats at Robinson and mimicked machine-gun fire. Stanky, the Dodgers' second baseman, called the Phillies gutless and told them to pick on somebody else.

Lessons learned—new pitches, determination, doing the little things well, helping your teammate and standing up for what's right. Higher education, indeed.

AT A CROSSROADS

TODD JONES

1993–96: Houston Astros
1997–01: Detroit Tigers
2001: Minnesota Twins
2002–03: Colorado Rockies
2003: Boston Red Sox
2004: Cincinnati Reds
2004: Philadelphia Phillies
2005: Florida Marlins
2006–08: Detroit Tigers

*A*fter the 2003 season, Todd Jones had pitched eleven years in the big leagues, earned 184 saves and was one game away from going to that season's World Series with the Boston Red Sox—until the Yankees' Aaron Boone sent a Tim Wakefield pitch into the left-field seats of Yankee Stadium. The Red Sox did not re-sign Jones to come back to Boston in 2004, and he returned home to Pell City in a funk.

"I had lost my career," he says. "I was ready to retire after that."

Then he heard about John Paul Montgomery, a ninth-grader from Pell City who had suffered a broken neck and a bruised spinal cord playing football. The injuries left him paralyzed. Montgomery was a sports fan, and Jones agreed to meet him to cheer him up.

The meeting cheered both of them up.

"Look at this guy in a wheelchair, and he's smiling, and you're in the big leagues, and you're pouting," Jones says.

When he met John Paul, Jones noticed that in Montgomery's home, all of the bedrooms were upstairs, making living arrangements challenging and uncomfortable for a resident in a wheelchair. Jones organized a group of volunteers to build the Montgomerys a new home that was wheelchair-friendly.

The meeting with Montgomery energized Jones's baseball career, too. "John Paul convinced me that everybody gets knocked down, but you have to get back up," Jones says. "And I hired a strength and conditioning guy and re-dedicated my life, re-dedicated my career and played another five years. Got to the World Series. Got to Team USA and pitched for the World Baseball Classic because of the stuff John Paul taught me."

A religious man, Jones has been a believer in Jesus since 1991 but says he realizes he wasn't fully committed until 2003, when he lost what defined him—his baseball career. That's when the preaching he had been hearing for years started to sink in.

"I felt like I was told to help with John Paul Montgomery's situation," Jones says. "To help somebody and quit focusing on yourself, and it's not as bad as you think it is. Quit being a baby and grow up and do what you're supposed to do and help your fellow man. You know, believe in me, and I'll take care of you. It's an old tale, but it was the first time it had ever come true in my life."

BEGINNINGS

Jones started playing baseball as a youngster in Marietta, Georgia. He arrived in Oxford, Alabama, after high school.

"I didn't really have great grades coming out of high school," he says. "I had a few offers, but they were just small schools and JUCOs because I couldn't get in anywhere else."

Jones took a recruiting trip to Jacksonville State at the invitation of head coach Rudy Abbott. "He showed me the facilities, and it was way better than I had ever seen. So I signed."

When asked about highlights at Jacksonville State, Jones answers that he met his wife, Michelle, there. "She fell in love with me when I drove a Gremlin," Jones says. "We've been buds ever since."

With respect to noteworthy baseball moments, he says, "I was really awful in college. Really bad." He concedes that as a freshman, he was the only first-year player to pitch for the Gamecocks. He acknowledges that he had a good sophomore year. But things soured the next season. "My junior year, I was supposed to be in the top ten picks and all this stuff, and I just wasn't mentally mature enough to handle it. And fell apart."

Jones points to a lack of control as one reason for his struggles. "I was first or second in all-time walks at Jacksonville State," he says. "And you have to look up the numbers, but I think I'm like a 5.50 ERA, maybe a 6.00 ERA my junior year. I threw really hard, but just didn't have any idea where it was going. And I was a frustration point for the coaches, I imagine."

In terms of adjustments made to go from "really awful" to becoming a first-round pick, selected twenty-seventh overall by the Houston Astros in 1989, Jones says there were none. "They just took me on my ability. I didn't do anything to warrant being a first-round pick other than throwing like I did."

Consistently, Jones could hit ninety-four to ninety-seven miles an hour on the radar gun. The raw talent attracted some. The lack of control deterred others. "I was very, I don't know about polarizing, but I was a beauty in the eye of the beholder for all of the clubs," Jones says. "They either liked me a lot or hated me. And I can't blame them for either."

Jones spent three seasons in the Astros minor league system as a starter before switching to relief pitching. The reason for the change? Lack of control. "I had a lot of walks. And the Astros and any club, they want their starting pitchers to go five or six or seven innings on a good night and keep it around 100, 110 pitches. I never could do that because I'd throw three or four innings, and I'd have 100 pitches. I'd have six or seven walks and five or six strikeouts, and I'd be out of the game."

The Astros' farm director, Fred Nelson, suggested trying Jones in the bullpen. Jones was open to the change. "They decided to let me be a closer, which was intriguing and fun, and I ended up really enjoying that role."

Being a relief pitcher suited his personality. "I think what made the transition easier is because I was really bad ADHD and hyper and couldn't sit still. So, the transition to the bullpen of being involved, engaged every day was great. And then I found that, being a reliever, when you pitch really bad, you could have a chance to pitch the next day. That was good. You didn't have to sit and wait for five days to think about it."

Jones showed he could close successfully, saving thirty-seven games in the 1992 and '93 minor league seasons. The Astros took note, and on July 7, 1993, he made his major league debut against the Pittsburgh Pirates.

"I was called in from Canada," he says. "We were playing a Triple A team in Canada. I was with the Tucson Astros. And I was flying in from Canada to Houston, so I was exhausted. Got to the field an hour and a half before the game. Hit a home run during batting practice. Don't know why I remember that. Tim Wakefield was the starting pitcher that night [for the Pirates]. And he hit a home run off of [Astros' pitcher] Mark Portugal in the second deck of the Astrodome. And I'm thinking, 'My gosh. This is the *pitcher* who just hit the ball this far. I'm never going to get anybody out.'"

The first hitter Jones faced was Pirates catcher Don Slaught. Jones threw three pitches and struck him out. Jones then proceeded to throw two and two-thirds scoreless innings.

Jones says he was lucky to join a Houston team with multiple mentors—veteran pitchers like Doug Jones, Mike Henneman and Doug Drabek. Doug Jones counselled the younger Jones about his mechanics. ("He was always trying to help me calm down my delivery. Because I wasn't smart enough to think about setting up hitters and stuff like that. I just wanted to throw it forward and see how hard I could throw it.") The NL's 1990 Cy Young Award winner, Drabek, served as a model for how to prepare for a game.

Jones also admired position players Craig Biggio and Jeff Bagwell. "Biggio always used to tell us about playing hard, and he says because you're out there three hours a night. The least you can do is play hard." In 1994, Jones observed Bagwell hit forty-two home runs en route to the National League Most Valuable Player Award. "I just remember it was almost like a video game watching with Jeff. It was like whatever we needed that night to win, he was always able to provide in that situation. I think he had over 100 RBIs by August 12, and we went out on strike."

As he acclimated to the big leagues, Jones found some game-day routines.

I was kind of a get-to-the-ballpark-early kind of guy. So, I'd be at the ballpark at 2:30, 2:00 in the afternoon for a 7:00 game, and I'd get my running and my lifting in, stretch and do things like that, then arm weights and ice and go in the locker room. Read the paper. Then get ready for BP. I guess early in my career I played 500, which is the fly-ball game you play in batting practice. You know: a fly ball's 100, a line drive's 50 and a ground ball is 25, and the first one to 500 wins. We did that all the time. Towards the end of my career, I learned. I sat out in the power alleys, left center, right center. And I'd put a guy to my right and my left. And we'd just talk, and I never had to move because they would go get the balls. Because they were closer, you know? So, you learn little stuff like that.

Jones also carried a cheat sheet with him to the mound. "I wasn't able to remember, so I had to write it all down. Inside my pocket was a folded piece of paper with notes on each hitter. Where to start and their weaknesses and what to do."

He also found a habit with gum. "I was a two-piece bubblegum guy every day. I chewed one half of one piece and then one half of another piece to make one whole piece out of two. And I put them in in the fifth inning. Out of routine or superstition, I'm not sure."

Jones was not the only one with an idiosyncratic routine. "Darryl Kile's wife wore a black dress every start he made in one of those years. May have been '95," he says. "Shane Reynolds had to eat a certain cheeseburger from Burger King, which doesn't sound like a big deal until you have a day game on the road, and then you have to go find a Burger King, or find a Burger King the night before and keep it in the refrigerator and then bring it to the park. Biggio always hit with orange Franklin batting gloves even after the Astros changed uniform colors four times. He was always in orange batting gloves."

STRIKE

In his second major league season, Jones was on the front lines of a significant chapter in baseball history: the labor dispute between the players and owners that led to the players striking in August 1994. No World Series was played that season.

Jones served as the Astros player representative for the players association. "If I was going to be out on strike, I wanted to know why," he says. "And if I was going to walk away from fifty-two days of games, I wanted to make sure that our side was doing everything it could do."

Being the team's player representative carried some risk. "That created a lot of animosity among clubs," Jones says. "Unless you were a premier guy, which I was not. Some of those guys got traded. Some of those guys got released."

After the players decided to strike, Jones was in Washington, D.C., as the players association negotiated with the owners. Jones says the meeting blew up, with both sides at an impasse, when President Bill Clinton called the lead player reps, Jay Bell and Tom Glavine, and invited them to the White House to see if he could reach a middle ground. "I was at the hotel when that

happened, and I was thinking, 'You know, this thing is bigger than any of us thought because the President of the United States is fixing to get involved in it.' And then he found out he couldn't do anything about it because neither side was going to budge. And he left it up to [William] Ussery, who screwed it up, and he got out."

Jones says Ussery didn't understand how unique a job a baseball player is. "It's because of the reserve clause. You know, there's no reserve clause in any other industry. So in any other industry, if you're offered a better job, you're able to go. And in ours, you're not. And that's why we would never agree to a salary cap. And hopefully, never will."

Jones found his experience as a player representative rewarding, but after he was traded to the Detroit Tigers, he stepped down.

TIGER TOWN

During his first stay in Detroit, Jones blossomed as a closer, saving 142 games, including 42 in 2000 to lead the league and win the American League Rolaids Relief Award and good enough for him to finish fifth in the AL Cy Young Award voting.

Jones credits a number of factors for his success in Detroit. One was having a great catcher in Brad Ausmus. Another was seeing a sports psychologist, Charlie Maher, a professor at Fordham University. "He taught me that your brain is in one of three places at all times," Jones says. "It's in the past, the present or the future. A perfect example is man, I pitched bad last night. I hope I don't pitch bad tonight. You know, you're thinking about the past and a little bit of the present. And that your mind is better off if you're focusing on what's going on right now. I'm able to compartmentalize. Get all the garbage away from the situation, and I was able to focus on what I had to do that time and not worry about I pitched bad last night. Because I've got to get this hitter out and do everything I can to make this pitch right here. And for me, that was something that had to be taught. You know, for [Greg] Maddux and the great ones, I guess they picked that up, but it took me a sports psychologist showing me how to do that."

Another was working with a manager he loved, Buddy Bell. "He was the first manager to ever believe in me," Jones says. "He was the first person who said, 'I'm going to make you a closer whether you like it or not.' He unlocked everything. He was the greatest influence in my career."

Todd Jones on the mound, ready to get the job done. *Mark Cunningham/Detroit Tigers.*

Clockwise from top left: Comfortable and focused; Preparing… Releasing… Delivering. *Mark Cunningham/Detroit Tigers*.

Jones admired Bell's personal touch. "He was the first one when I got traded, he called me, welcomed me to Detroit, asked me how Michelle was doing, my wife. I mean, just took the time to look up in a media guide and find my wife's name. And that's just little stuff that he did that nobody else ever did."

And in 2000, Jones says it was "the perfect storm. I had gotten...the most save opportunities that I had ever had and was able to execute."

Jones also mastered a new pitch, the cutter. He noticed that his velocity decreased slightly and looked for a way to compensate. He remembered former Astros pitcher and pitching instructor Vern Ruhle showing him the cutter's grip and explaining how to throw the pitch. "I had had it for two or three years and just never really used it in a game and then, in 1999, I started throwing it. And it really gave me another facet to what I was able to do. As my velocity started to go down, I needed something that looked like a fastball that could move a little bit and keep them off of it."

Jones admires how another great relief pitcher, Mariano Rivera, mastered the cutter to achieve success. "He had control," noting that Rivera could throw to all four corners of the strike zone with his cutter. "I could only do one: down and in to a lefty or down and away to a righty."

LIKES AND DISLIKES

As he spent time in the majors, Jones developed preferences.

"I was more of a history guy, so I liked Fenway and Yankee Stadium and Wrigley," he says.

Speaking of history, Jones appreciated being the last pitcher to appear in Tiger Stadium. The stadium's final game was on September 27, 1999, and Jones was on the mound to record the final out, striking out Carlos Beltran.

"That was the first really cool thing I had ever gotten to do in my career," Jones says. "To be part of something that historic. You know, that's where Lou Gehrig's streak ended. That's where Babe Ruth hit [home run number] 700. That's where Mickey Mantle blew out his knee for the first time and really injured his knee from the storm drain out in right- and left-center."

Before uniform standards were applied to mounds, Jones says the SkyDome in Toronto was the perfect mound, because it's mostly clay. "I liked the SkyDome because I was a reliever and you couldn't tell that anybody had pitched."

The worst? Candlestick Park in San Francisco. "It was so dry. The mound would get so hard and just break off."

Playing from 1993 to 2008, Jones faced some of the game's best hitters. He threw more than one thousand innings but vividly recalls the first time he faced Tony Gwynn, Ozzie Smith and Barry Bonds. ("The first time I faced Bonds, I struck him out.")

With humility and humor, he remembers the hitters who hit him well. "Albert Pujols, his numbers off of me are ridiculous, personally. He wore me out—like seven for nine with four homers. Jim Thome: he has a nice eight-by-ten glossy of me that he probably has in his locker. I'll be upset if I don't get invited to Cooperstown for his acceptance speech, to be honest with you."

He also remembers thinking, "'Man, you know? Barry Bonds has to give me his undivided attention right here.' I mean, for a minute and a half of his life, I was all that mattered. And I can remember thinking that. Because I know every time I faced any of those big-league hitters, that was all that mattered. I knew them inside and out and knew what to do, and either I did it or I didn't."

As he spent sixteen seasons in the big leagues, Jones noticed some changes from his rookie season to when he retired as a forty-year-old. One evolution was video. "When I first got to the major leagues in '93, you had half a year until you saw a team again and before you really had to make any adjustments. Because there was just starting to be satellite TV where other teams could watch you and exchange information. So, you had a third of a year at least or a half of a year before word started to get out, but nowadays, it's a series."

As an example, he refers to Hideo Nomo. "You know, he had that weird windup. On his fastball, his hand would be up in the glove, and then on his forkball, his hand would be way down here on his turnaround. He would turn around toward second base—his hand would be out of the glove on a forkball and up in the glove on a fastball. If he'd done that now, it wouldn't have taken any time to figure out. Not that I'm taking anything away from him. He's great. I played with him. He showed me sushi. I love it."

Not only is the information available more quickly, but also its depth is stunning. "They had it to where you can pull up what he did in a 2-2 count, what he did in a 1-1 count. They had it broken down into whether you were ahead in the count or behind in the count. You could do it day game, night game. You could do it home and roads."

One preference he retained for most of his career: the number on the back of his jersey, 59. "That was my first number in the major leagues. And I didn't know you could change it once you got to the major leagues," he says. "Nobody ever told me. See, there's not a pamphlet when you get to the major leagues of do's and don't's. You just kind of have to feel your way around, and I guess I never thought of myself as a big enough guy to ask if I could change my number."

After he was traded to Detroit, he kept 59. When he then moved to the Minnesota Twins, he gave pitcher Jack Cressend $1,000 for the number. In Philadelphia, the bullpen coach wore 59, but Jones gave him a few bottles of wine in exchange for the number. In Florida, Guillermo Moto wore 59. Despite Jones offering $10,000 for the number, Moto wouldn't give it up.

"That's the only year I wore number 50. Everybody thought I wore 59 because I lived in St. Clair County, and it was 59 on the license plate, that that's why I kept it, but then I became hard-headed. And I started to realize, as I started to change teams, that nobody had 59, so I could always get it. So I saved money. I didn't have a cool number. So it was always available. That was about it."

ROCKY TIMES, GOOD TIMES

After achieving great success in Detroit, Jones followed his former manager Buddy Bell and signed as a free agent with Colorado in 2002.

Jones's tenure in Denver was difficult. Bell, the reason why he chose to play for the Rockies, was fired twenty-two games into the 2002 season. Jones dealt with some injuries, which impacted his ability to pitch. In turn, two teams released Jones. Jones remembers meeting "some pencil-pushing goob telling me I'm finished."

"The first time I ever got released was in Colorado in '03," he says. "With my numbers, I deserved it. I'm not complaining."

The next day, Jones signed a contract to pitch for the Boston Red Sox. After the season, Jones learned that the Red Sox did not want to re-sign him, so he accepted a minor league invitation to spring training with the Tampa Bay Devil Rays. General manager Chuck LaMar told Jones, "You'll have to pitch your way off this team."

Despite having a solid spring of eleven innings and giving up only two runs, the Rays released Jones. "The people in Tampa told me, 'You know,

we're going to go with Jorge Sosa instead of you. Because we think Jorge Sosa's good.'"

Jones landed on his feet, signing with Cincinnati. He led National League relief pitchers in wins in 2004 with eight. In Cincinnati, Jones was the setup man, pitching the eighth inning and paving the way for the closer, Danny Graves. "I had twenty-eight holds and like seven or eight wins. Doing awesome."

Despite not being the closer, Jones was thrilled to be playing and contributing. "You get to the big leagues, and you're thinking, 'So what? You've never seen me.' Every person that's put on a big-league uniform has said that. And then you crumble. You get humbled to your knees. And then you figure out your niche. Because everybody, when you're growing up, you hit the game-winning home run in the bottom of the ninth of the World Series. You don't think about being the setup man. Nobody thinks about it because they don't understand how hard it is."

Along the way, Jones evolved as a pitcher. Losing some velocity, he could no longer blast the ball past hitters to get them out. He had to think more about setting up hitters and remember some of the lessons that Doug Jones, Mike Henneman and Doug Drabek taught him ten years earlier. "You can look at the numbers. My strikeouts go down. My walks go down. And then, by 2006, '07 and '08, I had more saves than strikeouts. Because I was able to pitch. Learn how to locate. Command. Think three or four pitches ahead. Change speeds."

Reinvigorated and healthy, Jones served as closer for the Florida Marlins in 2005. As a thirty-seven-year-old, he had forty saves, including a streak of twenty-three consecutive saves. On September 15, his earned run average was less than 1.00.

Putting this success into context, he started the season as a setup man. As the year progressed, the two relievers behind him suffered injuries. "I got my first save like April 20th. 25th. And had forty by the end of the year. Had a great catcher, Paul Lo Duca. And I had an amazing infield. Luis Castillo, Alex Gonzalez and Mikey Lowell. All of them were Gold Glovers. Heck, we pulled a hidden ball trick that year. At third base."

The hidden ball trick happened in the ninth inning against the Arizona Diamondbacks with the Marlins ahead two to one. Arizona's Luis Terrero hit a lead-off single. He advanced to third after a sacrifice fly and then a single by Tony Clark. "I'm backing up third, and Mikey's got the ball, and he wasn't throwing it to me, and I just kind of started walking towards the mound," Jones says. "Because, you can't walk on the

dirt. So I was walking around the mound and grabbing some rosin and taking off my hat, and the guy stepped off, and [Lowell] tagged him."

Jones says that a lot went right in 2005. "I had a lot of confidence. Just got hot and just kept it going."

One of his goals was to pitch the entire season without receiving a visit from the pitching coach, Mark Wiley. Jones made it to September 20. "That's when you're rolling."

The following season, Jones reached the World Series with the Detroit Tigers. "It was the first time that anybody cared about baseball in Detroit since 1987 at least. And I was back home. That year, Magglio Ordonez hits the walk-off home run to put the Tigers in the World Series, and me and my wife, we go out to dinner that night at a restaurant, and we get a standing ovation. That was awesome. It was so cool. To just be a part of little stuff like that."

The Tigers won the American League pennant on October 14. Then they had to wait seven days for the Cardinals to wrap up the National League pennant and for the World Series to start. "We sat in Detroit for a week. And it was twenty degrees outside. The Tigers had kicked around flying us to [spring training site] Lakeland [Florida], so we could play some scrimmage games with the instructional league guys, but at the end of the day, I think they didn't want any of our guys to get hurt, so we worked out in the twenty-degree weather," Jones says. "And it was so cold we couldn't get any work done. We just took BP and got in and got out. We took infield at [domed football stadium] Ford Field."

The lag between winning the pennant and playing the World Series meant that Jones and the Tigers were rusty. "I threw Game One of the World Series just to get some work, and you should never have to do that," he says.

The Cardinals won the Series, but Jones makes no excuses. "We didn't play good, but I wish we

Todd Jones shaking hands after a win. *Mark Cunningham/Detroit Tigers.*

would've had the momentum going into it. But that's not an excuse. Because the Cardinals beat us. They outplayed us."

One of Jones's teammates in Detroit was 2011 Cy Young Award winner and American League Most Valuable Player Justin Verlander. "[Verlander's] first full year was '06, so I played with him '06, '07 and '08. I saw him throw a no-hitter. Saw him win Rookie of the Year. I didn't think he could get much better, and then he just got better and better and better. We had always joked about how when Kenny Rogers was with us and he won his two hundredth game. And we were asking Justin if he would trade his career for Kenny's career, and Justin said, no, he wouldn't. And we abused him for it. 'How can you turn your nose up at two hundred career wins? This guy had a great career, and you think you're going to do more? Who are you?' And boy, were we going to end up being wrong."

WALKING AWAY

Jones says he was lucky the way he ended his career.

"I knew I was done. I was retiring, and I knew I was retiring the whole year. I didn't tell anybody until like the all-star break. But I was able to tell everybody that I wanted to tell: hey, I love you. Or I never really did like you. Or whatever. But I was able to come to grips and closure with everybody that I wanted to, so I was very fortunate in that regard."

Today, Jones doesn't miss playing, but he misses the camaraderie of the clubhouse and the flights and the bus rides and "ragging on each other and stuff like that."

He keeps in touch with some former teammates but makes it a point not to be intrusive. "I try to keep in touch with them when nothing's going on in their life. Like if Curtis Granderson hits for the cycle, I'll call him a week afterwards. I won't call him that night. Because he's getting slammed."

Now he enjoys concerts and video games. He volunteers as a baseball coach at Pell City High School (2015 was his sixth season with the team), and he is involved in four Bible studies. He enjoys the work of Dr. Wayne Grudhem, a religious scholar who has written a book, *Systematic Theology*.

As he was at a crossroads following the 2003 season, Jones faced one again. In 2015, his daughter graduated from high school. His son was already out of the house and attending the University of Montevallo. An empty-nester, he questioned what his next move should be. "I want to

Saying goodbye to Tiger fans at Comerica Park. *Mark Cunningham/Detroit Tigers.*

Jones today. *Author's collection.*

TALES OF HARDBALL IN THE HEART OF DIXIE

share my faith, and I want to influence kids and people. But I don't know whether to influence that in baseball or if I stay around here."

He likes living in Pell City, his wife's hometown. "If you lose your wallet here, you get it back. You don't have to lock your doors. And everybody keeps up with everybody's kids."

He also likes the idea of coaching but is wary of getting back into baseball on a 162-game schedule.

Undoubtedly, Jones figured it out. He always has.

SO CLOSE

2003 CHICAGO CUBS

*I*n Game Six of the 2003 National League Championship Series against the Florida Marlins, the Chicago Cubs started the eighth inning six outs away from advancing to the World Series, the team's first since 1945. *Six outs!* The perennial underdogs had a pennant within their grasp after decades of futility and frustration. (In the 1950s, the team's highest finish was fifth place. In the 1960s, a gulf separated the Cubs from first place some seasons—the 1962 team finished 42.5 games out of first.)

Hewitt-Trussville and South Alabama alumnus Mike Mordecai led off the inning for the Marlins, trailing by three runs. He faced Cubs starting pitcher Mark Prior, who had just thrown seven shutout innings. After four pitches to Mordecai and a fly ball to left field, Prior moved one out closer to a shutout.

"He threw me a cookie, and I got under it just a little bit," Mordecai says. "And I thought I could've gotten a base hit or a double. That might have gotten us going here. I go back to the dugout going, 'Man, just missed a chance right there.' You don't get very many of those against guys like him."

Mordecai didn't connect solidly off Prior, but he noticed the pitcher was tiring. "His control was leaving him a little bit," Mordecai says. "He wasn't as pinpoint as he was. It looked to me like he was pulling his fastball a little bit."

Although Mordecai was the first out, the Marlins showed signs of life. Juan Pierre hit a line drive for a double. Then Luis Castillo smacked the ball

Mike Mordecai. *Author's collection.*

down the left-field line. Cubs outfielder Moises Alou raced toward Wrigley Field's stands to catch the ball in foul territory, but fans were likewise trying to catch the ball. Amid the outstretched hands, the ball didn't reach Alou's glove. Frustrated, Alou slammed his glove down. Instead of two outs with a runner on second, the Cubs had only one out. Prior went on to walk Castillo, and Florida's next hitter, Ivan Rodriguez, hit a single to drive in Pierre. Fans quickly scapegoated Steve Bartman, seated alongside the field, for interfering with Alou, showering him with curses, beer and venom. Meanwhile, the Marlins kept hitting.

Years later, Mordecai asked Alou about the play. Alou answered that it would have been a tough play, no guarantees he would have caught the ball. "I was upset I didn't have a chance. I thought I had a chance at it," Alou said.

As the runs accumulated, Mordecai hit for a second time in the inning, this time against relief pitcher Kyle Farnsworth with the bases loaded. Mordecai stepped to the plate and thought, "Okay. There's two outs. This guy's throwing really hard. His ball's got a little run to it. I may push bunt to second base. If I push a bunt and get it by the pitcher, I might have a chance to beat this out, and we'll go up two runs."

Farnsworth, though, fell behind in the count. As a result, Mordecai started looking for a fastball, and sure enough, that's what Farnsworth offered. Mordecai sent the pitch into left field, a double that drove in three runs, making the score 7–3, Florida.

"I'll take the double with the bases loaded," Mordecai says.

And for the Cubs, six outs from a World Series became another thirteen seasons.

THINGS HAPPEN FOR A REASON

TIM HUDSON

1999–04: Oakland A's
2005–13: Atlanta Braves
2014–15: San Francisco Giants

When he retired following the 2015 season, Tim Hudson had won 222 games, the most among active pitchers. Not only is that a remarkable accomplishment, but it is also truly amazing in light of the fact that when he graduated from Glenwood High School in Phenix City, Hudson received *one* offer to play baseball. At the junior college level.

"I really didn't have a whole lot of options," Hudson says. "I was a pretty average player in high school as far as my velocity goes with pitching. I topped out at about eighty-five or eighty-six. I'd pitch around eighty-two to eighty-three, which isn't D-I [Division I] caliber."

Undersized at five feet, ten inches and 145 pounds, Hudson lacked the body scouts crave. He visited Central Alabama Community College and tried out for the team but didn't receive a callback, much less a scholarship invitation. D.R. Johnson, the head baseball coach at Chattahoochee Valley Community College in Phenix City, had watched Hudson play several games in high school. Johnson's daughter played softball at Glenwood High, and baseball and softball games often overlapped. Johnson liked Hudson's passion for hardball and took a chance on him.

"I just loved playing the game, and I loved going out there and competing," Hudson says. "I was always one of the first guys at the field and one of the last guys to leave. I was one of those kids who loved baseball, and I would've played it year-round if I could have. Back then, there was no such thing as travel ball and that kind of stuff, so my year-round of baseball consisted of going out in the backyard with my dad and going with some buddies and getting a little pickup game going."

At Chattahoochee Valley, Hudson blossomed as a pitcher, a position new to him. "I didn't start pitching until I was a junior in high school because my control wasn't that good. Growing up, I always knew I had a good arm, but I didn't know where it was going."

In junior college, Hudson began baseball-specific workouts and training. He ran sprints foul pole to foul pole and did side-to-side pickups. Using five-pound weights, he strengthened his shoulder and forearm. He gained weight, and he gained velocity. "By the end of my freshman year at CV, I was hitting ninety-one to ninety-two miles per hour on the radar gun," he says. "It was a pretty nice jump from where I was in high school."

He also gained more experience playing regularly against good competition. "God has a way of making things happen for you for whatever reason. It was meant for me to go play at Chattahoochee Valley and play every day. At the time, it was a Division II junior-college program, so there was an opportunity to go there and step in and pitch on a regular basis. That really helped me develop as a pitcher. It was one of those things where it was a blessing in disguise going to CV because I had that opportunity where, if I went somewhere like Central Alabama or a Division I junior college, I might not have had a whole lot of opportunities to pitch right away."

Hudson's improvement attracted interest. The nearby Auburn Tigers let him know they liked him and wanted him to join them. And in the thirty-fifth round of the 1994 amateur draft, the Oakland A's selected Hudson. "They drafted me without an offer for me to sign," Hudson says. "Because I was such a small guy and I was still early in my career as a pitcher, it was a draft and follow. They wanted to watch me for a year. See how I developed. See how much weight I could put on."

Hudson continued to pitch well his second season at Chattahoochee Valley. By now, suitors like college baseball powerhouses Alabama, Florida State and Mississippi State wooed him. Hudson stuck with Auburn, though. "Auburn showed a lot of interest in me early on, and that interest never changed. It was close to home. I had a buddy that I grew up with named Bryan Hebson that was playing at Auburn at the time, and he went on and

on about the coaching staff there and how great Coach Baird was as a head coach and as a pitching coach."

Despite growing up a Crimson Tide fan, Hudson was intrigued with what he was hearing about the Tigers' program. He visited Auburn on a recruiting trip along with eight or nine other recruits.

> *David Ross and Josh Etheridge and a few other guys were there the same time I was. By the end of that recruiting trip, I think seven or eight of us had committed to Auburn. It was one of those things where we fell in love with the atmosphere. We fell in love with the coaching staff and the direction we thought the program was going. At the time, they had gone to the World Series the year before. I think they was currently ranked number one at the time we came in on our recruiting trip, and it was an easy choice for me. I was like, man, here's an opportunity to play for one of the best coaches in the SEC. At the time, the program was up and coming in the best baseball conference in the country. It was probably the biggest and best decision I made in my baseball career.*

Hudson credits head coach Hal Baird for helping him refine the split-finger fastball. "I threw the split before coming in to Auburn, but it was kind of hit or miss. But he worked with me on the pitch and showed me different grips and just helped me develop that pitch."

Not only did Baird help Hudson as a pitcher, but he also provided some life lessons to the young man in his early twenties. "I was a little rough around the edges where I came from," Hudson says. "I grew up in Salem, Alabama. Played ball at Phenix City and went to a junior college. So going from that area of my life to SEC baseball was a big jump for me socially. Coach Baird taught me how to handle myself in a professional manner on and off the field. How to play the game. How to play it with the utmost respect for my teammates and for the other team."

GROWING AS A TIGER

Hudson began his Auburn tenure in the bullpen with an occasional spot start. He questioned whether he had the ability to pitch against Southeastern Conference hitters.

"It's a different level, a jump or two up from Chattahoochee Valley to the SEC to be sure," he says.

I think that jump was more mental than anything. I think the physical tools and the talent was there. It's just going out there and applying them and believing that, when you take that field, you have to believe that you're the best player on the field. Especially as a pitcher. If you don't go out there and pitch with confidence that the other team in the other dugout don't have a chance to hit you that day, then you're going to be at a little bit of a disadvantage. Even though there can be a lot of times when you're not the best guy out there, you have to somehow trick yourself into believing that you are. And that's kind of where I was. Once that confidence started growing, it was one of those things where I was like, all right. I can do it.

Against the Arkansas Razorbacks in Fayetteville, Hudson realized he belonged. The Tigers' starting pitcher left the game in the second inning, and Hudson entered in relief. "I pitched five or six innings, and that was where I felt like I had my best game by far," he says. "I picked up my first SEC win against a really good Arkansas team. I never will forget, Eric Hinske is a guy I played with here in Atlanta. He was a freshman for the Razorbacks then. We'd sit around and talk about that game in the locker room sometimes in Atlanta. Because he talked about how he faced me and he was like, 'Man! You were so skinny! And so little! But, gah, you were nasty!'"

The performance earned Hudson a regular spot as the Tigers' Friday-night starter. And the wins kept coming.

THE A'S CALL AGAIN

Drafted again by the Oakland A's—this time in the sixth round of the 1997 draft—Hudson began his professional career.

"I was really happy to see that they were still interested in me and that they wanted me to be a part of the program," Hudson says. "Coming into that draft, I was told that I would probably be anywhere from an eighth- to a twelfth-round draft pick. And they ended up ultimately drafting me in the sixth round, which I was really excited about. Obviously, with the earlier draft picks you get, you feel like you're a little more cemented into the organization."

Another thing that pleased Hudson: opportunity. In 1997, the A's finished in fourth place in the American League Western Division, twenty-five games out of first. When signing Hudson, the team told him they

drafted a lot of young pitchers, and if they did well, they had a chance to be in the big leagues sooner rather than later because the team needed good pitching.

Hudson responded, moving quickly through every level of the A's minor league system. As he progressed, he changed his outlook about how he pitched, from trying to strike every hitter out to retiring batters with a pitch or two. Hudson credits Oakland's minor league pitching coordinator, Rick Peterson, with this adjustment.

"His philosophy was let's try and get guys out in three pitches or less," Hudson says.

> Command the bottom of the zone, paint the bottom of the zone, across the zone at the knees. Especially with me being a sinker-baller, that was really key. Because I could miss right over the middle of the plate, but the ball was down at the bottom of the zone and working down with my sink, I would get ground ball after ground ball. So, once I started doing that, it was like, man, this is really cool. Give up a base hit to start an inning, then just pound the bottom of the zone. The next thing you know, you have a two-pitch double-play ball. Once I started buying into that and realizing, yeah, it's really cool to see thirteen strikeouts in your line score, but it's way more cool to see seven innings pitched, two hits, no runs.

Within two years, Hudson reached Triple A. Before a start against the Las Vegas Stars, manager Mike Quade sat Hudson down. "The big club doesn't want you to pitch today," Quade said.

"Okay," Hudson said, uneasy and wondering if the A's were releasing him and going in a different direction.

"There's a chance you may pitch on Tuesday for the big team in San Diego."

Hudson said, "Wait a minute, wait a minute. There's a chance I might pitch? Don't tease me like this."

Quade explained the team needed to make some roster moves first to make room for Hudson at the big-league level. Amazed and relieved, he headed to San Diego, and as Quade said, he took the mound on Tuesday night. "I remember walking out on that field and looking around and seeing that big stadium. It's almost like having a sense of relief. Like, man, I finally made it. Here I am, a long way away from Salem, Alabama. I'm finally here. Let's not blow this opportunity. Let's try and make this thing work, and let's see where I am at this level."

Although he didn't receive a decision, Hudson pitched masterfully in his major league debut on June 8, 1999, going five innings, giving up three runs and striking out eleven. After the game, he was satisfied. He reflected on his performance and the results and thought, "You know what? I can do it up here. These are the best hitters in the world, but I belong out there."

For the rest of the season, Hudson concentrated on one start at a time. "I know it sounds clichéd, but I took one game at a time. Never really looked at my numbers. Never really looked at my wins and losses. By the end of the season, I was 11-2, and it was a good start for me."

Hudson compares the A's team he joined to a fraternity. "It was a collection of interesting characters. We were loose and fun. We cut up. We were really young. Oakland didn't have a lot of money to go out there and spend on veteran free agents, so they built within their organization. They gave their young players opportunities to come up to the big leagues and make impacts right away."

The opportunities for younger players created an exuberant atmosphere. The radio blasted in the clubhouse as guys played video games. Or they stepped outside and raced remote-control cars around the infield during batting practice. "We felt like a family," Hudson says. "Because, for half the team, it was our first taste of the big leagues. And it was awesome. We were excited to be there. It was an atmosphere that you don't have at the major league level a lot of times, because a lot of organizations, they fill their locker rooms up with veterans, and they fill them up with guys that are journeymen. So it was almost like a really good college baseball team. We were all that young. We were all really good. We just felt like we could go out there and beat anybody. But we done it in a childlike manner. It was like kids going out there and playing against men, but able to beat the men. It was really cool."

As he acclimated to the big leagues, Hudson found two mentors: Rick Peterson, now the A's pitching coach; and Jason Isringhausen, the veteran relief pitcher.

"Rick was the best at mechanical analysis," Hudson says. "He helped me understand my balance points, your power position, how your hips work in relation to your arm and your arm action. And feeling like when you're out there pitching, how things are almost in rhythm and almost like you're, it's kind of a cheesy way to say it, but almost like you're doing ballet out there on the mound. How things are working together, your leg comes up, then you have some hand movement. When everything is on time and everything is moving fluidly, that's your most efficient delivery. He was the guy that helped us understand that."

While Peterson offered mechanical insight, Isringhausen helped with adjusting to daily life as a big leaguer.

> *He showed me the things you do, the things you don't do. Rookies, when they come up, there's certain things that you do. The training room, for instance. Veterans come in and get their work done whenever they want to get their work done. For rookies, we had to be the first ones in the training room getting worked up by the trainers because, as soon as the veterans came in, "Sorry, kid, but you've got to get off the table." Just knowing your place in the locker room. You had to bow down to the older guys. At the same time, if you're a rookie that was able to come in and embrace that and not get your feelings hurt, the older guys see that, and they are obviously a little more prone to take you in and not give you that much of a hard time. Some of the rookies that push back on that kind of stuff are the ones that the veterans have a tendency to ride harder.*

Although in 1999 Hudson was taught to be deferential to veteran players, he senses this aspect of the game has changed. "The rookies that come up nowadays have definitely more of a sense of entitlement for sure. I'm not quite sure when that started or why it started, but a lot of rookies that come in nowadays, they're not taught how to be big leaguers, per se. A lot of it has to do with these young kids come in, and they're really, really good, one of the best players on the team. And it's hard to ride one of your young studs off the field and in the locker room because you need him to produce on the field to help your team win. Teams are relying a lot more on their young stud talent to help them win, more so than in the past."

TWENTY STRAIGHT WINS

As Hudson settled into the big leagues, the A's emerged as one of the league's best teams. After six seasons of finishing below .500, the 1999 A's won eighty-seven games. The next four seasons, the A's made it to the playoffs. One critical factor in the team's success was its dominant starting pitching and one of the league's best rotations, with Hudson, Mark Mulder and Barry Zito, the 2002 American League Cy Young Award winner.

> *They were both unbelievable pitchers in their own right, but they were two totally different pitchers. Mulder was, honestly, one of the best pitchers,*

stuff-wise, I think I ever played with. He was a big tall lefty. Threw ninety-two to ninety-five with a sinking fastball. Threw a cutter. Threw a big curveball. But, his bread and butter pitch was a big overhand split he threw eighty-seven to eighty-nine miles an hour. And he was just so nasty. He was a lefty that threw a sinker, but he could also throw that Greg Maddux comeback sinker to right-handed hitters that started at their hip and then bring it back over the inside corner, which is unbelievable for left-handers to be able to [do] that because you just don't see it. Not many left-handers could do that and make that pitch, but he could. So, watching him go out there and compete, it was one of those things where, every time he took the mound, I remember thinking to myself, "This team may not get a hit." His stuff was that special. Unfortunately, he started having shoulder problems and those kind of things and that kind of sidetracked his career a little bit.

Zito's curveball was one of the best Hudson ever saw. "He had a curveball that, for left-handed hitters, it would literally start above their head and behind them and break down and away, away at the black and down at the knees. It was just one of the biggest, sharpest breaking balls I've ever seen. He would throw it, and the ball would be above the hitter's head literally at the grass of the cutout of the hitter's circle, and then, all of a sudden, it would just drop off the table four feet. It was fun to watch him throw that thing because left-handers had no shot. They didn't even have a chance to hardly even foul it off, and he could throw that thing pretty much at will and whenever he wanted."

Hudson was a part of the A's when the team broke the American League record for consecutive wins (twenty) in 2002.

After the first fifteen wins, it was kind of nail-biters for the next five. I think like three or four of the last five wins was come-from-behind wins. Walk-off home runs. You know, Scott Hatteberg had a huge walk-off home run for the twentieth win against Kansas City. A lot of people remember that game because it was the twentieth game in a row. What a lot of people forget is, a couple of games before that, we had walk-off wins in the ninth inning as well. Walk-off wins are exciting anyways, but when you throw in the fact that you're keeping a major, major streak alive, it multiplies it by 100. The energy and the emotions that go into it. It was truly remarkable. I look back on it now, and I'm like, "Man, I can't believe we did that."

Amid the success, Hudson was superb. In 2000, he won twenty games and finished second in the voting for the AL Cy Young Award. Against the White Sox, he threw his first shutout, a one-hitter. He ended the season winning seven games in a row. As he achieved success, he carried himself with confidence, much as he did when he pitched at Auburn.

"Baseball truly is a tough sport. You have to have some confidence to go out there and be successful, just because the sport is that hard. If you had that confidence that you are one of the best, and you have that ability to go out there and not do it in a cocky way and not do it in a way that's showing up the other team, but if you carry yourself on that mound like you're a guy who's going to be a tough walk in the park for the other team, more times than not, the guys in the other dugout, they're going to see that. 'Look, he's got good stuff, and he's not scared out there.' I think if you can have that swagger or whatever you want to call it, half your battle is behind you."

During his stay with the A's, his home field was Oakland Alameda County Stadium. Hudson liked the stadium and its fans. "It's a pretty good pitcher's park. It was a lot of foul territory. The ball didn't really carry much at all at night. You could pretty much throw it and let guys hit it, and it just wouldn't go anywhere. It was a good place to pitch. The fans there are really good. They don't get the credit they deserve because they bring a lot of energy. There may not be as many fans in the stadium as other places, but they bring it. It's an older place, but a good place. It's had its flaws over the years, but for us being young players in the big leagues, it didn't matter to me. I could've been playing in an alley somewhere, and I'd've been good with that."

COMING HOME

In December 2004 and after six seasons in Oakland, the A's traded Hudson to the Atlanta Braves. Hudson had mixed emotions about the move.

"It was bittersweet. I loved my team out there. I loved my teammates. And so I was disappointed from that standpoint. On the other hand, I was getting a chance to play for the team I grew up rooting for."

In Atlanta, Hudson found himself working with a manager and a pitching coach he admired, Bobby Cox and Roger McDowell, respectively. "Bobby's like your teammate. He's in your corner. He's fighting for you, screaming and getting tossed out of games. All of this is for you. You felt

like he was the father-figure and he was fighting for you regardless of if you were right or wrong. You knew Bobby Cox had your back, and you knew he was going to fight hell backwards for you. And in return, you played your butt off for him. You competed as hard as you could for the guy because he was doing the same for you. And I think that's ultimately why he gets the best out of his teams every year."

In fact, the highlight of Hudson's nine years with the Braves was 2010, Cox's final season. "I really liked seeing how much the other organizations and players respected Bobby," Hudson says. "Everybody recognized him as he made his last stop in that city, kind of his farewell tour. Seeing it from the perspective of the dugout was really special for me."

Hudson believes that Braves team played beyond its talent to make Cox's last season memorable. "I don't think we had the most talented team that we've had since I was there, but we had some guys that went out there and played their butts off. And I could tell you the number-one driving factor of us getting into the playoffs and trying to win was for Bobby. Because we knew it was his last season, and we wanted to try and make it as special as we could for him. We probably overachieved a little bit that year just getting to the playoffs."

With McDowell, Hudson hit it off. "He's a fellow sinkerballer. At that point, I understood my mechanics better than anybody," Hudson says. "Roger helped me as far as a game plan and talking about how to attack hitters. He was really good at breaking down film of a hitter and trying to figure out what their strengths and weaknesses were."

As he acclimated to the National League, Hudson discovered his favorite park to pitch in: Wrigley Field. "I just loved pitching in the older stadiums. I liked old Yankee Stadium. But I just really enjoyed pitching at Wrigley. You have day games. I love the city of Chicago. It's my favorite city on the road that I would go to. There's something about looking out there and seeing the ivy on the wall. The fans are always excited. Probably half of them don't even understand that we have a baseball game, but they're all having such a party in the stands. That energy, you can feel it on the field. It's fun to be a part of."

Hudson also liked picking up a bat and stepping to the plate to hit. "I had a chance to face Pedro Martinez when I was in Atlanta. I watched him for a lot of years when I was in Oakland just be amazing on the mound and dominate hitters throughout the '90s and the early 2000s. Having the chance to get in the box and face him was something that was really cool. Because I looked up to the guy. He was a smaller, right-

handed pitcher. He was one of the best in the business when I came up as a rookie."

Hudson dug in and watched Martinez throw in the mid- to upper eighties. Timing his swing, Hudson laced a double off the great pitcher.

JESTER, LEADER

As Hudson became a veteran player and a fixture in the Braves locker room, he grew into two clubhouse roles: the practical joker and the team mediator.

For jokes, Hudson's specialty was to sneak into a rookie's hotel room and scare the hell out of him during a road trip. "Any time you check into a hotel room in the big leagues, all of your keys are laid out on a table," he says. "So you get off the bus, you grab your key and you go up to the room."

Hudson, though, would snag a rookie's key as well. While the rookie went to the front desk in search of his lost key, Hudson headed to the rookie's hotel room. Once inside, he stepped into the shower and hid behind the curtain. As the rookie entered the room and began to use the restroom, Hudson would announce his presence, jumping out from behind the curtain and startling his teammate, which soon turned to laughs.

Hudson liked to provoke smiles and good times, not animosity. "I'm a non-confrontational guy. I liked to ease the tension. If somebody was bothered about something, I wanted to talk things out. Get everybody to relax."

While Hudson helped teammates with their frames of mind, catchers helped Hudson with his, particularly David Ross, his teammate from Auburn and his battery-mate with the Braves from 2009 through 2013. "If there was a game where I just wasn't feeling good or didn't have good stuff, he'd come out there. He'd snatch that ball and walk out there to the mound. I could tell, man, this meeting ain't going to go too well."

Ross would arrive at the mound and push Hudson's buttons. "Hey, man!" Ross yelled. "Come on! Let's go!"

Although he didn't relish these exchanges, Hudson acknowledges they helped. "Younger catchers, they're a little hesitant to do that with veteran pitchers. But he knew that, once in a while, if he would just piss me off a little bit, that's all he would need to do. Just go out there, get in my butt a little bit. Piss me off, and the game changes after that."

After the game, when Hudson and Ross returned to the clubhouse, Ross would snicker about their conversation. "I just had to fire up the redneck in you," Ross laughed.

OVERCOMING OBSTACLES

Though Hudson enjoyed success with the Braves, winning 113 games, including 17 in 2010, he dealt with adversity. For one, he missed part of 2008 and nearly all of 2009 because of Tommy John surgery. But he returned after a fourteen-month rehabilitation on September 1, 2009, to pitch against the Marlins in Miami.

"It was interesting, because that was the place where I blew my elbow out," Hudson says.

> *And I've been waiting thirteen months* [to] *come back and pitch, and this particular game, we had a two-and-a-half-hour rain delay to start the game. We didn't start the game until 9:30 at night. Nobody wanted to play the game. I remember looking around the locker room and half our team was asleep, sitting in their lockers. And I was walking around with my heat packs on, chomping at the bit to pitch because I hadn't pitched in so long. So I remember them saying the game's in thirty minutes. I remember looking around and being really excited and fired up, and everybody on the team saying, "Geez! Why don't they call it off?" I was the only guy in that whole entire stadium who wanted to play, I can tell you that.*

The return was great for Hudson. He earned the win, pitching into the sixth inning, striking out five and giving up only two runs.

In 2013, in his final game in a Braves uniform, Hudson suffered a fractured and dislocated ankle while covering first base and Mets base runner Eric Young Jr. stepped on Hudson's foot as he ran toward the bag. "It was a very painful injury. Something as simple as covering first base, and all of a sudden a devastating injury happens like that. Even though it's a non-contact sport for the most part, there are times when things can get a little hairy."

GIANT WEST

Hudson loved his nine years in Atlanta, but following the 2013 season and his becoming a free agent, he sensed his time as a Brave had come to an end. He signed a two-year contract with the San Francisco Giants, winners of two recent World Series, 2010 and 2012.

"They showed the most interest," he says. "I never envisioned finishing out on the West Coast. I didn't think it was do-able with three kids in school, but it was a different atmosphere and culture—that made it appealing. The kids experienced something new, a different part of the country for a summer. As a family, we made some great memories and some new friends. And to be a part of a World Series winner: that was special."

With the Giants, Hudson made an immediate splash, setting a team record for pitching thirty innings before allowing a walk.

> *My stuff may not be as a good as it was when I was younger, but I'm going to go out there, and I just wanted to challenge guys to swing the bat, to pitch to contact more so than I have any time in the past and just trust the guys behind me are going to make the plays. And that's what I did. I tried to make good quality pitches. And just try to induce weak contact. If you're able to do that, you're going to be able to get some outs and not walk guys. For a guy like me whose stuff wasn't as good as it was in the past, for me to start walking guys, that's a recipe for disaster because I didn't have the stuff to strike out guys to get me out of jams.*

Control specialist by the bay. *Hudson Family Foundation.*

He enjoyed and respected manager Bruce Bochy, the 1996 National League Manager of the Year. "He's similar to Cox. He's a throwback kind of guy. He has your back. He feels like he's your teammate. He understands his players. For his pitchers, he's good about knowing whether you have gas left in the tank or going to the bullpen at the right time. As far as the chess moves of the game, his strategy is spot-on."

The 2014 Giants finished in second place in the NL Western Division, but they earned a spot in the one-game playoff against the Pittsburgh Pirates. Behind left-handed pitcher Madison Bumgarner, the Giants marched through the playoffs and into the World Series. "It was an unbelievable run, and the guys in that locker room, they're proven winners," Hudson says. "They have a championship pedigree, and they've been there and done it. Even though I was an older guy in the locker room, I was still a rookie when it came to that. I had never been past the first round of the playoffs. All those guys had won two World Series already."

Bumgarner won honors as the Most Valuable Player in the National League Championship Series and the World Series. Against the Kansas City Royals in the World Series, Bumgarner won two games, saved the decisive Game Seven by pitching its final five innings while giving up no runs and posted a tiny 0.43 earned run average. "Madison Bumgarner, he pretty much put us on his shoulders, and he went out there and was the stud we all expected him to be."

Hudson also shined in the playoff spotlight. He started Game Two of the Division Series against the Washington Nationals, facing Jordan Zimmerman. Hudson pitched seven innings and gave up only one hit in a game the Giants ultimately won after eighteen innings. Against the Cardinals in the League Championship Series, Hudson pitched into the seventh inning and left with the score tied at four.

Hudson started Game Seven of the World Series. "It didn't go as well as I wanted to," he says, referring to his outing where he pitched into the second inning. "But we won, and winning the World Series is amazing. Amazing."

HELPING ALABAMIANS

Hudson retired following the 2015 season. He enjoys spending time with his wife and children and working at his farm. One popular social media post

At home in Alabama. *Hudson Family Foundation.*

from early 2016 shows Hudson relaxing with a baby goat, Douglas, sleeping on his chest.

Hudson gives back to his community. With his wife, Kim, he formed the Hudson Family Foundation. The foundation's goal is to help children who need physical, emotional or financial assistance. The help can range from ensuring a small child receives medicine to treat her cystic fibrosis to providing dinner to families staying at a Ronald McDonald House to sending members of an after-school program to a Braves game.

One fundraiser for the foundation is an auction and country music concert held at The Arena at Auburn University around the Super Bowl. In 2016, music was provided by Justin Moore, Frankie Ballard and Montgomery Gentry. Attendees bid on sports memorabilia, clothes and trips. The proceeds help kids.

For Hudson, his role in the foundation is about doing the right thing. He appreciates the journey from Salem to seventeen years in the big leagues to being back home again. Just as he fired sinker ball after sinker ball from the mound, Hudson continues to deliver, improving his state and helping those in need.

BO BIKES BAMA

*B*o Jackson is a legend for his achievements in multiple sports—Heisman Trophy winner (1985) as the most outstanding player in college football; an all-star in Major League Baseball (1989) who made highlight-reel catches and throws and hit deep bombs; and a two-time all-state decathlon winner from McAdory High School. After tornados ravaged multiple Alabama communities on April 27, 2011, and 238 Alabamians lost their lives from the storms, Jackson turned to another sport, cycling, to help his native state.

Since 2012, Jackson has organized an annual Bo Bikes Bama bicycle race to raise money for building storm shelters across the state. Courses vary. In 2012, riders journeyed five days across Alabama, visiting the areas most severely impacted by the storms. In 2017, riders chose either a twenty-mile or a sixty-mile route, both of which led them through the campus of Auburn University.

Jackson encourages participants to ride with someone they don't know. "It's not a race," he says. "We're here to raise money to help rebuild people's lives."

Several cyclists competed in 2017, some of whom are all-time great athletes, like Ken Griffey Jr. and Brett Favre and Auburn University's head football coach, Gus Malzahn. The result? Since Bo Bikes Bama's inception, more than 3,100 riders have participated and more than $1.1 million has been raised for the Alabama Governor's Emergency Relief Fund, resulting in repairs to nearly 580 homes and construction of 63 community storm shelters.

Bo Jackson. *Staff Sergeant Alex Licea*.

The work isn't done. After the 2017 race, Jackson says, "For the next four years, let's raise another million dollars."

Just as coaches, teammates and fans said after an electrifying athletic display: Go Bo.

CONCLUSION

*E*ach season, the Double A Birmingham Barons return to Rickwood Field for one game, the Rickwood Classic. The day bristles with activity. Fans file in under the park's Spanish tile entrance. The teams wear throwback jerseys, flannels and woolens, taking the field shortly after noon under an early summer sun. A dignitary, like Baron alumnus Rollie Fingers, throws out the ceremonial first pitch, and a small brass band plays music between innings. Fans can look at the painted advertisements on the outfield wall for the Tutwiler Hotel and Burma Shave and watch the numbers change on the manual scoreboard when a run scores. It's easy to feel some timelessness and slip back and think that, just maybe, when you look back at the field, Satchel Paige toes the mound, instructing his catcher to lay a gum wrapper across home plate as his target, or a young Willie Mays bounds across the outfield grass.

Timelessness. The past and the present—1954, when this book begins, to its end six decades later—are so different, yet baseball is a constant. When Alex Grammas debuted in Sportsman's Park, the Korean War had ended the summer before. Dwight Eisenhower was president. Jonas Salk led a team of researchers at the University of Pittsburgh to perfect a polio vaccination. A computer was so large it consumed an entire room. Fast-forward to 2015, when Tim Hudson threw his last pitch and handheld iPhones were ubiquitous. Headlines advised of computer hacks, protests that Black Lives Matter and the Supreme Court finding that the Constitution guarantees a right to same-sex marriage. In between, Alabama and the country

This page: Baseball at Rickwood. A pitch, a catch and the timelessness continues. *Author's collection*.

experienced civil rights advances and struggles. The steel business faded as a primary employer in Birmingham, but the healthcare industry ascended as the University of Alabama at Birmingham became a premier medical institution. Similarly, northern Alabama and Huntsville blossomed into an aerospace research and development stronghold.

Change is inevitable, yet three strikes, three outs and nine innings remain the same as when Alex Grammas played his first major league game. A common thread connecting the times and the generations, as former players nearing ninety like Grammas discuss the nuts and bolts of good baseball with as much gusto, insight and humor as a current player.

Within this constant is a critical element: perseverance. Most players faced a long road to reach the major leagues. For Tim Hudson, the message he received after high school was that his baseball journey was over. No colleges or professional teams knocked on his door asking him to join them. But he pressed on. Hudson's enthusiasm and love for the game prompted a community college coach to offer him the chance to keep playing. *He* knocked until a door opened, creating an opportunity.

For Mackey Sasser to pursue his baseball passion, it meant supporting a young family as he juggled school, sports, being a husband and a dad and working the graveyard shift for United Parcel Service. He credits the experience for forcing him to grow up and accept responsibilities. He could have quit. The challenges he faced could have overwhelmed some, pushing them to set a game aside because it was too hard to fit in. Sasser kept hitting, though, and the San Francisco Giants noticed him at Wallace Community College and drafted him to join their organization.

Progressing through the minors and its gauntlet of long bus rides, dank clubhouses and uncomfortable motel beds is difficult in and of itself, but Billy Williams and Bob Veale dealt with racial discrimination as an additional hurdle. They couldn't stay in the same hotels as teammates. Veale endured taunts about his skin color. It was humiliating, frustrating and aggravating to be good enough to take the field with teammates yet treated differently. Despite the obstacles, Veale and Williams continued working toward playing baseball at the highest level.

Progress can be incremental. A decade later, in 1968, twelve-year-old Gary Redus and his friends integrated Limestone County baseball. Their routine was meeting every day, choosing sides and playing baseball on a nearby field perfectly suited for the game. As they prepared to play one Saturday morning, someone mentioned, "The high school is having baseball tryouts today."

Collectively, the group agreed: let's try out. With their gloves and bats, they walked to the high school's baseball field, where a large group of kids auditioned. Just five years earlier, Governor Wallace proclaimed segregation forever, but Redus and his friends weren't turned away. Nor was the scene one of dramatic confrontation—it was just kids wanting to play baseball. The coach leading the tryouts saw the group of black kids and said to them, "Get in line. Do what everybody else is doing."

Redus did. And he made a team.

Chipping away at wrong-headed institutions by playing a game—progress.

The journey doesn't end once a player reaches the big leagues. Obstacles continue. And the challenges can seem insurmountable. Chris Hammond resurrected his career after years of not touching a baseball. Midcareer, Todd Jones was told he wasn't good enough to pitch in the big leagues anymore. He could have returned home to Pell City, proud of his career, one of the few pitchers to ever finish in the top five for Cy Young Award voting, and called it a day. He didn't. He revamped his training and went on to pitch five more seasons. Hudson tore a ligament in his elbow and underwent Tommy John surgery and a grueling rehabilitation more than one year long and returned to pitch multiple seasons in the big leagues.

These players persevered. They pursued their goal even when facing challenges. Some may have doubted having the ability to overcome these obstacles. Some may have thought it's not worth trying to run the race because the odds were so overwhelmingly against them. But these players illustrate that with determination and talent and breaks, the journey can lead to the highest level and lofty goals can be realized.

"Don't ever let nobody tell you you can't live your dream," Mackey Sasser says. "You can live it—you just got to work to get it because nobody's going to give it to you."

Indeed. Keep chipping away, and we'll see you at the ballpark.

FURTHER READING

*T*o prepare for the interviews with the players, I reviewed newspaper and magazine articles, box scores and books. I used www.baseball-reference.com for most statistics, awards and leaderboard information. I also consulted the Society for American Baseball Research's materials for information ranging from articles about players' careers to histories of ballparks. I also relied on media guides from Mississippi State University's baseball program for historical information. For an explanation regarding sabermetrics, I reviewed David Laurila's article "Sabermetrics 101" from *Baseball Digest* (May/June 2016).

Quotes from Willie McCovey are from Mark Mulvey's article "The Pursuit of Willie and Clyde" from the September 15, 1969 edition of *Sports Illustrated*. Quotes from Ozzie Smith are from John Kuenster's article "Ozzie Smith Reinforces Sentiment to Honor Game's Defensive Stars" from the October 2002 edition of *Baseball Digest* and Barry Jacobs's article "The Wizardry of Ozzie Smith" from the May/June 1983 edition of the *Saturday Evening Post*. Information about Bo Jackson's Bo Bikes Bama event is from its website, www.bobikesbama.com. Quotations from Mr. Jackson about Bo Bikes Bama are from Lindy Oller's article "Thousands Participate in Bo Bikes Bama Ride," in the *Opelika-Auburn News* (April 30, 2016).

This book does not capture all facets of Alabama baseball history. Helpful resources to consult include the following:

Aaron, Henry, and Lonnie Wheeler. *I Had a Hammer: The Hank Aaron Story*. New York: Harper Collins, 1991.

Barra, Allen. *Mickey and Willie: Mantle and Mays, the Parallel Lives of Baseball's Golden Age*. New York: Crown Archetype, 2013.

————. *Rickwood Field: A Century in America's Oldest Ballpark*. New York: W.W. Norton, 2010.

Colton, Larry. *Southern League: A True Story of Baseball, Civil Rights, and the Deep South's Most Compelling Pennant Race*. New York: Grand Central Publishing, 2013.

Fehler, Gene. *Tales from Baseball's Golden Age*. New York: Sports Publishing, 2000.

Fox, William Price. *Satchel Paige's America*. 2nd ed. Tuscaloosa, AL: Fire Ant Books, 2005.

Kahn, Roger. *Good Enough to Dream*. New York: Doubleday, 1985.

Lowry, Philip J. *Green Cathedrals: The Ultimate Celebration of Major League and Negro League Ballparks*. New York: Walker and Company, 2006.

Marshall, William. *Baseball's Pivotal Era, 1945–51*. Lexington: University Press of Kentucky, 1999.

Mauriello, Ralph. *Tales Beyond the Dugout*. Moorpark, CA: Mauriello Publishing, 2017.

Warner, Joey. *Professional Baseball in Lower Alabama: Minor Leagues in Mobile Since 1886*. N.p.: self-published, 2017.

Watkins, Clarence. *Baseball in Birmingham*. Charleston, SC: Arcadia Publishing, 2010.

INDEX

ABOUT THE AUTHOR

*D*oug Wedge writes about baseball history. He also writes short stories. In 2015, Texas A&M University Press published *The Cy Young Catcher*, the book he co-wrote with former major league catcher Charlie O'Brien about O'Brien's experiences working with several award-winning pitchers. Wedge earned English degrees from the University of Tulsa and the University of South Carolina. He lives in Edmond, Oklahoma, with his wife and four children.